Art of Clay

Art of Clay

Timeless Pottery
of the Southwest

Edited by Lee M. Cohen

Foreword by Roger G. Kennedy

CLEAR LIGHT PUBLISHERS
SANTA FE

Clear Light Publishers
823 Don Diego
Santa Fe, N.M. 87501

Library of Congress Cataloging in Publication Data
Cohen, Lee (Lee M.)
 Art of clay : timeless pottery of the southwest / Lee Cohen. —
1st ed.
 p. cm
 Includes bibliographical references.
 ISBN 0-940666-19-7 : $34.95
 1. Indians of North America—Southwest. New—Pottery.
2. Pottery—Southwest, New. 3. Indian artists—Southwest,
New. I. Title.
E78. S7C575 1993
738.3' 089' 974—dc20 91–58828
 CIP

First Edition
10 9 8 7 6 5 4 3 2

Printed and bound in Hong Kong, China
by Book Art Inc., Toronto.

For the ceramic artists of the American Southwest
who over the centuries and in our own time
have created a body of work that is a world treasure.

Contents

Acknowledgements

The dedication, support, and energy of close friends and colleagues have made this book possible. For years, all of us have shared the conviction that pottery from the southwestern United States, past and present, is some of the most significant American ceramic art that has been created. That many of the artists happen to be Native American should not characterize their work as merely regional or ethnological in substance. On the contrary, the traditions of these Native American cultures have provided the inspiration for great art that transcends regional or ethnic origins. In these pages you will find art that is worthy of the national and international acclaim it is now beginning to receive.

Special, heartfelt thanks go to:

Roger Kennedy, who wrote the Foreword to this book, and his wife Frances who have come to be dear friends in recent years. To name Roger's recent role as the director of the National Museum of American History, Washington, D.C., and more recently as director of the National Park Service only begins to suggest his very significant contributions to the cultural heritage of the United States. For example, he was vice-president for finance at the Ford Foundation, on the board of directors of the National Trust for Historic Preservation, one of the founders of the Tyrone Guthrie Theater in Minneapolis, and is well-known as the host of the Discovery Channel series *Roger Kennedy*

Rediscovering America. I was delighted and honored when Roger agreed to participate in this book. His words offer illuminating insights and information of value to both neophytes and sophisticated collectors.

Ron McCoy, Ph.D., who wrote the essays on Al Qöyawayma, Tony Da, Popovi Da, Sarafina and Margaret Tafoya, Helen Cordero, and Joseph Lonewolf, is an historian, anthropologist, novelist, and teacher. He has written several books and numerous articles dealing with the Native American peoples of the Southwest and Great Plains. Honors accorded his publications include a Wrangler Award from the National Cowboy Hall of Fame, the American Association of Museums Award of Distinction, and a second place in the Western Writers of America annual Spur Award competition. While completing graduate studies, McCoy lived on the Navajo Reservation and then moved to Santa Fe, where he managed an art gallery dealing in American Plains Indian art. He is now a professor of history at Emporia State University in Kansas and the director of its Center for Great Plains Studies. He has studied and followed the innovative developments of the many artists about whom he has written over the past ten years of our acquaintance. He is highly regarded for his ability to discern the artistic as well as the ethnological content of art objects from the Great Plains and the Southwest.

Barton Wright, who wrote the essays on Nampeyo and Dextra Nampeyo, is an anthropologist, artist, and acknowledged authority on art of the Southwest, particularly of the Hopi and Zuni. His life has been devoted to the world of museums, notably as a curator and assistant director of the Museum of Northern Arizona in Flagstaff for twenty-two years and science director of the Museum of Man in San Diego. He has worked as an artist at the Arizona State Museum at the University of Arizona and at the Amerind Foundation in Dragoon, Arizona, where he was also an archaeologist. A participant in the founding of the first archaeological state park in North Carolina, he is currently involved in consulting work in his field. He has authored innumerable scholarly articles and a large number of books, the most prestigious of which are *Kachinas: A Hopi Artist's Documentary, Pueblo Shields, Kachinas of the Zuni, and Hopi Material Culture.* He is in the unique position of combining his artist's eye with an unparalleled knowledge of ethnology.

Roberta Burnett, who wrote the essays on Richard Zane Smith, Nancy Youngblood, and Dorothy Torivio, has been a freelance writer, editor, and publisher since leaving a first career as a college professor of writing and literature. For the last twenty years, she has written about the arts of the Southwest from multiple perspectives, as an award-winning feature writer, reviewer, and marketer of the fine and performing arts. Through her affiliation with Gallery 10 of Santa Fe over the last ten years, she has developed close personal and working relationships with many artists whom she has publicized, particularly her subjects here. She focuses a clear professional eye on both the aesthetics and the creative process that went into the development of their art. Her contributions are a special and important part of this book.

Ellen Reisland, who wrote the essay on Grace Medicine Flower, has been immersed for the past ten years in art objects of the Southwest.

In her various positions with Gallery 10, she has had continuous contact with contemporary potters of Arizona and New Mexico and, in many cases, has developed close personal friendships with them. With that background and her passion for the art, she brings a unique view of this wonderful American pottery.

Phillip Cohen, one of my sons was attracted early to the magnificent art of the Southwest and has built a career in this field. He wrote the chapters on Nathan Youngblood and Tammy Garcia, as well as providing captions for all illustrations in the book. He and I spent many hours fashioning the thoughts which led to this book.

And, finally, my deep thanks to my wife *Adele Cohen,* who wrote the essays on Dora Tse Pé Peña, Jody Folwell, and Russell Sanchez. It was she who led me to the Santa Fe Indian Market some eighteen years ago. At that time, we both realized that our culturally sheltered upbringing in the Midwest had not prepared us for the stunningly beautiful art of the Southwest. Adele has had a very special personal relationship with the artists about whom she wrote and, like me, has found the last sixteen years of living with the art of the Southwest rewarding and enriching.

Photographer credits—We would like to acknowledge the photographers who have worked with us over the years: Addison Doty, Jerry Jacka, Herb Lotz, Bill McLemore, and Robert Sherwood.

(And to a contributor of another kind, *Bruce Bernstein,* Assistant Director and Chief Curator at the Museum of Indian Arts and Culture, Santa Fe, many thanks for dropping everything, countless times, to come to the rescue with valuable information and photos. —Phillip Cohen)

LEE M. COHEN

Foreword

Once upon a time the words *simple* and *primitive* were applied to some of the objects presented in this book. We are not a generation with any reason to be smug, but we can smile in modest satisfaction because fortunately we have moved beyond that. We now perceive that the people who create useful sculpture of consummate beauty were, and are, very sophisticated. Greeks, Etruscans, Chinese, Japanese, Bavarians, Franconians, Mimbres, and Santa Clarans have made beautiful pottery. Sevres, Meissen, and Wedgewood have produced beautiful ceramics. Words such as *primitive* and *advanced* are not useful in a discussion of their variety, except for those who think that complex technology always means an advance in art.

If we take each work as independent, without pressing it against a background supplied from the history of technology, we will see a sophistication stretching over centuries. One of the virtues of this book is that it does not beguile us with any straight-line progressions — neither cultural nor technological. Instead, it induces us to focus on the artistic quality of each work of art as it left the hands of its maker.

Of course it is interesting to know when that potter lived and what the conditions of life were at the time. But when we see these pots glowing on the page, we need very little art history or social history to lead us to a respectful appreciation of the artistic sensibilities of the people who made them.

Though I am a social historian, who makes his living sketching in backgrounds for great events and supplying crowd scenes to surround heroic characters, I do believe there are instances in which objects speak for themselves. The virtue of permitting them to speak without interruption or translation is that this is how we become capable of discourse with them. It is with a new fullness, a new seriousness, that we can at last perceive them and their makers.

The works become ends, not means of studying the culture from which they come. They are present — not as contingent goods, useful examples, or evidence of social phenomena — but as beautiful objects manifesting the craft and genius of their makers.

Though these pots almost speak for themselves, they are not abstractions. They are pots whose forms have developed from household use. We can be excused for wanting to know what sort of households, what sort of use. Even contemporary art pottery can be said to have a household use — one of gracing the house, of bringing beauty or resonance that is as real as water or grain, if less tangible. Thus the question "used for what?" leads us away from the utilitarian and toward the spiritual. For every one of these works of art is a container of something invisible.

It takes only a limited acquaintance with a great potter to learn that the shaping and decorating and firing of a pot is a liturgical sequence.

First comes an invocation of the spirit. Then there is the making of a place for it to reside. The gift of a great pot is the gift of what its creator put within it, which it will forever contain. It holds the ether of genius.

"Used for what?" takes us back to the beginning. There is great sophistication in the art depicted here, from earliest to newest. There is also great sophistication in the book itself. The authors, the photographers, and designer have encouraged us to attend to the work itself, not to its antiquity or modernity and certainly not to its current valuation in the art market. The authors, who know that market well, urge us to step outside it, and to look all around us for objects which merit our respect.

This is a remarkable and important exhortation. It empowers us as perceivers; and thereby it empowers living artists to attract us by the quality of their art, not by their fame or the opinion of the crowd.

When a presenter of art invites us to join in his or her delight in each object, as these authors have, a sharing occurs and a risk is taken — shall we dance? We may not, after all, like that object. Nevertheless we are still beguiled by the offering. If, on the other hand, a presenter bludgeons us with a valuation of the piece — either in terms of esteem or money — it is a harmless invitation, as interesting as a conversation with the presenter's accountant.

Nothing like that has occurred here. Quite the contrary. The overview by Lee M. Cohen sets the tone. It is a passionate proclamation of faith in our capacity to choose for ourselves, to seek out quality with our own eyes, to endorse unknown or uncelebrated artists.

Hurray! say I. This is a good book. These are good pots.

ROGER G. KENNEDY

Introduction:

Redefining Southwest Pottery

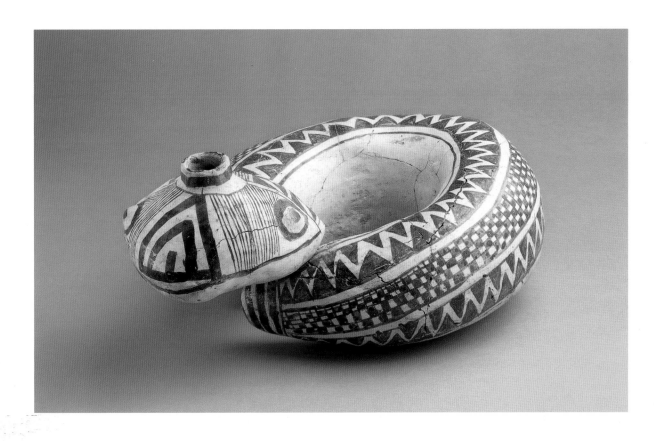

1. This powerful snake effigy from the Tularosa region of southwestern New Mexico, circa a.d. 1200, shows reverence for nature translated into magnificent artistic expression.

Every year during August, tens of thousands of people from around the world converge on the historic plaza of Santa Fe, New Mexico. The night before Indian Market, hundreds stand in line to secure a good place in front of certain artists' booths, waiting under the stars for the artists to appear with the sun around seven the next morning.

What draws them? Simply this — it is here that many of the nation's best Native American artists and craftspeople offer a concentration of their work for sale: paintings, sculpture, wonderfully crafted musical instruments, weavings, clothing, jewelry; and, of course, the ceramic art that is the subject of this book.

Indian Market is further enhanced by other influences: the ambience of Santa Fe, with its dark-gold adobe walls warmed by the New Mexico sun; the forests and canyons of the Sangre de Christo Mountains close above the town; and a sky renowned for its daily show of color and clouds. Santa Fe's museums are among the most enjoyable and accessible in the world, and the city's cuisine blends Spanish and Native American flavors into distinctive food of the Southwest.

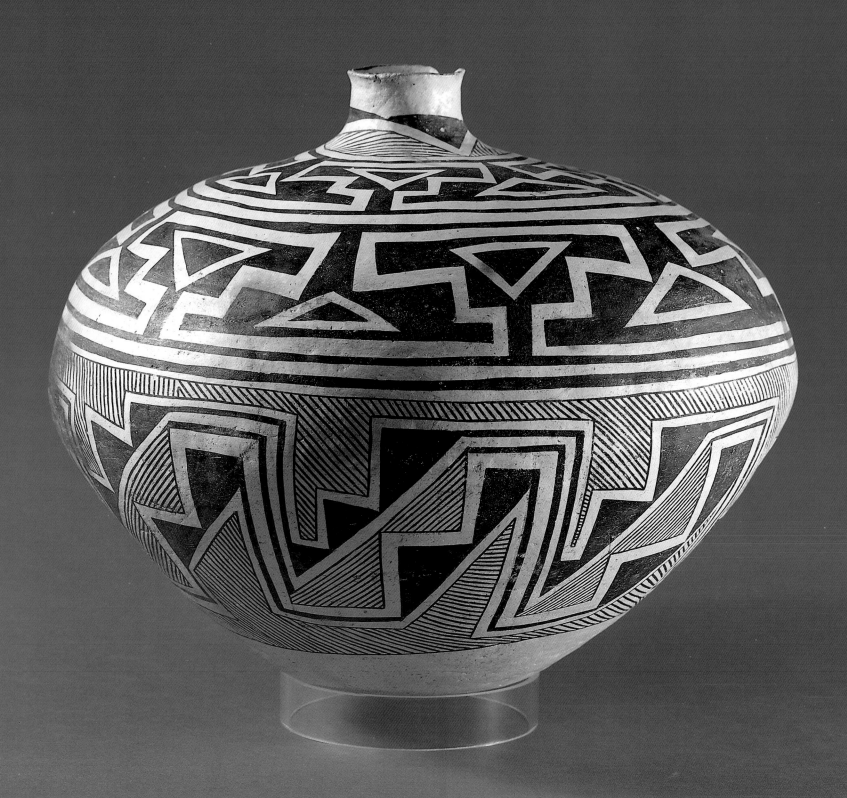

For many connoisseurs what really makes Indian Market so magnetic is its gathering of some of America's most talented ceramic artists — who happen to be Native American, and who bring with them works flowing from centuries of creative spirits.

An astonishing number and variety of pots are presented at Market, some of extraordinary quality. The event is a public showcase, and judging by the turnout and the enthusiastic buying, it is safe to say that ceramic art of the American Southwest has a compelling appeal — no longer to just a few initiates, but to an increasingly diverse body of collectors and art lovers. This breadth of appreciation is relatively new, since for nearly a century the beauty and significance of these works, were submerged under the perception that their interest was a matter of anthropology, not of art.

This characterization took root in the late nineteenth century. Scientists from the Smithsonian and the great universities came to the Southwest on archaeological expeditions and to record the Indians' daily life. When it came to pottery, they classified the physical appearance and the social significance of their finds with scant reference to artistic content. Their writings, and the subsequent United States Bureau of Ethnology reports, were fundamentally ethnological treatises. This established the point of view taken by more popular books and articles too, and soon America as a whole saw its Southwest as primarily an ethnological resource. The magnificent pottery created over centuries was regarded as scientifically interesting — which it also is — but the art of the pottery was essentially overlooked.

This anthropological bias fostered a network of misconceptions. For example, it was assumed that the pottery made by living Southwest Indians at the time of archaeological discovery was simply a remnant of an ancient craft, rather than a contemporary ceramic art in its own right with merits far exceeding mere

adherence to traditional technique. Artistic achievement by living Southwest Indians went largely unrecognized.

At the same time, the Native American potters living near the excavations were themselves regarded somewhat as artifacts — as quaint practitioners of a traditional craft. The likelihood of an 1890s archaeologist, Indian trader, tourist, or collector comparing Pueblo Indian ceramists to, say, their European contemporaries was virtually nil. This perception — this eagerness to classify southwestern ceramics as ethnological expressions — clung to the pottery for the better part of a century. Even today some Indian Market patrons plainly view the artists and their work in this way.

This book is intended to undo this inappropriate perception once and for all. The old, strictly ethnological point of view is a detriment to the ceramic artists of the Southwest and their

2. (Opposite) The bold geometry of pieces such as this prehistoric Socorro (southwestern New Mexico) olla, circa a.d. 1200, set the standard by which almost all modern Acoma Pueblo potters are guided. The makers of these impressive vessels had a well-practiced sense of marrying design with form.

3. Occasionally the Mimbres (circa a.d. 900–1100) depicted fairly explicit sexual imagery in their bowls. The figures are often accompanied by objects of ceremonial significance, perhaps indicating initiation or fertility rites.

work, as well as a hindrance to the development of a more accurate, more sophisticated way of understanding the field among people who appreciate and collect American pottery in general.

The format we have chosen to shed better light on the ceramic art of the Southwest is:

— first, to establish an historical perspective within which contemporary pottery can be viewed;

— to observe major changes that have occurred periodically over the centuries;

— to present the concept of *intrinsic value* in art, as a quality inherent in those works which were an integral part of those periodic changes, and thus seminal to the art form's development;

— to identify certain artists responsible for dramatic changes that occurred in the early twentieth century;

— and finally, as history repeats itself, to focus on a number of contemporary ceramists who are on the cutting edge of the changes happening today.

If we view pottery, or any art form, from an historical perspective, observing the distinct deflections in form and style that occur at varying intervals of time, we are better able to appreciate major changes in the ceramic art of the past; and we become more adept at identifying those that are occurring now.

Pottery appeared rather suddenly in the American Southwest about two thousand years ago. The suddenness and other factors suggest that the skills were learned quickly during a certain period of contact with pre-Columbian cultures of Central America. The pottery dating from the time of this contact until the arrival of the Spanish about 1540 is called *prehistoric*; the pottery made from the inception of Spanish rule until roughly 1920 we call *historic*; and pottery dating from then until the present we term *contemporary*.

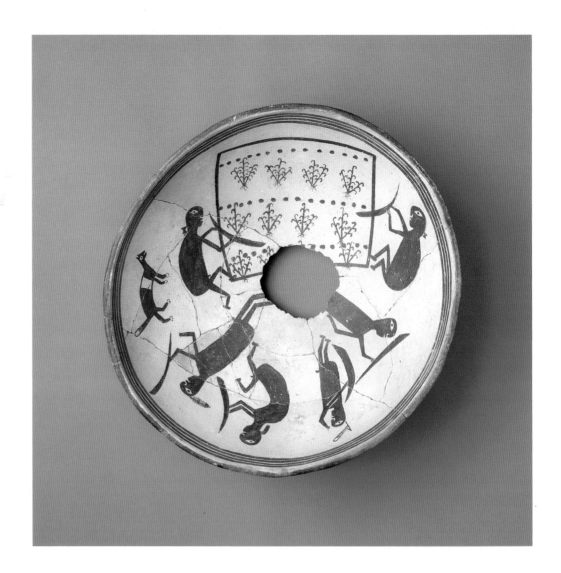

Students of this whole two-thousand-year evolution have observed that dynamic changes in the form and design of southwestern pottery have been occurring roughly every fifty to one hundred years. As in all art, these significant changes were events that became etched in cultural memory for all time. And — as in all art — we can assume that a small number of potters have actually been the "movers" whose artistic innovations have piloted the art form from antiquity to its current expressions.

Innovation of this magnitude is the most important gauge of what we regard as intrinsic value in art. This concept underlies a phenomenon familiar to anyone who has spent a day wandering through galleries and seen one 30-inch by 40-inch oil painting priced at $350, another the same size at $3,500, and still another at $350,000. The difference will almost always lie in the intrinsic worth of each.

4. One of the great contributions of the prehistoric Mimbres culture was pictorial imagery depicted in the inside of delicately formed bowls. This piece clearly shows a farming scene— a rare view into the life of these people.

A cynic might suggest that art can be hyped, resulting in inflated prices. In truth, this occasionally happens; but when it does, the phenomenon is short-lived. Short-lived, too, is lack of recognition of great art. True, Vincent Van Gogh never lived to see his paintings sell to anyone but his brother, but this is not because his work lacked intrinsic worth nor because it was eclipsed by the hype given the work of others. It was simply because the intrinsic worth of Van Gogh's work was not recognized during his brief lifetime. Needless to say, it took very little time after his death for his paintings to be recognized as trailblazers for an entire movement of subjective, individualistic expression. *Intrinsic value is most apparent in a work of art when it helped fuel a major, original movement — thus helping to cause a significant deflection in the mainstream of the art form when viewed from an historical perspective.*

As we learn to view southwestern pottery with regard to significant deflections in form and style, we are better able to distinguish lasting contributions to the art form from un-memorable aberrations. For example, art that is merely different does not necessarily signal a fundamental change. Difference is not enough; what the innovator introduces is some new level of expression, something aesthetically moving and powerful enough to evoke imitation by those who follow.

It seems to be one of the cycles of the evolution that most works which follow major breakthroughs in artistic style tend merely to imitate, rather than to advance upon, the significant innovation. It takes other innovators to do that, and they may often be separated in time by more than a generation. The imitative pieces, no matter how technically excellent, lack the intrinsic value of the originals. We remember Van Gogh not just for his technical proficiency, but for his vital role in deflecting the mainstream of painting in the few years that he was active. Imitators who came after

were consigned to lesser ranks or soon forgotten.

Once we gain an understanding of the concept of intrinsic value and arm ourselves with some knowledge of the history of southwestern ceramics, we can look back in time upon the art of the region and see it in a new light. We begin to gravitate toward examples which embody this idea of periodic breakthroughs, or what we might call memorable additions to the vocabulary of the art form. We see, among other examples of ancient pottery:

—A Mimbres picture-bowl (Mogollon culture, southwestern New Mexico) from the eleventh century, which was part of a highly original pictorial movement in pottery decoration that changed the nature of Mogollon pottery profoundly. The incorporation of figurative imagery drawn from lifestyle, legend, and ceremony brought the pottery to a new level of

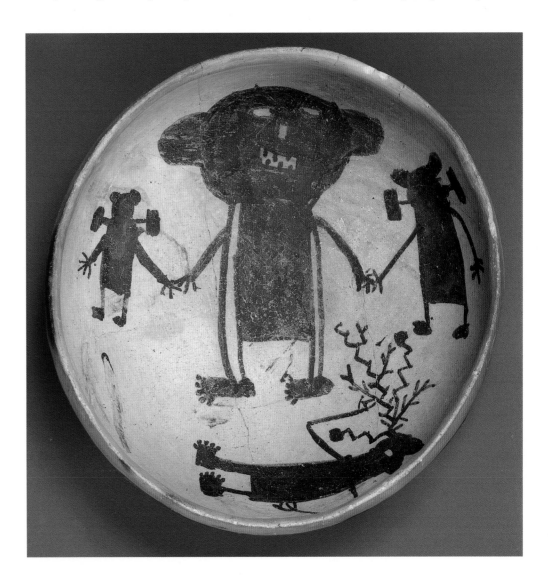

5. Already clear in this prehistoric Hopi Jeddito bowl circa a.d. 1200-1300 are the power and sophistication that would influence future potters. This artist used highly developed technical abilities to portray important aspects of ritual life.

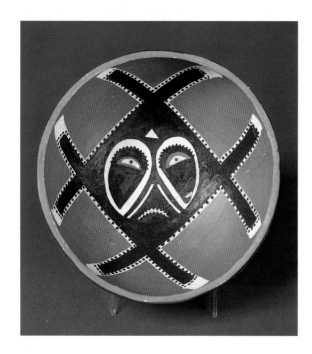

personal and artistic expression. Modern eyes are delighted by the Mimbres potters' seemingly whimsical imagery and their startlingly "modern" handling of line and space. But most important, the movement brought southwestern ceramics to a new height of expressiveness for that time; and even today the Mimbres style remains a strong influence on southwestern art.

—A superb example of a Socorro (southwestern New Mexico) olla from the thirteenth century. We see a beautifully balanced sculptural form and, more important, a sophisticated integration of design into the form. This level

of design integration represents a major change from what had been going on for at least a hundred years; thus the vessel was part of a creative process invoking originality, and intrinsic value is present.

—A magnificent Hopi bowl (northern Arizona) created during the Sikyatki period in the sixteenth century. Its abstract design is worthy of Picasso — first-time viewers are astounded by its abstraction, and collectors are keenly aware of the visual sophistication of its maker. Most important, such a bowl was part of a major change in Hopi pottery and so has intrinsic value.

There certainly were periodic innovations

during the historic period, including influences from Spanish, Mexican, and the early years of American rule. Again, using historical perspective, we are able to see memorable changes and radical innovations at three of the best-known pottery-making pueblos:

At Hopi, a woman named Nampeyo initiated a renaissance in pottery quite single handedly. By the late nineteenth century, Hopi pottery had declined in quality and had been largely stagnant in terms of innovation for decades. Nampeyo's husband was involved in archaeological work in northern Arizona and

6. This Four Mile polychrome bowl, circa a.d. 1300-1450, would bear up to the most modern standards of sophisticated proportion and positioning of design, with a quality and care of execution that speaks of the innate desire of potters to create objects of beauty and power.

7. This prehistoric Sikyatki bowl, circa a.d. 1400-1625 displays a powerful and striking design which is carefully calculated to be integrated into the form of the bowl.

8. The highly sophisticated geometric abstraction of this Sikyatki design is probably derived from a composite of forms drawn from nature.

9. *The prehistoric Hopi period known as Sikyatki was a high point in the development of southwestern ceramic art. Potters today still marvel at the sophistication of form and design demonstrated in works like this flat, "flying saucer"-shaped vessel, whose upper body is almost parallel to the base.*

brought her shards of Hopi pottery from the sixteenth century (the Sikyatki period), which inspired her to originate new shapes and designs. Her innovations have been imitated for seventy years, with perhaps twenty-five of her descendants (and countless potters not related) working even today in essentially the same style. She is the truly memorable one whose works are intrinsically valuable.

At Santa Clara, pottery had become plainly utilitarian by the early twentieth century, with little emphasis on grace of form. But in the 1930s Sarafina Tafoya and her daughter Margaret, through an innate and truly exceptional sensitivity to form, began translating the utilitarian shapes into pieces of great elegance. They introduced carved decoration, which Margaret refined by using it sparingly and in just the right proportion to call attention to the sculptural grace of her vessels. Thus the vocabulary, indeed the potential, of the art form was expanded; and while some imitators of her style are technically more proficient than Margaret, their lack of originality makes them un-

10. This low-shouldered Ogapoge storage jar (probably eighteenth century) demonstrates a development of shape and design that would influence later pueblo ceramics— including that of Maria and her husband, Julian Martinez. (Cat. 16116/12, Ogapoge Polychrome. Douglas Kahn, photographer. Museum of Indian Arts and Culture/Laboratory of Anthropology, Santa Fe.)

likely to be remembered.

San Ildefonso Pueblo pottery underwent significant changes at intervals during the historic period. For example, the pottery shapes of the first half of the eighteenth century changed rather dramatically around 1760; innovation became dormant till about 1880, when another significant change occurred. But starting about 1920, Maria and Julian Martinez initiated an unmistakable change with the introduction of black-on-black pottery. Today, we are tempted to call this style "traditional," but in 1920 it was revolutionary. It is the change that Maria and her husband caused which makes their work memorable and intrinsically worthwhile.

I have used the word "traditional" intention-

ally to call attention to a term which is more misleading than it is helpful, and has been a conceptual stumbling block to many who seek an overview of the field. When we apply an historical perspective, we begin to see that there is no such thing as traditional San Ildefonso pottery. On the contrary, the art form is dynamic, changing periodically over the centuries. The common notion of "tradition" can get in the way of understanding the pottery and its ongoing evolution.

Yet "traditional" does have a meaning in southwestern pottery, albeit more a specific one — specific to the process of making it. It applies to the essence of creating pottery from the stuff of nature and with the spirit of many centuries guiding the process. The gathering of the clay; the mixing; the curing; the hand-coiling used to construct the shapes; the painting with liquid clay slips, or the carving; the stone-polishing; the outdoor firing; all are performed with an almost spiritual reverence, as if the potter were the medium for an ancient force fashioning the elements of nature into objects

11. This nineteenth-century Powhoge polychrome storage jar from the early nineteenth century shows a dramatic change in form from its Ogapoge predecessor. The shape is more rounded and balanced overall, the design bolder and better proportioned to the shape of the vessel. (Cat. 45611/11, Powhoge Jar. Blair Clark, photographer. School of American Research Collections in Museum of New Mexico.)

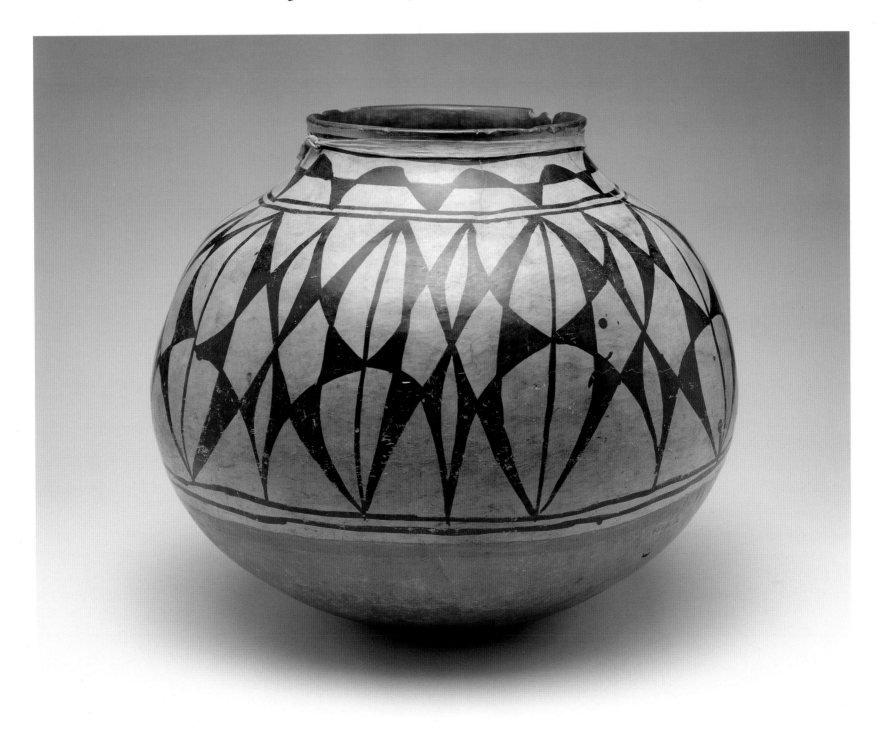

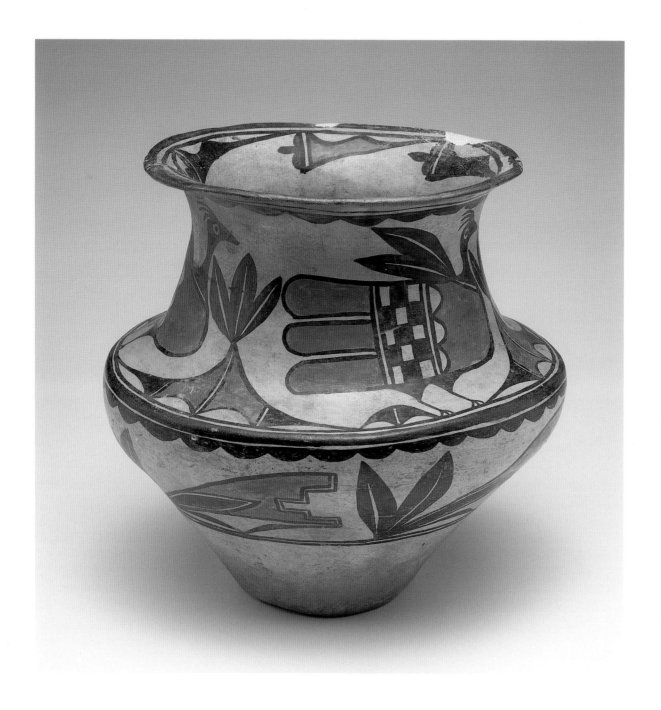

12. This water jar was made at San Ildefonso Pueblo shortly before the turn of the century. It shows refinement in form and construction, and the sharp shoulder at mid-body allows for the division of design fields above and below. The flaring rim adds drama. (Cat. 12192/12, San Ildefonso Jar. Blair Clark, photographer. Museum of Indian Arts and Culture/Laboratory of Anthropology, Santa Fe.)

13. (Left) The best of the historic potters had an innate talent for integrating design with form. This Acoma Pueblo four-color parrot jar (circa a.d. 1900) is exemplary of its type.

of beauty. To see a potter working with her eyes closed, sensuously shaping a vessel with her hands, is to understand the true meaning of tradition.

Today, a half-century after the last significant changes, a group of ceramists are again causing the kinds of major deflections that have occurred through history. Though space limitations prevent including all of the significant innovators, it is with considerable excitement that I introduce the work which follows, in the belief that this extraordinary branch of American art will give pleasure to a widening circle of appreciation in our lifetimes. We have deliber-

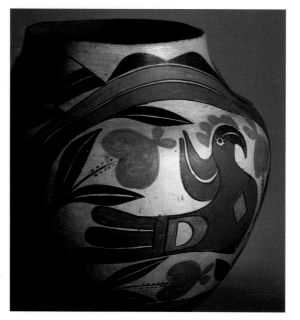

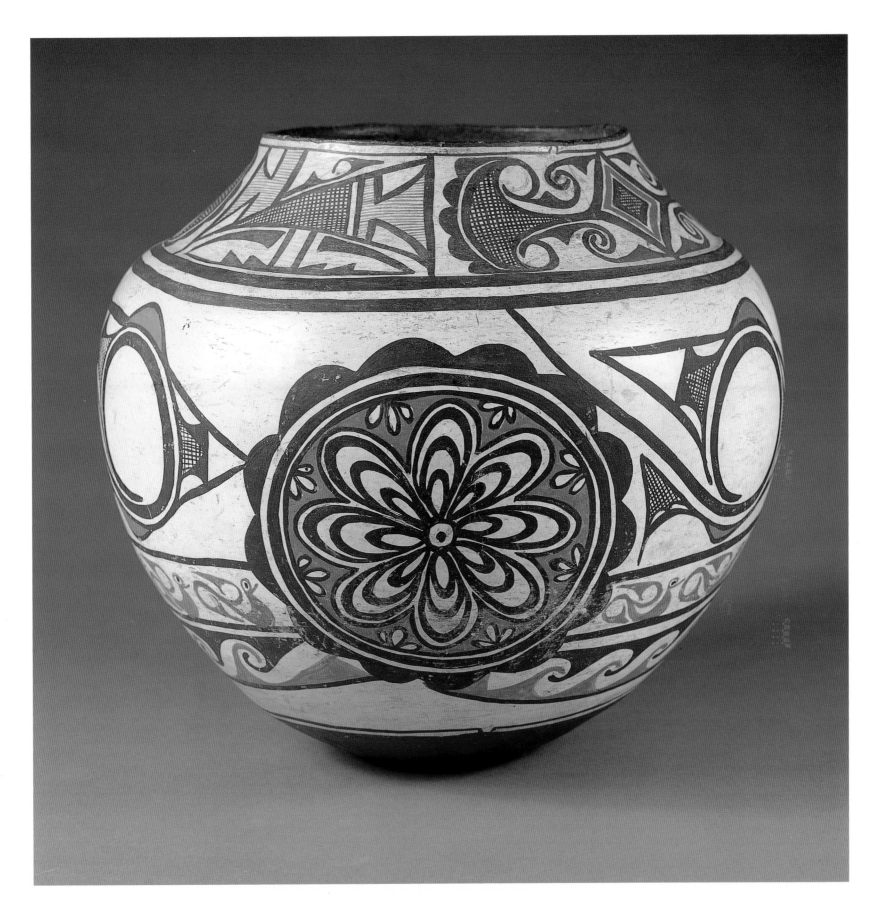

ately not restricted our selection of artists to Native Americans but rather have focused on those who have represented or continue to carry on the inspiration of centuries of southwestern pottery. The spirit of originality shining forth from the works of art in these pages calls us toward our own potential. This art is precious, life-giving, and a national treasure.

LEE M. COHEN

14. A Fine example (circa a.d. 1890) of Zuni Pueblo pottery, this piece displays complicated curvilinear motifs integrated into a pleasing sculptural shape.

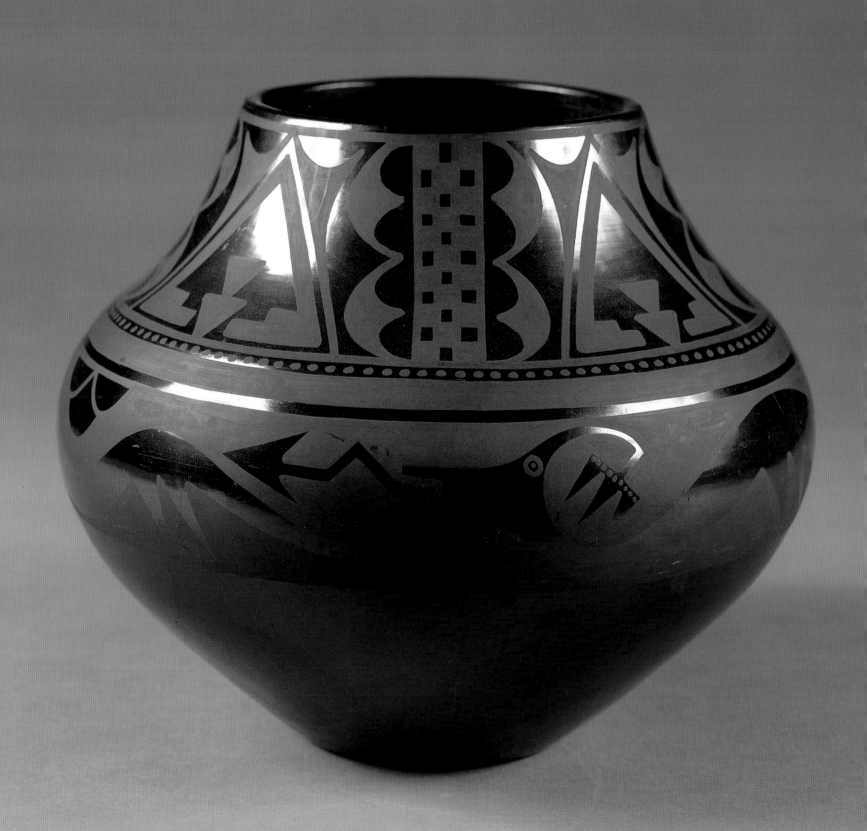

Maria Martinez
and Julian Martinez

LEE M. COHEN

Beginning in the 1920s, Maria and Julian Martinez of San Ildefonso Pueblo received recognition as major artists. There has never been any question that this acclaim — which continues to this day — is deserved. Maria, first with Julian and later with other family members, created during a long lifetime a body of work that is widely known and is included in the collections of many major museums; and almost anyone who is familiar with American ceramic art knows their names. But why? What are the principal reasons for this acclaim?

Maria remained unassuming and followed pueblo tradition in trying to avoid standing out from other women in her culture, but she and her husband nevertheless were internationally recognized as major American ceramists. Cultural roots and traditions were important, but they were not nearly enough to account for their recognition. The primary reason they achieved prominence was that they brought about major changes in the mainstream of American pottery starting around 1920. They were artistic innovators of historic significance.

Magazine articles and probably hundreds of newspaper articles about her have appeared since the early 1920s. She has been the subject of a number of full-length books, including Alice Marriott's 1948 classic, *Maria: The Potter of San Ildefonso*, still in print after forty-five years, and Richard Spivey's 1979 hallmark work, *Maria*, which was revised and expanded in 1989.

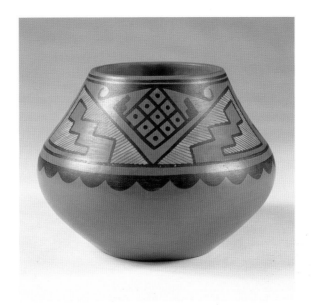

15. (Opposite) The mastery of black-on-black technique by Maria and Julian reaches its highest level, with designs beautifully applied in confluence with the balanced form of the jar.

16. This black-on-red jar by Maria and Julian, one of only a small number they created, shows a blending of older shape and design with a fresh perspective on balance and abstraction.

Among other honors and awards, Maria and Julian received special recognition from the Ford Exhibition at the Chicago World's Fair in 1934 and were awarded a Bronze Medal. Maria received the American Institute of Architects Craftsmanship Medal in 1954, the nation's highest honor for craftsmanship. She was awarded an honorary doctorate from Columbia College in Chicago in 1977, an annual award to outstanding individuals who have achieved excellence in their fields — joining such well-known individuals as Dr. Ralph Bunche and Greer Garson. When Bernard Leach toured the United States in 1952 with the world-famous Japanese potter Hamada, they went to visit Maria to spend time with her and to see and study her work.

It is ironic that Julian is so often overshad-

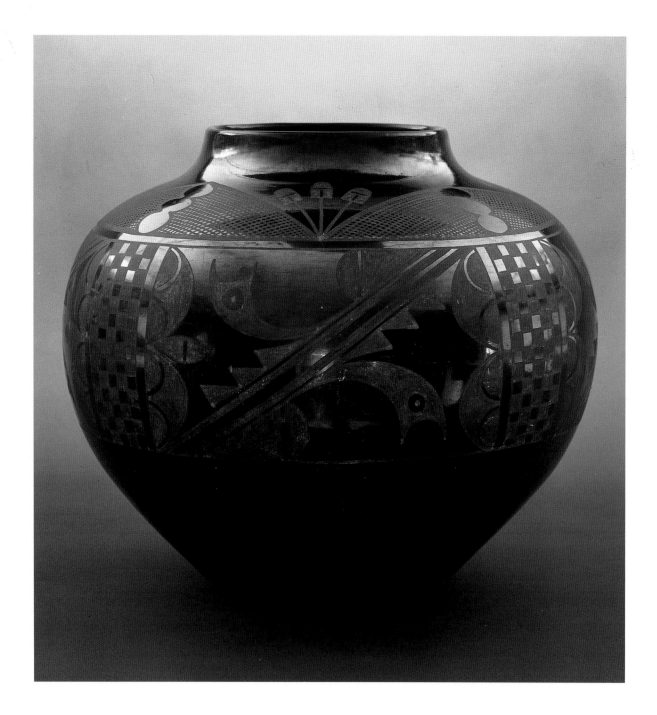

17. This black-on-black storage jar, the last large piece that Maria and Julian worked on together, exemplifies the best that they brought to the art form. It won the award for "Best of Large Pottery" at the 1940 Indian Market. (Cat. 31959, San Ildefonso Jar. Douglas Kahn, photographer. Museum of Indian Arts and Culture/Laboratory of Anthropology, Santa Fe.)

owed by Maria, for it was Julian, with his easy-natured, outgoing personality who most often served as spokesman for the two. Though Julian was Maria's artistic partner for four decades, he has received comparatively little attention. Although he is usually mentioned in the literature, it is very rare that he gets top billing or a solo piece. An exception is Frederick J. Dockstadter's *Great Native American Indians: Profiles in Life and Leadership*, in which Julian is listed and Maria, inexplicably, is not. Perhaps one reason for Julian's not receiving the attention that people have given his wife is that Maria lived on into ripe old age, reaping an increasing

amount of fame and adulation with every year before finally passing on in her mid-nineties in 1981. Julian, on the other hand, died in 1943, five years before Alice Marriott's biography of Maria signaled the beginning of the period of real fame for the art they created together.

San Ildefonso Pueblo, the creation point of this modern renaissance in the ceramic art of America, lies near the junction of the Rio Grande and the Chama River in northern New Mexico, close to the pueblos of Santa Clara and San Juan. It was here that Maria and Julian were born — Julian Martinez in 1885 and Maria Montoya in 1887 (or earlier, as there

18. (Opposite) This water jar, attributed to Maria and Julian Martinez, was made in the first quarter of the twentieth century. The shape shows refinement of the San Ildefonso style (see Plate 12). The shoulder is rounded and the flaring rim now has a diameter somewhat smaller than the mid-body. The painting uses traditional themes in a more open design that complements the contours of the jar.

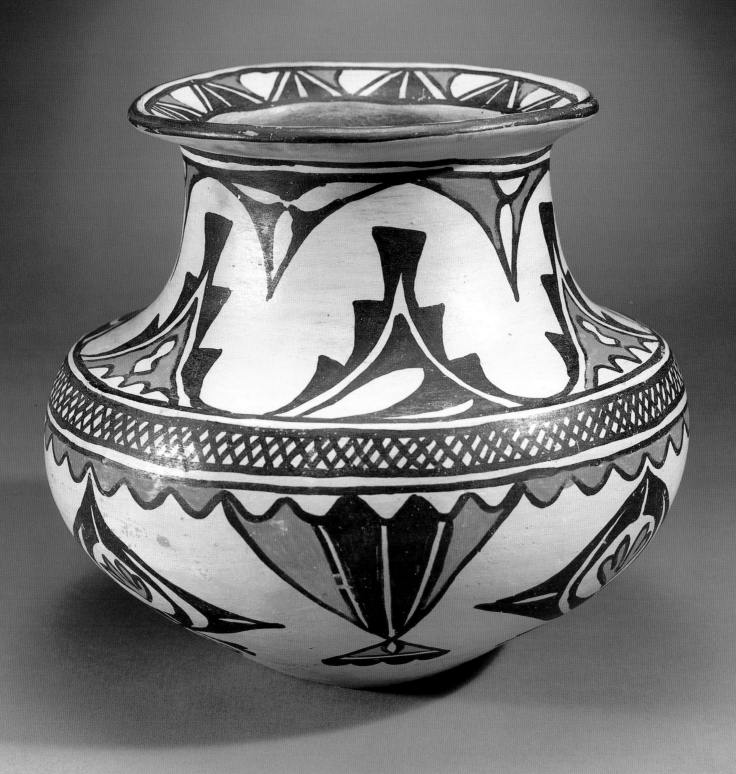

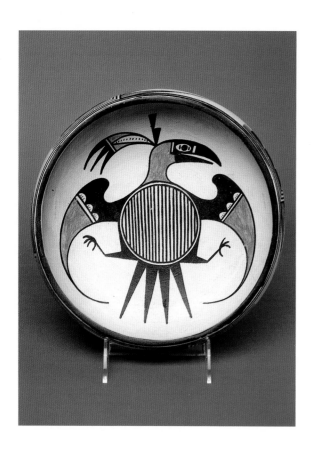

to make there illuminated the history of pottery in the region. The experiments that Julian and Maria conducted during this time form the foundation for the major innovation that would dramatically alter the course of the mainstream of American pottery starting about 1920.

To understand and appreciate these innovations, one has to look at pottery from the San Ildefonso area over several hundred years. From about 1600 to 1730, pottery jars had a very low, sharp shoulder generally about a quarter of the way up from the bottom, with gradual narrowing to the top and a slightly flared rim. Works from this period are referred to as Sakona Polychrome and *Tewa Polychrome. Design im-

* Pottery typologies are drawn from Larry Frank and Francis H. Harlow, *Historic Pottery of the Pueblo Indian*.

19. Conveying a reverence for powerful creatures is a natural expression for tribal people with a close relationship to nature. Julian Martinez was able to capture that primordial relation with boldly executed painting reminiscent of the ancient Mimbres.

20. Perhaps one of the greatest plates by Maria, this piece shows the artists' sensitivity to form and balance in pottery. The polychrome mineral-pigment design is composed so that the eye is completely satisfied without being overwhelmed.

21. (Opposite) Designs on these polychrome works are borrowed from the ancient Mimbres pottery admired by Maria and her family. The skill of composition makes for an agreeable alliance of shape and design.

is no certain record of her birth).

In their youth, before marriage, both had already expressed themselves as artists in addition to pursuing the activities common to all members of their community. Maria, along with performing household duties, learned to make pottery from watching and imitating others, among them Martina Montoya and her aunt Nicolasa Peña Montoya. At this time there was nothing unique in Maria and Julian's pottery making, for it was part of the natural rhythm of ordinary daily life at San Ildefonso.

The genesis of their work together was their marriage in 1904 and their honeymoon at the St. Louis World's Fair. Julian had been hired to take a large group of Indians there — many of them Tewa speaking like himself — to be part of an Indian village where they would dance and make pottery. The possibility of continuing to make pottery together at San Ildefonso was attractive to both Maria and Julian.

In 1908 Julian was offered a job as a laborer at an archaeological excavation of two ruins on the nearby Pajarito Plateau. The discoveries that Dr. Edgar Lee Hewitt and his team were

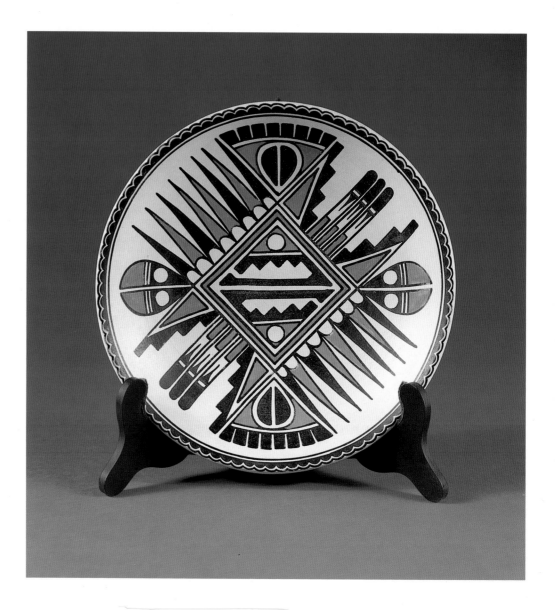

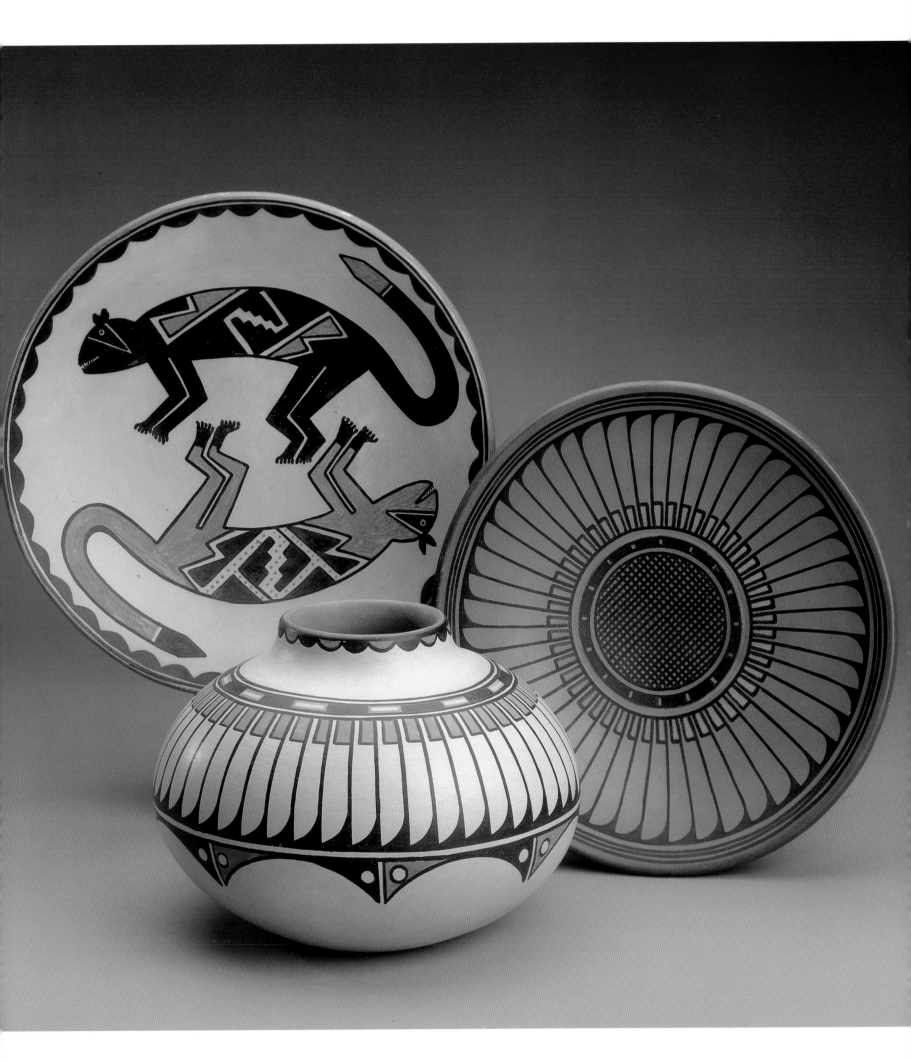

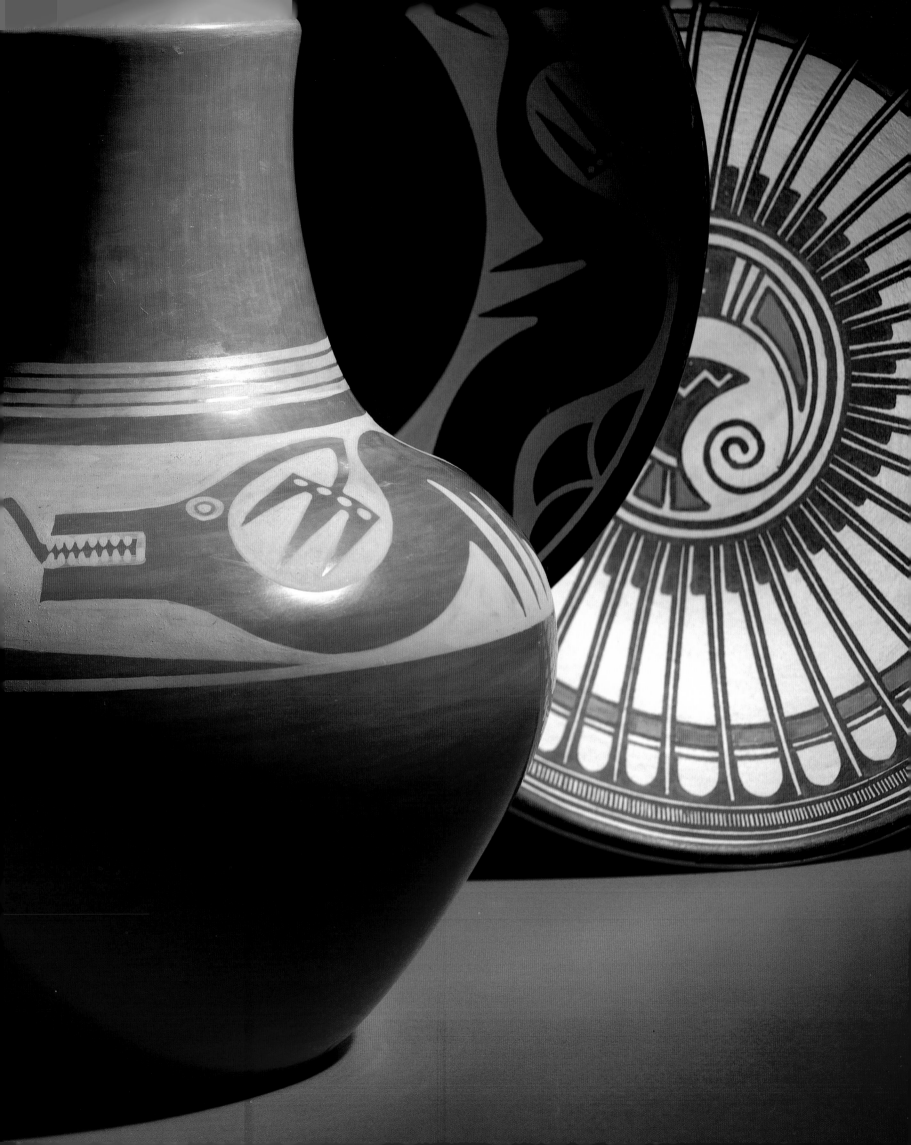

agery on the upper three-quarters of the vessel was segregated and generally somewhat different from the design on the bottom portion. A feather image was often used in the upper design area. Liberal amounts of red coloring were used along with black and a creamy tan.

The period between 1730 and 1760 saw the advent of what is now referred to as Ogapoge Polychrome. The form changed, with the widest point of the jar moving upward to perhaps one-third of the height from the bottom, not quite as sharply defined as it began to curve inward to a narrower diameter. Again, there was a flare at the rim. Most of the design appears in the upper third of the vessel and once more displays the feather motif and an abundant amount of red.

During the Pojoaque Polychrome period, from about 1760 through perhaps 1880, another major change occurred. The jars became more spherical, with considerably less angular change between the bottom and top of the vessel. In fact most of the jars were elliptical in shape without any sharp demarcation. The design elements appeared largely on the upper portion of the vessel, combining geometric shapes with abstractions of the feather motif. For the most part the pottery was more crudely executed in form and design than work from the Ogapoge Polychrome period, and by the early 1880s the imagery and shapes lacked sophistication.

Starting about 1880 there was a brief period of revitalization, the motivation for which may have been the influx of many more visitors to the Southwest. During this San Ildefonso Polychrome period, pottery was created with more sculpturally interesting shapes. The widest part of the vessel was near mid-body, widening from the bottom and narrowing again to the neck. The rim was slightly flared. The design imagery was more carefully executed, and with the use of various geometric elements such as checkerboard and crosshatch patterns and occasional bird

images, it became more interesting artistically.

By the time of the Pajarito Plateau excavation thirty years later, however, pottery making at San Ildefonso was in decline. There were potters to be sure, Maria among them, but while they were skilled at forming pots, the work was more frequently than not utilitarian and undecorated; ceramic objects were made only when someone needed a water jug, a storage jar, or a bowl.

The discoveries at Pajarito Plateau provided the spark that changed this forever.

Maria's job at the archeological dig was cooking. It was Julian who first did artwork for the dig, copying a cave painting of a water snake (*avanyu*) so well that one of the archaeologists gave him a supply of colored pencils and suggested that he make other drawings. Julian also collected decorated pot shards to study the designs of earlier artisans. A few years later he would be inspired by these designs to begin painting similar imagery on his wife's pottery.

Neither did Maria's skill in ceramics go unnoticed at the excavation site. The team had unearthed pot shards of a kind not known to have existed in the area. They were jet and charcoal black, and some were polished smooth. Intrigued by them and impressed with Maria's ability, Dr. Hewitt showed them to her and suggested that she try to reproduce the remarkable effect of these shards. He also asked her to try to reproduce the forms of the pots as they had appeared before time, weather, and soil deposition had altered them.

The forms themselves were easy for Maria to create —- her skill in that area was never in doubt —— but since she did not know how to make the clay surface black, her initial attempts resulted in failure. Julian had better luck. After several months of experimenting with various firing techniques, he was able to help Maria create the effect that Dr. Hewitt had suggested. Just as Dr. Hewitt had only recently opened a door to the past by discovering a form of ceramic art that had been lost, Maria and

22. (Opposite) Three superb Maria and family ceramics. The distinctive buff-painted design on a sienna ground was perfected by Popovi Da. The black-on-black plate has a design masterfully integrated with form and scale. The polychrome plate in the background shows precise control of painted line, with the usual attention to overall balance.

Julian had now opened a door into the future.

Soon they would raise their skill to a higher level. Their first pots were simple, with a coal-black finish and no decoration, but these works were the precursors of the black-on-black pottery for which Maria and Julian would eventually become most famous.

By 1915 Maria and Julian were introducing the first of the dramatic changes in American pottery that they would make together. Maria was now unsurpassed at San Ildefonso for her skill, and Julian's ability as a painter had steadily increased as well. In addition to painting the *avanyu* image, he had become extremely adept at painting stylized eagle feathers. Both are widely used now throughout the Southwest as testament to his lasting influence.

Maria continued at that time to perfect her talent in molding clay to three-dimensional aesthetic excellence, creating shapes that were much more graceful and interesting than those of the past. She and Julian were working in polychrome, in black-on-red, and in polished blackware.

Maria's work during this period had soft curves from bottom to top, with each section of the changing shape sensitively proportioned to the other parts of the piece and to the whole. Julian was now decorating Maria's pottery with such skill that his painting was an integral part of the whole, rather than merely an image added to a curved surface. Together, their work at this juncture represented a great leap of sophistication in sculptural form and in integration of design with that form. This achievement alone would have assured them a place in history as great ceramic artists.

But in 1918 came the change for which they are most noted: the development of black-on-black pottery. During their earlier experiments with blackware the finish had been simple: coal black, seldom polished, and with no designs. Now Julian strove to add highly polished design elements to the polished surface of the pottery.

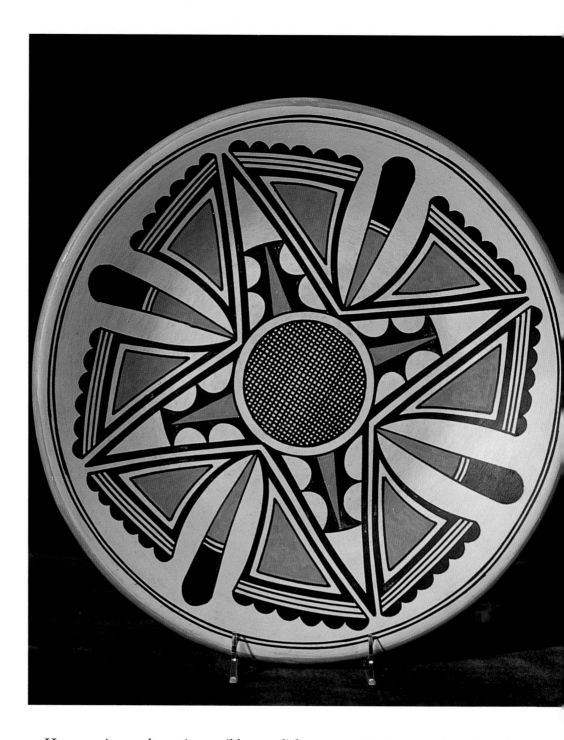

However, it was almost impossible to polish the design portion while leaving the rest of the surface matte. The first attempts were only qualified successes. After further trial and error and much thought, Julian decided in 1919 essentially to reverse the process. The entire background area of the piece was polished first; then the matte-finish design was painted on the polished surface to form a specific design element which contrasted with the original polished surface. Black-on-black pottery came into being. As if that weren't enough, Maria went on to perfect her skills at polishing her pottery to a

23. Pueblo potters will testify to the difficulty of building plates. In this large polychrome painted plate, we see Maria's mastery of the form combined with Popovi Da's powerful and harmonious design.

never-before-achieved highly lustrous finish, which after firing gave the work a dramatically different appearance from southwestern pottery of the past.

The combination of the sophisticated sculptural shapes, the newly introduced black-on-black style, and the extraordinary polished finish all resulted in a virtual revolution in southwestern ceramic art. For their effort Maria and Julian were to receive international acclaim

Not only did Maria and Julian come to be considered at the forefront of the ceramic artists of the Southwest, the two were also instrumental in creating a change in the way the entire region's ceramic art was viewed by experts and the public. Under the influence of individuals such as Dr. Hewett of the Museum of New Mexico and Dr. Kenneth Chapman of the School of American Research, Maria and Julian had come to believe that if they continued to perfect their already abundant technical and creative skills, their work could take its place as a respected form of American ceramic art and even draw international attention.

This was a notion quite different from the way southwestern Native American cultures had viewed their pottery in the past, and it helped to change the direction of southwestern ceramic art in general. There had always been influences upon the pottery of this region from other indigenous cultures, but the view that southwestern pottery could be held as an equal art form alongside the esteemed art of non-Indian people was a new perspective.

After Julian's death in 1943, Maria continued to refine the form of her pottery with her daughter-in-law Santana, who skillfully painted the design imagery that had been initiated by Julian. In 1956 Maria began working with her son Popovi Da, who, like Julian, painted many of Maria's pieces, traveled with her, and often served as her spokesman. From then until 1971, when Popovi Da died, they created a body of work that reached ever higher levels of artis-

tic merit. As Richard Spivey states in *Maria*, his study of her life and work:

"Many experts feel that the Maria/Popovi period expressed the highest level of Maria's genius. Certainly this is true in the introduction and refinement of firing techniques, creating new colors and combinations of colors, new finishes and a higher level of perfection."

Popovi Da's development of firing procedures led to a silvery-black, or gunmetal, finish that added a new element of aesthetic power to the pottery, and the buff-on-red works that resulted from his other imaginative firing techniques added a special luster to the later years of Maria's magnificent career.

It is a shame that we cannot penetrate the anonymity of the artists who, before the time of Maria and Julian, were responsible for the dramatic changes from 1600 to 1880 summarized above. But we are fortunate to know the names of Maria and Julian. They were imitated by hundreds of other potters after 1920 until history repeated itself and the next major changes began occurring approximately forty to fifty years later. Interestingly, it was Maria's son Popovi Da and then her grandson Tony Da who were at the forefront of the next set of major changes.

Maria and Julian's mastery of form, their introduction of a new style, their inventiveness, and their technical excellence assure them a place of great eminence in the history of American art. They will be remembered.

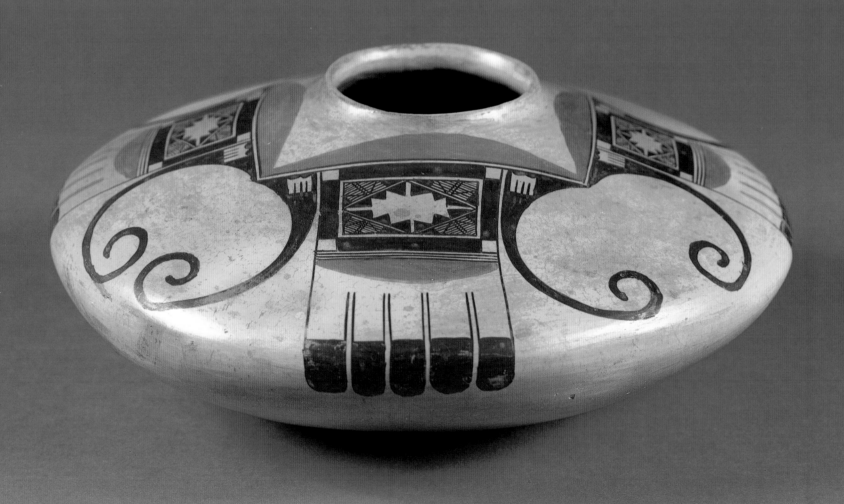

Nampeyo

BARTON WRIGHT

To pottery enthusiasts the name Nampeyo is as well known as the name of Maria of San Ildefonso. Both were individuals credited with innovative pottery that sparked a revived interest in the craft and gave inspiration to generations of ceramic artists. But who was Nampeyo? How did she come to produce her unique pottery? And how was it that she influenced other artists? Her story must be pieced together from events that happened around her rather than from her personal history, that of a humble woman living in a remote corner of northeastern Arizona on the Hopi Reservation.

It is known that her mother was a Tewa woman named White Corn (Qötca-Ka-e) from the village of Hano, huddled on the northeastern end of First Mesa, hundreds of feet above the valley floor. Her father, Qötsvema, was from Walpi, the Hopi town crowded on the opposite end of the mesa, a stone's throw away. Although Nampeyo was born into the Corn Clan of her mother, her father was from the Snake Clan and it was from that clan that Nampeyo received her name, "Snake-that- does-not-bite."

Nampeyo was born before the Civil War began (circa 1860). The loss of thousands of young men and the social upheaval of that event were unknown and of little consequence to the remote Hopi. For them it was a period of even greater peril, a time of plague, drought, and raids that decimated entire villages, a devasta-tion that sent them fleeing to their neighbors, the Zuni, for survival. When Nampeyo was in her early teens, the inhabitants of First Mesa were attempting to gather the fragments of their lives together as they drifted back to their former homes on the mesa tops. The full effects of the loss of family members, priests, leaders, and individuals versed in all the crafts are not recorded in our histories, and only bare indications survive to document the changes they wrought among the Hopi.

Fortunately, one of the most easily tracked changes occurred in ceramics. Evidence exists that the returning Hopi brought home with them many of the shapes, techniques, and designs of their Zuni hosts. It was during this interval of readjustment when the Zuni influence was strong that Nampeyo probably learned to make pottery from her grandmother at Walpi.

When Major J. W. Powell explored the Colorado River, the Grand Canyon, and the lands nearby during the 1870s, he reported that pottery was made only on First Mesa and Third Mesa at that time and was of inferior quality. During this interval Nampeyo would have been a young married woman and presumably making and contributing to the pottery labeled "inferior" by Powell. It was also a time when goods from outside were becoming more common among the Hopi. There is evidence that in addition to the hoes and axes the men had

24. *This piece shows how Nampeyo's rounding of the shoulder and gradual, curved tapering toward the neck yielded a wonderfully balanced form. Her refinements of shape and design have inspired generations of Hopi potters.*

received from both the military and the Mormons, the women were acquiring containers made of new materials. Interest in pottery utensils was probably at an all-time low, although the making of large canteens by the Tewa and stew bowls by the Hopi seems to have continued unabated.

A decade later as the railroad that would eventually be known as the Santa Fe worked its way westward through the country to the south of the Hopi, Nampeyo was making pottery that would be taken in trade at the post in Keams Canyon. If the pottery was as inferior as Powell indicated, it is unlikely that it would have been accepted by Thomas Keams, who, although friendly and sympathetic to the Indians, was a businessman first and last.

The railroad brought rapid change to the distant villages of the Hopi in a way quite different from the slow influx of Anglo goods that had arrived with traders, missionaries, and the military. It brought the traveling public, visitors in ever increasing numbers. First came the scientists, who wanted to record the life of the Hopi, or to excavate the ruins which dotted the countryside. Their reports and articles whetted the curiosity of others who may have wanted to view the people who danced with snakes, but also wanted something more. They wanted mementos and curios to take home that were different and reminded them of places they had visited and their friends had not. They bought the craftwork of the Hopi and foremost among these purchases was the pottery of First Mesa. In the forefront of these potters was Nampeyo, whose innovative work was unique. It was also easily available at the trading post, where Keams promoted it.

During the first two decades after the turn of the century Anglo-Americans "discovered" the American Southwest and the Indian people. But their interest was primarily in the Indians themselves and not in their crafts, which were seldom appreciated as art but taken rather as mementos. Entrepreneurs like Fred Harvey did a land office business in making it easier to get to the Hopi Mesas by arranging trips in large touring cars with a guide to drive, explain the sights, and even introduce some of the Hopi. This interval was the high point in Nampeyo's career in terms of pottery production. The period closed when the Crash of 1929 reduced the touring public to a mere trickle.

No documented pieces are known from Nampeyo's girlhood at Walpi, where she learned the craft. The forms of that period were crude and limited to decorated flare-rimmed stew bowls, large globular water jars, and plain piki bowls. The decorated pieces were slipped with heavy white clay that crackled when fired and were painted with Zuni style designs, reflecting the recent sojourn of the Hopi. Despite the fact that her earlier work is not distinguishable, Nampeyo did not suddenly blossom as an artist. There is every indication that she spent her early years honing her skills to the point where she became the leading potter of First Mesa by the 1880s and was a major supplier of the trader at Keams Canyon, with her pieces much sought after.

It was and is common practice for potters to gather potsherds from nearby ruins to be ground and used for temper in their vessels. Nampeyo and her husband Lesou frequently visited nearby sites for this purpose, but it was not until the excavations of J. W. Fewkes at the nearby ruin of Sikyatki in 1894 that Nampeyo saw numerous complete examples of the spectacular pottery made generations before. Lesou, who worked for Fewkes and was enthusiastic about Nampeyo's abilities as an artist, brought home any fragments he found with unusual designs. It was at this point, as she realized the potential afforded by the ancient shapes and designs, that Nampeyo's talent began to flower. Abandoning all the designs and forms she had been using, she began first to duplicate and then to expand upon the Sikyatki

examples. She went to the field camp of Dr. Fewkes and made careful sketches of the pottery being removed, even going so far as to locate the source of clay these people had used and adapting it to her own needs.

The genius of Nampeyo was to grasp the possibilities this pottery offered and then to explore every aspect for her own creative purposes. Her early duplications were so well done that Dr. Fewkes feared her pottery would be mistaken for ancient pieces. But this phase soon passed and she went on to express her own creativity.

Her subtle changes in the configurations of Sikyatki design elements gave more fluidity to curvilinear lines. The characteristic isolated motifs were abandoned, leaving behind and uncluttered background space as an integral part of the overall decoration. This use of openness,

one of the most distinguishing aspects of Nampeyo's pottery, creates a classical elegance. Even in the vessels where a small motif is endlessly repeated she has managed to surround some portion of the design with open space. Other decorations which she used are deliberately asymmetrical, a style of embellishment rarely seen in pueblo pottery. One of the many motifs that she seized upon is that of the so-called "migration pattern" or "bat-wing design," a repetitive design which has become almost a hallmark for the Nampeyo family. However she did not, as many believe, invent this design but instead adapted it from a tenth-century pottery type known as Dogoszhi black-on-white.

Many of the Sikyatki vessel shapes had fallen into disuse among the Hopi, but Nampeyo revived them. She brought back, among others,

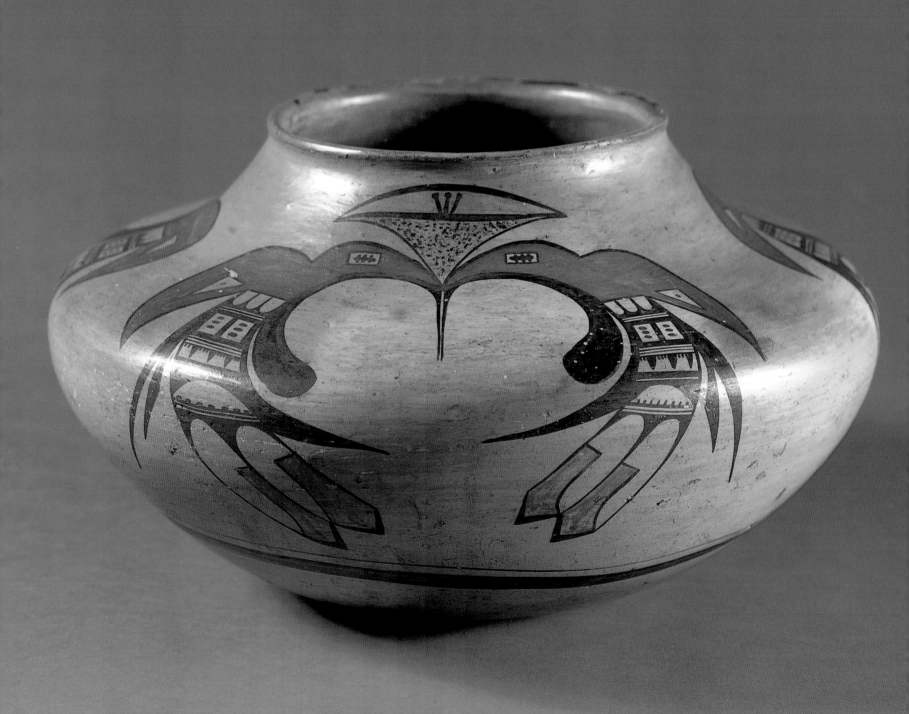

the low wide-shouldered and narrow-necked seed jar but gave it a more graceful form by removing the angularity of the shoulder found in the earlier vessels. When the Sikyatki shapes proved to be too rigid to complement the designs she had created, she changed the forms. With eclectic taste she also used non-native vessels for inspiration, in one instance taking the shape of an elongated vase and the Anglo desire for a container for wet umbrellas to produce the first Hopi umbrella jar.

With the introduction of her new style of pottery Nampeyo became increasingly well known and her pottery was sought after by collectors. Noted personalities arranged for Nampeyo to leave the mesas and demonstrate her abilities at the Grand Canyon and as far away as Chicago on different occasions. On these junkets she was accompanied by her husband and various other family members, all of whom could either make pottery on their own or assist her in the painting of the various vessels. As her fame spread so did the monetary returns for her pottery, and it took but a short while before the other potters on First Mesa recognized this and followed her lead in producing new forms and designs. The greater recognition in the outside world also precipitated conflict on the home front as Nampeyo attempted to retain control of the designs she had created, but little could be done to stem the flood of imitators. In a very short time there were numerous other skilled potters who lacked only Nampeyo's originality and creative ability to make them almost her equal.

In the 1920s at the height of her success Nampeyo began to go blind, but the gradual loss of her sight did not prevent her from continuing to make pottery. With the same sure hands she continued to mold the forms she was familiar with, rendering the vessels almost perfectly round as she sat with her family and encouraged them to continue the tradition. Now, however, she became dependent upon her husband Lesou to paint her pottery. Following his death in 1932, she turned to her daughters to paint the decorations she needed.

Most of the pieces made by Nampeyo during her lifetime were unsigned, as she never learned to write, but when Annie, her eldest daughter, began to help her paint her designs she printed the name "Nampeyo" on the bottoms of the vessels. When Annie ceased to do this Fannie continued the practice. Nampeyo continued to mold her own impeccable bowls and jars until a few short years before her death on July 20, 1942.

The legacy Nampeyo left behind was twofold. Not only did she leave scores of artistically decorated and beautifully formed pieces of pottery for the appreciation of today's collectors, she also left a family who through the generations has kept alive and even extended the tradition of fine pottery and the innovations she introduced so long before.

26. Inspired by the prehistoric Sikyatki style of ceramics, Nampeyo's genius was in her adaptation of form, the creation of a more fluid and balanced effect than her ancient predecessors achieved. Her instinct for pleasing composition allowed designs to appear boldly on a simple background, bringing a classical elegance back into Hopi pottery.

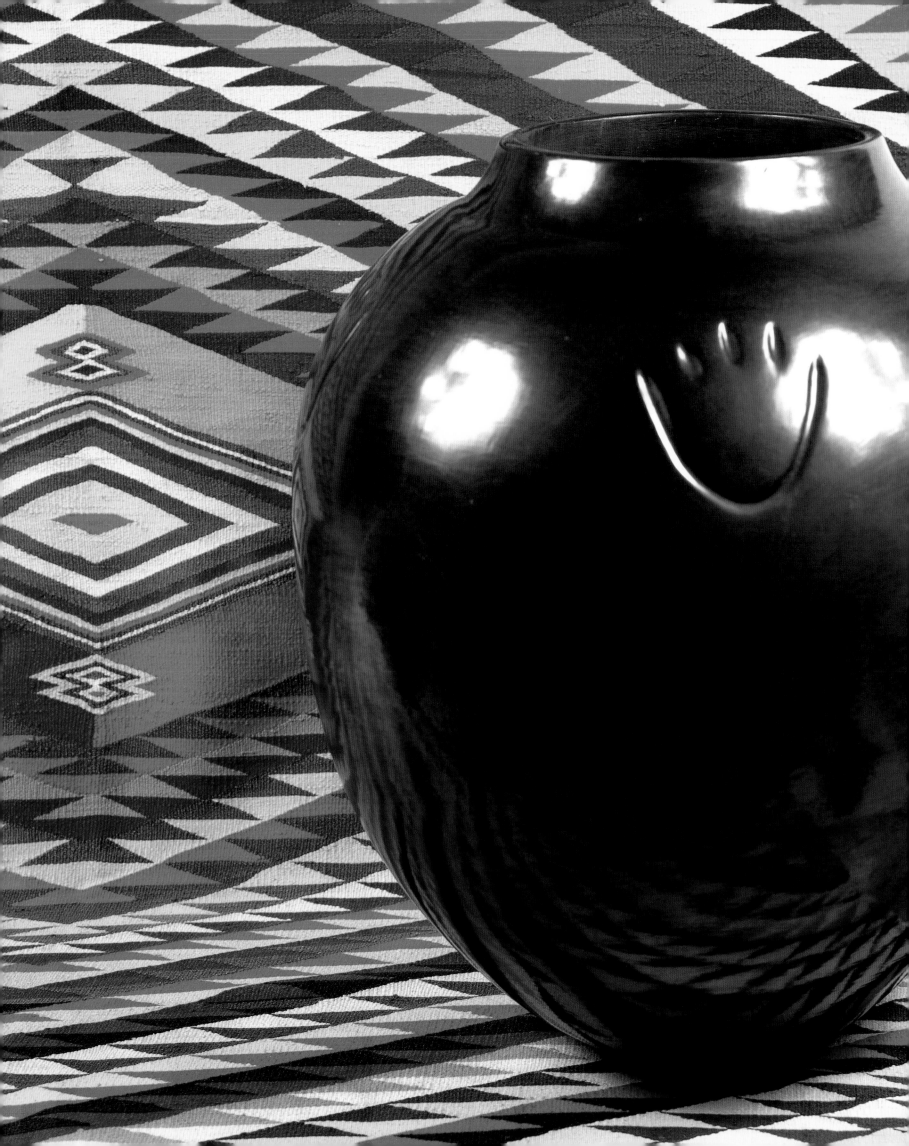

Sarafina Tafoya
and Margaret Tafoya

RON McCOY

The master potters of southwestern prehistory and their successors during much of the historic period remain anonymous and unrecognized. Fortunately, the situation changed around the beginning of the twentieth century with the dawning of recognition of the named Indian artist and the important, fertile ground this created for Native Americans and their art. Originally, pueblo potters of genius had remained anonymous. Later they would come to be recognized by an appreciative and accepting audience. Among the most influential of these early modern potters were Sarafina Tafoya and her daughter Margaret.

In many ways, Sarafina Gutierrez Tafoya of Santa Clara personified the emergence of the named artist by helping establish a high standard of excellence for early twentieth-century pueblo pottery. Whether she realized that her work represented not only a highlight in southwestern art but also a significant point of deflection in its evolution is unknown; but her daughter, Margaret Tafoya, realizes it clearly. As the last living representative of the century's early recognized pueblo potters, Margaret freely acknowledges the enormity of her debt to those who preceded her, and particularly to her mother.

Sarafina, whose Tewa name translates as Autumn Leaf, married Margaret's father, José Geronimo Tafoya, also known as White Flower, around 1883. This was four years after Santa

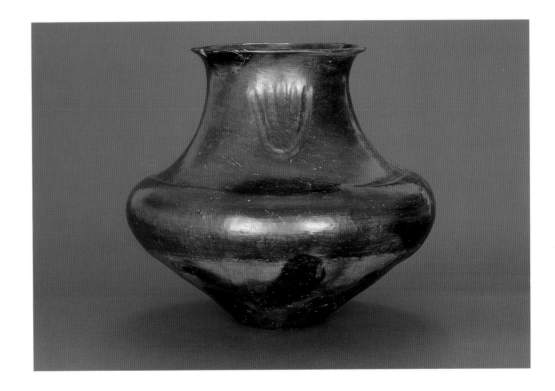

Clara's potters discovered an outside market for their wares among travelers at the new railroad depot in nearby Española. In fact, the railroad spurred Sarafina and her contemporaries into making pottery good enough to find favor in the marketplace created by passersby.

Sarafina's early wares were small, undecorated utilitarian pieces of the sort long used by Santa Clarans for storing food and water. Yet Sarafina also brought something else to her pottery, a quality which might be the single most important aesthetic element in pueblo art. This is the expression of the idea that the most utilitarian object can be graced by some functionally unnecessary adornment; that the things

27. (Opposite) Margaret Tafoya is best known for her large-scale storage jars (this one measures 25 inches in height) of classic grace and proportion. No one since has been able to duplicate this achievement with any degree of consistency.

28. This classic water jar displays the restraint in embellishment that is characteristic of Sarafina's work. The bear paw design (seen at the neck) is still associated with the Tafoya family. (Cat. 11050, Santa Clara Blackware Jar, by Serafina Tafoya, circa 1900. Douglas Kahn, photographer. School of American Research Collections in Museum of New Mexico, Santa Fe.)

of everyday life need not appear as prosaic as the chores associated with them.

Sarafina's expression of this principle is seen in her seminal works, which are decorated with scalloped rims and impressed rainbow motifs in tasteful proportion to the vessel. Her sense of proportion — of how little embellishment is needed to define a form sculpturally and give it an expressive presence — is really the guiding force that informed her daughter Margaret's career, set a standard at Santa Clara, and can be seen in the contemporary interpretations offered by her descendants' work today. Later, perhaps inspired by a growing confidence, Sarafina cut loose her impulse for more elaborate decoration, creating red and black bowls with painted or carved designs.

Sarafina's pursuit of excellence profoundly influenced her daughter Margaret. Born at Santa Clara in 1904, Margaret Tafoya was the last of Sarafina's and Geronimo's eight children. Baptized Maria Margaret, she was also given the Tewa name Corn Blossom. Typical of pueblo potters from ancient times to today, Margaret's exposure to the art form came from watching her mother at work. This was not a formal apprenticeship in any sense, for in the pueblo society of Margaret's youth daily activities and artistic pursuits were inseparable. Instead this was an instance of a girl imitating the activities of the woman whose life served as her model, who personified the standard by which the girl's own behavior would someday be judged.

Recalling her childhood, Margaret Tafoya once told a biographer: "When I was small, like all pueblo children, we sit around Mother's side when she is making pottery. We get a piece of her clay and try to make animals or maybe bowls. We make these just for fun. Sometimes Mother fix it for us, and that is the way we started, putting our hands in the clay and whether we know it or not, through our playing with clay we learned pottery making. We were brought up that way." The watchful child could

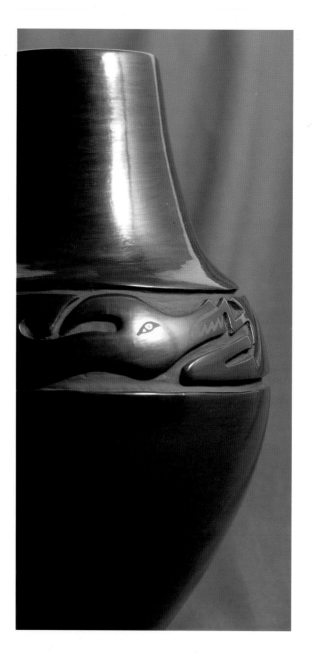

29. The recurrence of the avanyu, or plumed water serpent, in Margaret Tafoya's work shows her reverence for the forces which nourish the high desert. The undulating body of the serpent is said to represent water rushing through the arroyos after a downpour.

hardly have been luckier, for historians agree that Sarafina ranks as one of Santa Clara's most accomplished potters, ever.

In young Margaret's world pottery making was a family enterprise, with even her father Geronimo joining in the making of pots. One of his canteens from the late nineteenth century, along with a black water jar by Sarafina, found a place in the collection of the Smithsonian Institution. As a child Margaret often watched Geronimo load the fragile products of her family's labor onto the back of a burro and lead the little animal north, sometimes traveling as far as Colorado in search of customers.

However naturally Margaret took to potting — that she did is evident even in her early efforts

30. (Opposite) The "lamp base" is an elegantly proportioned shape that stems from the utilitarian tradition in ceramics. It was not unusual for Margaret to drill a hole in the bottoms of these jars for a cord, even in her own collection.

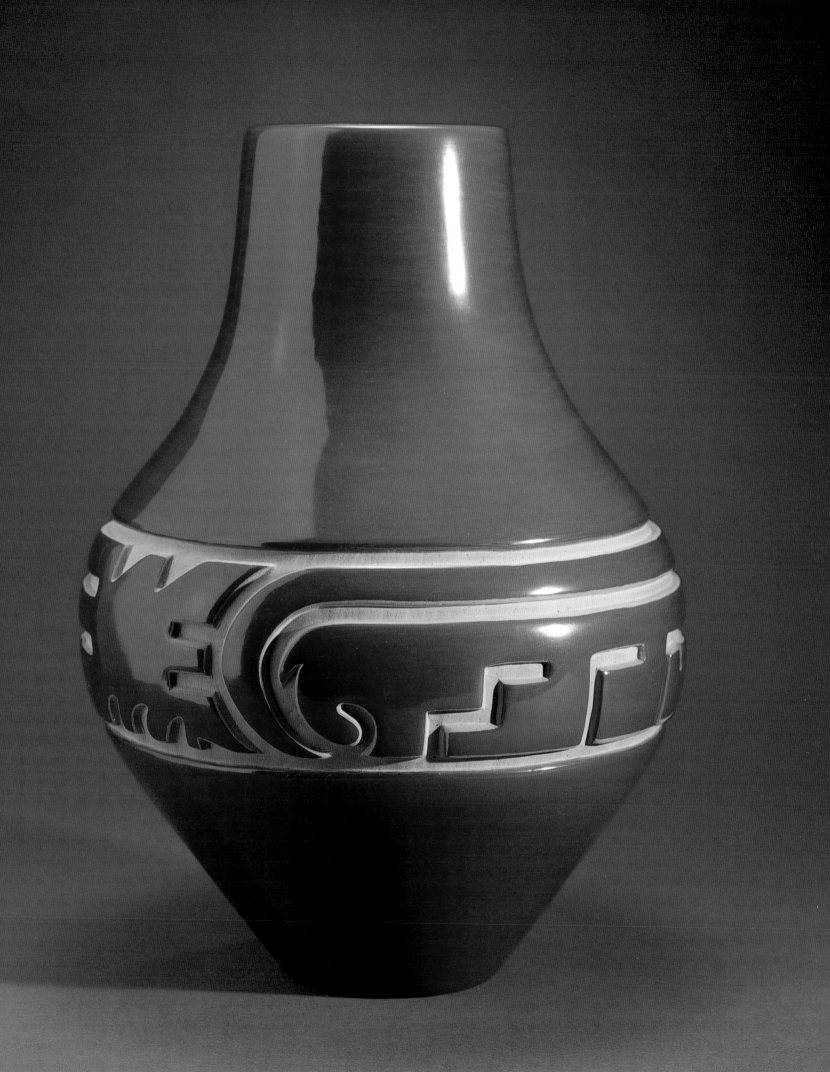

— making a living as a full-time pueblo artist seemed practically impossible in those days. Only later did connoisseurs come to the realization that pottery made by an artist was art. Before that, the sale of pottery at best augmented whatever other income one might muster. Thus the end of Margaret's teenage years witnessed her departure from Santa Clara for Dulce, New Mexico, where she worked as a cook at a Jicarilla Apache school. In 1924 she married Alcario Tafoya and the couple settled in Santa Clara, where they raised twelve children.

Reunited at Santa Clara, Geronimo, Sarafina, and Margaret commenced making pottery while her husband Alcario helped by painting and carving decorations on some of her works. Occasionally, Margaret traded her pottery to a visiting Anglo woman for secondhand clothing. More often, she and Alcario cushioned her pottery in the straw-covered bed of a wagon and drove to trading posts in Santa Fe or Taos. Often they went to Taos along a route which Margaret called "the going-up place," winding through the Rio Grande Canyon. Sometimes Margaret and Alcario headed for Santa Fe, typically spending the night with friends along the way at Nambe or Tesuque.

Margaret's early pieces tended to be constructed along a fairly vertical format. As time passed, her repertoire expanded and included a variety of elegant forms, horizontal as well as tall, ultimately including the huge, truly amazing storage jars for which she is most famous.

Increasing use of the impressed bear-paw design became one of the hallmarks of Margaret's pottery. This motif generally conveys good luck, because Santa Clarans believe bears' keen sense of smell tells them where to dig for underground water. The earliest documented example of a Santa Clara bear-paw jar appears to be a vessel collected for New York's American Museum of Natural History in 1903. Although the design itself predates Margaret's birth, she has become so well known for its use on storage

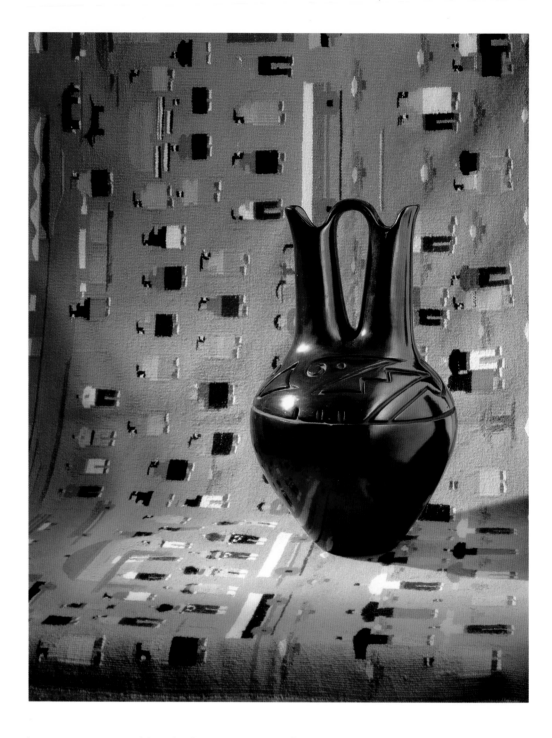

jars, water jars, and bowls that it is practically synonymous with her name.

The elements of the cherished past which Margaret never relinquished include her forsaking a kiln in favor of firing her pottery outdoors. She also holds true with tradition by using corncobs for polishing, and relying on scrapers made of cracked gourds. It is what one would expect from a potter steeped in the ways of her people, for whom Mother Clay is the spiritual embodiment of the raw material. As Margaret once told an interviewer: "Wherever you go and get the. . .clay, you take your corn

31. This is a large twin-spouted "wedding vase" by Margaret Tafoya, measuring approximately 19 inches in height. The style of deeply carved design in a band around the shoulder is one of Margaret's most significant contributions.

meal [sacred substance for ritual offerings in the Pueblo world]. You can't go to Mother Clay without the corn meal and ask her permission to come to touch her. Talk to Mother Clay."

By the 1960s, Margaret found herself receiving growing attention. This allowed the potter to express herself more fully. Not surprisingly, many of her largest and most magnificent pieces date from the 1960s and 1970s. In 1978, for example, Margaret entered one of her red bear-paw storage jars in Santa Fe's annual Indian Market competition and won Best of Division, Best of Class, and Best of Show. She returned to Indian Market the next year with a black bear-paw jar and repeated her previous triumph. In the early 1980s her work served as the focus of three separate museum exhibitions — at the Wheelwright Museum (Santa Fe), the Denver Museum of Natural History, and the Colorado Springs Fine Arts Center. In 1984 Margaret traveled to Washington, D.C., where she was named one of the nation's Master Traditional Artists by the National Endowment for the Arts.

Margaret Tafoya, who is today the unquestioned *grande dame* of pueblo pottery, came from a cultural milieu permeated with the compelling artistic tradition that allowed her mother Sarafina and others to blend the requirements of utilitarian wares with the imperatives of harmonious decoration. Not content with simply copying these early innovations, Margaret went farther, developing Sarafina's innovative style into her own skillfully sculptured, unambiguous, aesthetically pleasing forms. Her sense of scale and proportion, wedded with classic forms, transcends geographic and temporal horizons. This is because her art is, in a fundamental sense, informed by the universal desire to embody reality's essence, not simply its likeness. Because our spirits respond to tasteful abstraction and compelling beauty, we cannot help but admire Margaret's work, as clear an example of classicism as one could desire.

From Sarafina, who died in 1949, three pottery-making families have evolved — all known for the unusual ways they integrate form and decoration. Through Margaret came the Tafoyas and Youngbloods; through Margaret's sister Christina, the Naranjo family; and through their brother Camilio, Grace Medicine Flower and Joseph Lonewolf. In all there seems a trace element, as if some kind of genetic link to Sarafina Tafoya serves as the source of the power and allure invoked by the generations' collective work.

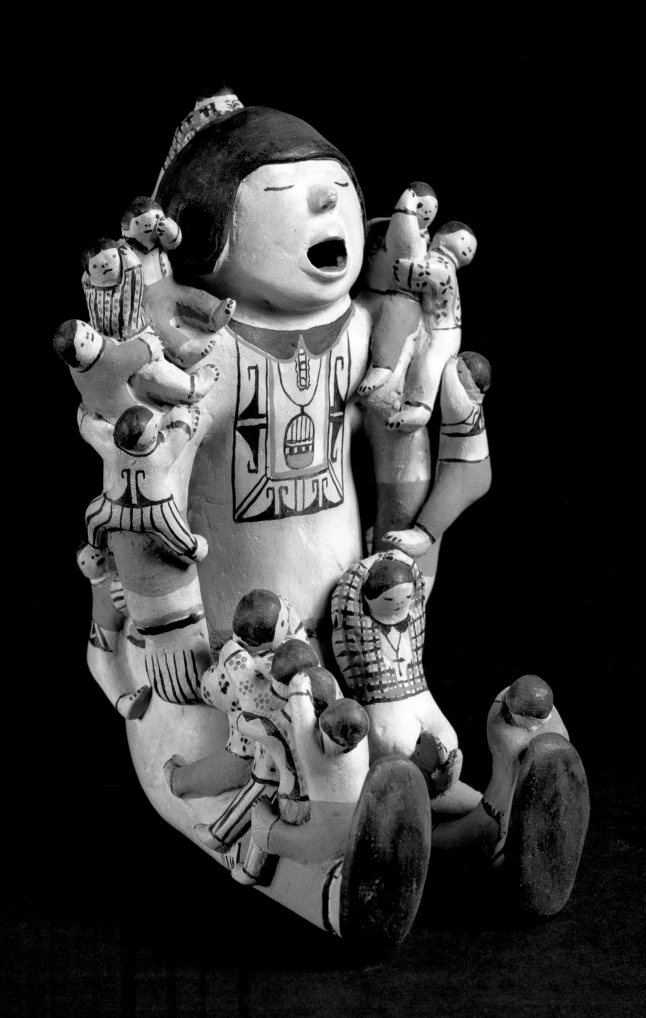

Helen Cordero

RON McCOY

Around the turn of the century, the potters' art slipped into a period of steep decline at Cochiti. "For a long time, pottery was silent in the pueblo," recalls Helen Cordero, who was born at the pueblo in 1915. Cordero is especially well qualified to speak about the topic of pottery making because it was she, more than any other, who revolutionized her people's ceramic tradition in 1964. She did this by bringing the famed storyteller figure to prominence.

In so doing, Helen Cordero harkened back to traditional archetypes expertly fashioned by her forebears, the Anasazi ancestors of southwestern prehistory. But Helen did not just imitate the ways of the past. Instead, she amplified a vibrantly inspiring heritage, adding appealing reflections of her own innovative spirit by creating pottery that was at once both like and unlike anything ever seen before.

Although the term *southwestern pottery* invariably conjures up images of jars, canteens, plates, and bowls, the region also enjoys a long-standing, albeit less touted, nearly two-thousand-year-old tradition of figurative pottery. Examples of this include the effigy jars and bowls discovered at such sites of prehistoric glory as Mesa Verde in southern Colorado and northern Mexico's Casas Grandes—elegant wares representing the birds, animals, and people that live together on this planet.

Although these intriguingly attractive pieces fulfilled a prosaic everyday purpose as containers, they were also used in a ceremonial context for holding corn meal and other items. For this reason, they often bore paintings of sacred designs, like those still seen on pueblo pottery. These motifs include representations of the rain and crops associated in the pueblo people's minds with the spiritual concepts of renewal and fertility.

It has been suggested that figurative pottery may have been what sixteenth-century Spaniards had in mind when they railed on about New Mexico's pueblo villages as repositories of *muchos idolos*, or "many idols." In any event, the Spanish spent quite a bit of their time immersed in an orgy of religious intolerance, destroying these objects, which were linked in their minds to exotic dark-side rituals.

As a result, we have practically no idea what sort of figurative pottery the pueblo people made during the sixteenth through late nineteenth centuries. By the mid-1870s, though, some of the later pieces worked their way into the market and into museum collections. As it happened, Cochiti became the center for the manufacture of this type of pottery.

Although pottery was made at Cochiti during Helen Cordero's youth, her own pottery-making apprenticeship was conducted years later under the tutelage of her husband's cousin, Juanita Arquero. Originally, Helen intended to make pin money by selling beadwork on leather

32. Helen Cordero's grandfather, Santiago Quintana, no doubt would be proud. His image lives on as a beloved storyteller of Cochiti — and indeed as the inspiration for his granddaughter's innovations in figurative pottery.

but she abandoned that effort after seeing that the small profits coming her way were quickly eaten up by the cost of materials. At that point, she took Juanita's advice and the two women turned to pottery, for which the raw material could be obtained simply by accepting nature's bounty: clay.

One thing became clear straight away: Helen was simply not cut out for making bowls and jars. That must have come as a disconcerting realization, though these days she laughs merrily when recalling how crooked her pieces looked compared to Juanita's accomplished wares.

Bowing to necessity, searching for other avenues of expression for Helen, Juanita hit upon an unusual idea. She suggested Helen give some thought to making figures modeled after creatures and people. Helen immediately found her forte in creating the steady procession of charming, attractively whimsical miniatures which seemed to leap almost effortlessly from her hands.

During the late 1950s and early 1960s, Helen and Fred, her husband since 1932, often traveled to the annual summertime pow-wow at Flagstaff, Arizona. The Flagstaff Pow-Wow, since discontinued, acted as the counterpart to Gallup's Inter-Tribal Ceremonial and served for many years as an effective showcase and productive outlet for Southwest Indian art.

During this time, especially between 1959 and 1963, Helen molded a number of singing mothers, a kind of open-mouthed, baby-bearing madonna-like figure popular with Cochiti potters since the 1920s. Around 1960, she journeyed from Cochiti to neighboring Santo Domingo and showed some of her pieces at the pueblo's annual feast-day celebrations. Her seven-to-nine-inch standing figurines representing a group of singers immediately aroused the interest of folk art collector Alexander Girard, who bought them for a nominal $7.50 apiece.

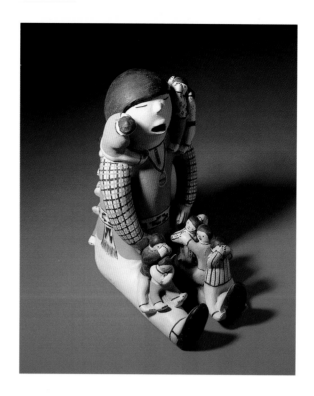

33. This piece displays not only delicacy in sculptural imagery but a detailed treatment of clothing. The pieces with children attached presented an additional challenge in the firing.

Girard's interest piqued the curiosity of other collectors. As a result, demand for Helen's work snowballed. Now, finally emerging as a professional artist in her forties, Helen started exploring her unique avenues of expression more fully than she probably ever thought possible. This first stage of major creative refinement led to what contemporary observers view as a revolutionary development in modern pueblo pottery: the creation of her first *Storyteller*, made for Girard in 1964 and now housed in the collections of Santa Fe's Museum of International Folk Art.

This seminal figure, standing just over eight inches in height, depicts a seated man with an open mouth and closed eyes. He is clearly a Pueblo Indian, one sporting the traditional *chongo* hairstyle, wearing tan deerskin moccasins and a squash-blossom necklace. The five children Helen arrayed across the storyteller's body — there is here more than a hint of Gulliver and the Lilliputians to Western eyes — listen eagerly to the tale coming from his open mouth. This is clearly a happy man engaged in an enjoyable task with youngsters who have come into joyful contact with a fellow they not only respect but obviously love.

Perhaps the most intriguing fact about *Storyteller* is that he is not a fictional construct. Rather, he represents an actual person — Helen's beloved grandfather, Santiago Quintana. As Helen told an interviewer who asked her about Storyteller: "When people ask me what it is, I tell them it's my grandfather. His eyes are closed because he's thinking and his mouth is open because he's telling stories."

Storyteller almost immediately received widespread critical acclaim, inevitably focusing attention on Helen's work. Here was something related to traditonal form but inherently different: a significant, aesthetically pleasing deflection in the mainstream of pueblo pottery.

The year Helen created this piece she won first, second, and third prizes at New Mexico's State Fair. The following year she triumphed with a prestigious first-place ribbon at Santa Fe's famed Indian Market. In 1971, the same year she received the Best of Show Award at Indian Market, Phoenix's Heard Museum cleared one of its heavily visited galleries to mount a one-woman show of Helen's work.

Triumphs at such venues as Indian Market and the Heard Museum do not guarantee the success of an artist like Helen Cordero, but definitely point a veritable spotlight on her work. Sometimes this sort of attention creates an incapacitating glare within which an artist freezes, incapable of functioning properly ever again. But this is not what happened in Helen's case. Instead, she continued broadening her repertoire and inventing a variety of additional new figurative forms.

In the years since *Storyteller* sprang from her fertile imagination, Helen Cordero has gone on to make an artistic impact with other equally inventive forms. The panoply of other Cordero figures include *Praying Storyteller, Smoking Storyteller, Pueblo Father, Mother Turtle,* and *Water Carrier.* She has also made *Owl, Turtle, Hopi Maiden,* and *Drummer,* modeled after her husband Fred, two-time governor of Cochiti and one of the pueblo's better known drummers and drum makers.

In *Children's Hour,* a form which initially appeared in 1971, as many as thirty pueblo adolescents gather around a storyteller. Again, the storyteller is Helen's grandfather, whom she remembers assembling an eager audience for his recitations of tales by calling out to Cochiti youth: "Come children, it's time." The children's hour pieces are doubly interesting because they require the person who possesses one to rise to the challenge of arranging the children, which are separate pieces. Thus the children's hour serves as a fine example of flexible, interactive pottery.

Over the years, Helen's pottery figures became increasingly complex in detail, painted with more consistent sureness, defter in execution, finer in finish. Arraying Helen's work by date and placing the wares side by side, it immediately becomes obvious that her storytellers have grown taller, thinner, and more naturalistically proportioned. The children crawling over the figure were once molded directly from its body, but in the late 1960s Helen started forming them separately and applying her "little kids" onto the larger figure. It was also in the 1960s that she began signing her pieces, first in pen or pencil and later in *guaco*, a black paint made from boiled Rocky Mountain bee weed.

Helen's readiness to proceed apace with the pull of outside stimulus combined with the force of her own imagination is illustrated by an episode recounted by anthropologist Barbara Babcock, Helen's biographer. In 1976, during a visit to a gallery in Santa Fe, Helen happened to see an example of figurative pottery from her native pueblo. Dating from around 1895, the piece depicted a little man wearing Anglo clothing. After carefully measuring the image Helen returned home to Cochiti and made a matching figure, but one distinctly reflective of her own technique and vision. Eventually, the two figures were placed side by side, form-

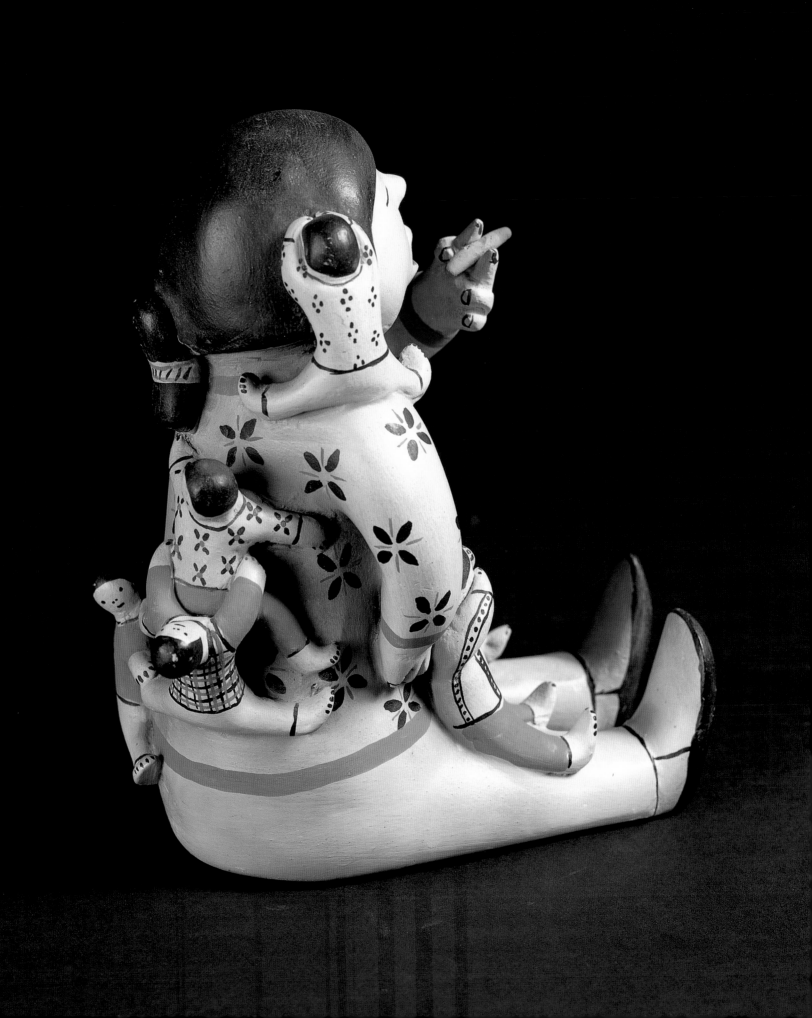

ing mirror images along an artistic continuum.

If imitation is truly the sincerest form of flattery, then Helen should indeed feel warmly honored: more than 150 other pueblo potters from at least a dozen villages have drawn obvious inspiration from the product of her invention, recreating the storyteller and those other forms which are now virtually her hallmarks.

"I guess I really started something," Helen once said with characteristic modesty. Indeed she did, though Helen is far too self-effacing to claim credit for what she has done or to analyze precisely what it is she has accomplished. She is quite content to leave up to others the busi-ness of speculating on the remarkable fact that what she has wrought is nothing less than a regeneration of the effigy form in Southwest Indian pottery.

"You have to have a happy feeling inside when you make pottery," Helen has said. Surely Helen Cordero must have more than a little of the shaman about her. After all, it remains this artist's supreme accomplishment that the happiness she feels inside while making pottery not only infuses the clay but spreads to fill the lives and play with the imaginations of those who come into contact with her little people.

34. *The* Smoking Storyteller *conjures images of the old grandfather telling tales around the campfire. The detail in the painting and the confidence in forming this figure identify it as an advanced example of her work.*

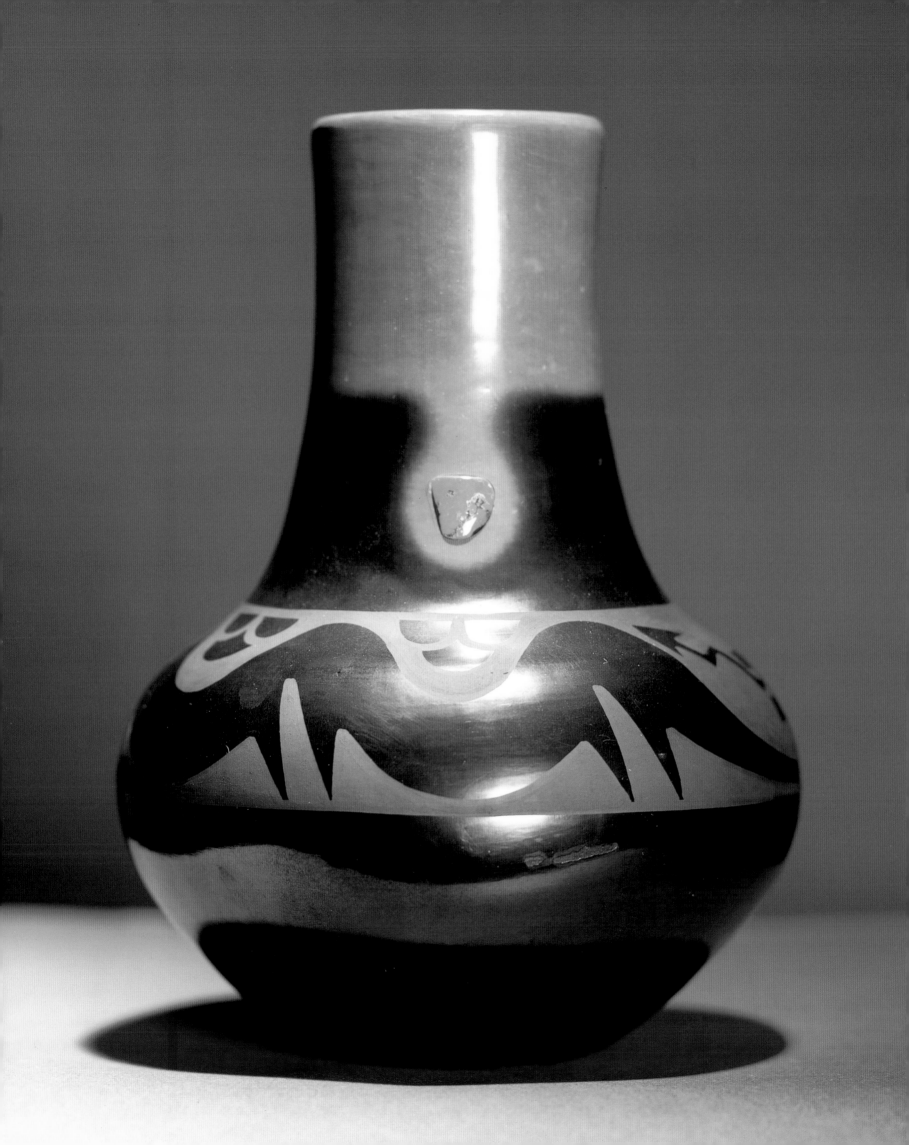

Popovi Da

RON McCOY

Popovi Da (pronounced Day) was a brilliant, multi-faceted potter who transformed the world of pueblo art. Son of Maria and Julian Martinez, the famous artist couple, Popovi Da developed highly original styles of his own, showing that his parents' artistic legacy not only survived, but actually seemed to recharge itself over a generation. The impressive array of Popovi Da's accomplishments as he flashed across the creative horizon stands as eloquent testimony to the presence of an experimentally inclined, highly innovative talent.

Maria and Julian had been married seventeen years when Po (as practically everyone would come to call him), the third of four sons, was born at San Ildefonso in 1921. Together, Julian and Maria were engaged in perfecting a variety of pottery-making techniques. In fact, their inventiveness established an entirely new style of pottery, with their meal boxes, plates, bowls, storage jars, and polychrome pieces — fashioned by Maria and painted by Julian. Their dedication to purity of form anticipated the concern their son would exhibit in the elegant restraint of his own work.

Po was twenty-two when his father died in 1943. After a short break Maria continued her practice of working in partnership — now with her daughter-in-law Santana. The wife of Maria's oldest son Adam, Santana competently carried on Julian's design work and firing methods, making possible Maria's continued productivity — without, however, inventing anything wholly new.

Meanwhile, Popovi Da studied painting with Dorothy Dunn at Santa Fe Indian School, now the Institute of American Indian Art. (Dunn's style, based on the look of nineteenth-century Plains Indian ledger drawings but modernized with more fluid lines, exerted a strong influence on mid-century pueblo painting.) Po also served in the military and married. Known early on officially by his Christian name Antonio Martinez, in 1948 he asked permission of his family to change it legally to his Tewa name, which translates as Red Fox. A reflective man, Po was profoundly inspired by pueblo history as well as art and grew uncomfortable being known to the world by a Spanish name. The same year, he and his wife Anita opened the Popovi Da Studio of Indian Art at San Ildefonso.

Around 1950, Po started slipping into the potter's world, helping Maria dig clay in the nearby mountains. His apprenticeship involved soaking and mixing clay, adding temper, hauling dung and wood for firing, and polishing Maria's wares to a nearly impossible degree of burnish. Having shown an aptitude for drawing animal figures in school, he now began painting designs on his mother's pots.

Even early on, as Maria once explained when recalling her son's growing involvement with the Clay Mother, Po's attraction to pottery

35. Po is thought to have been the first to apply turquoise to ceramics. This piece shows a boldly, simply used stone, while the black-and-sienna combination skillfully separates and defines the design fields.

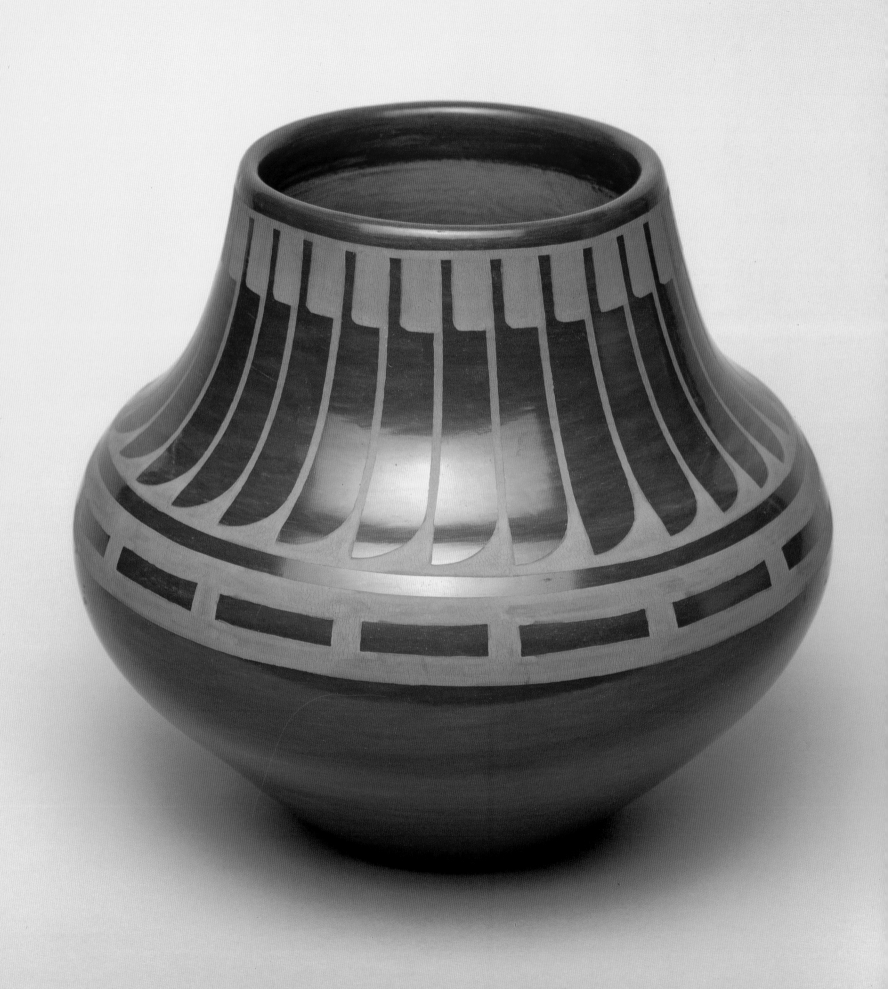

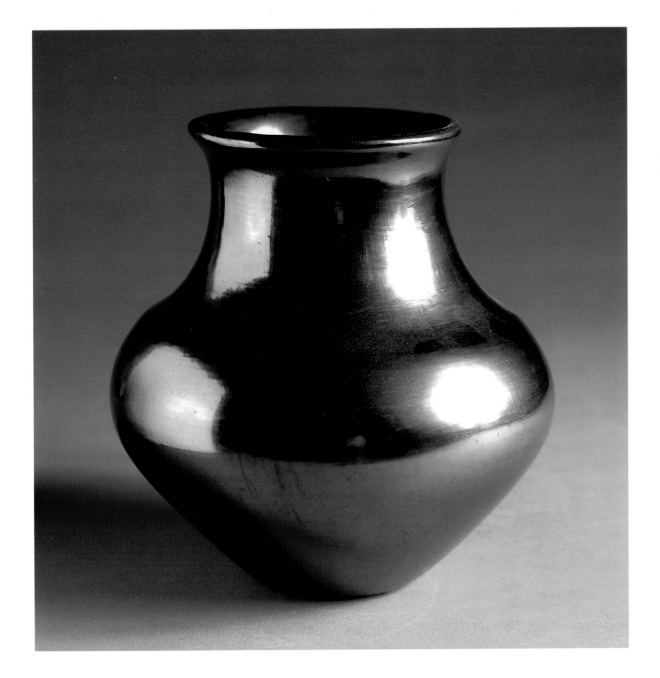

36. *(Opposite) The buff-on-red style of this jar is relatively uncommon. The light clay paint applied over the highly polished red slip also forms the basis for the famous black-on-black effect when a reduction firing is employed. Here, the puname, or feather circle, is adapted to the graceful slope of the jar's neck.*

37. *The silvery "gunmetal" finish is only attainable through a precisely timed firing—this was but one of the many major innovations brought to the art form by Popovi Da. The classical and sensuous shapes Maria produced gained new expressiveness with Po's perfection of this finish.*

was clearly of a compulsive sort. "Then he don't want to sleep," she remembered. "He just go ahead and paint [pottery]."

Maria encouraged Po's inclusion in this creative partnership. He agreed, and in 1956 the "Maria/Popovi" signature began appearing on their work. Initially he revived the polychrome painting which Julian excelled at early in his career. Po's polychrome plates, painted with mineral pigment, generally ranged from nine to fifteen inches in diameter; subjects included the Mimbres-inspired feather design that Julian made famous, lively animal designs, and geometrics. Po realized that a beautiful repertoire of pueblo images remained unexplored.

As he once said: "We have a multitude of symbols — corn blossom, squash blossom, eagle and deer, rainbow and fire, and storm cloud; the design of plants, of all living things; the underworld which gave forth man and all the creatures — symbols whose secret meanings are only secret because they are within and cannot be easily expressed."

Years later — by then a prominent artist — Po provided additional insight into his love for designs: "They point to rhythm and the motion in the dance, the action of the horse, the speed of the antelope, the heat of the desert. We have a form of art which is distinctively North American Indian, and we must preserve

our way of life in order for our art to continue." Po perceived his role as intrinsically wound up in his identity as a tribal person. Of Indians in general he believed, "It is our role to create."

As had been the case with Julian, Maria's expert molding and her partner's exquisite painting proved immensely popular. Po handled a yucca brush with such complete naturalness that Maria remarked with a mixture of wonder and pride, "Now I can look at one Po paints and one Julian, and I can't tell."

Appreciative recognition for Po's work came immediately; the first Maria/Popovi polychrome plate with traditional designs won Best of Show at the Gallup Inter-Tribal Ceremonial in 1957. Unfortunately, work from this period is rare because Po experimented with so many firing techniques that numerous pieces were destroyed during the final phase of production.

A feverish drive to experiment typified Po's art for the rest of his life. He even tried working with glazes, though they never attained the degree of perfection that satisfied him. By experimenting with double-firings to burn the carbon from a polished black pot, he developed a plain sienna finish as well as a black-and-sienna two-tone style. He created terra cotta wares and never tired of combining techniques. Po was likely the first potter to add turquoise to his work, although he soon abandoned the idea. Ultimately, he produced an amazing gunmetal finish of such richness that the aesthetic power of Maria's pottery achieved a new level. These are works of pure wonder, sheathed in a lustrous, sleekly fluid metallic sheen.

Trying for the gunmetal finish was risky business: removed too soon from the fire, the pot emerged as blackware; fired too long, it turned dull gray. (The only other potter who seems to have mastered the tricky intricacies of timing was his sister-in-law Santana.)

As if somehow possessed of a sense that his own time was too short for a leisurely career, Po introduced and refined firing techniques, colors, and finishes in a whirlwind of productivity during the 1960s. He acted like a destiny-driven spirit that needed to work its magic quickly.

Somehow, Popovi Da also found the time to emerge as a leader of his village. He served as San Ildefonso's governor six times, and his views commanded attention regionally during his service as chairman of the All-Pueblo Council.

Po once reflected on the changes in pueblo pottery over the generations: "As our society changed throughout the ages, there appeared variations in our art related to the life of the people. In time of high prosperity, pottery styles and our artistic talents were directed to forms showing our affluence: detailed lines, fine in form and of many colors and styles. During droughts and periods of trouble, we created less than at other times, because these were periods of oppression and frustration when the mind was controlled by anxiety."

And Po was beset by his own anxieties. His loyalty to Maria made him wish never to compete with her in the marketplace of collectors. But he seems to have felt constrained, even frustrated, as he held his full creativity in check while awaiting his mother's retirement. Maria was, after all — along with Margaret Tafoya of Santa Clara — one of the two most famous Pueblo potters alive. Thus Po hoped and believed his best work lay ahead of him. Ironically, Maria did not retire until late 1970, months before Po's own death.

In a way, Po summed up the mystical roots of his art during a lecture at Santa Fe's School of American Research in 1969. "Our values are indwelling and dependent on time and space unmeasured," Po told his listeners. "This in itself is beauty."

Po's time to create beauty was as fatefully measured as any tragedy from the classical age. But his was an utterly remarkable talent, a gift he used to expand the mainstream of his art form by never finding satisfaction in repeating himself.

38. This piece demonstrates Po's ability to translate his aptitude at two-dimensional painting into the three-dimensional world of his mother's ceramics. His figure painting skills were first developed under the tutelage of the noted Indian school teacher Dorothy Dunn.

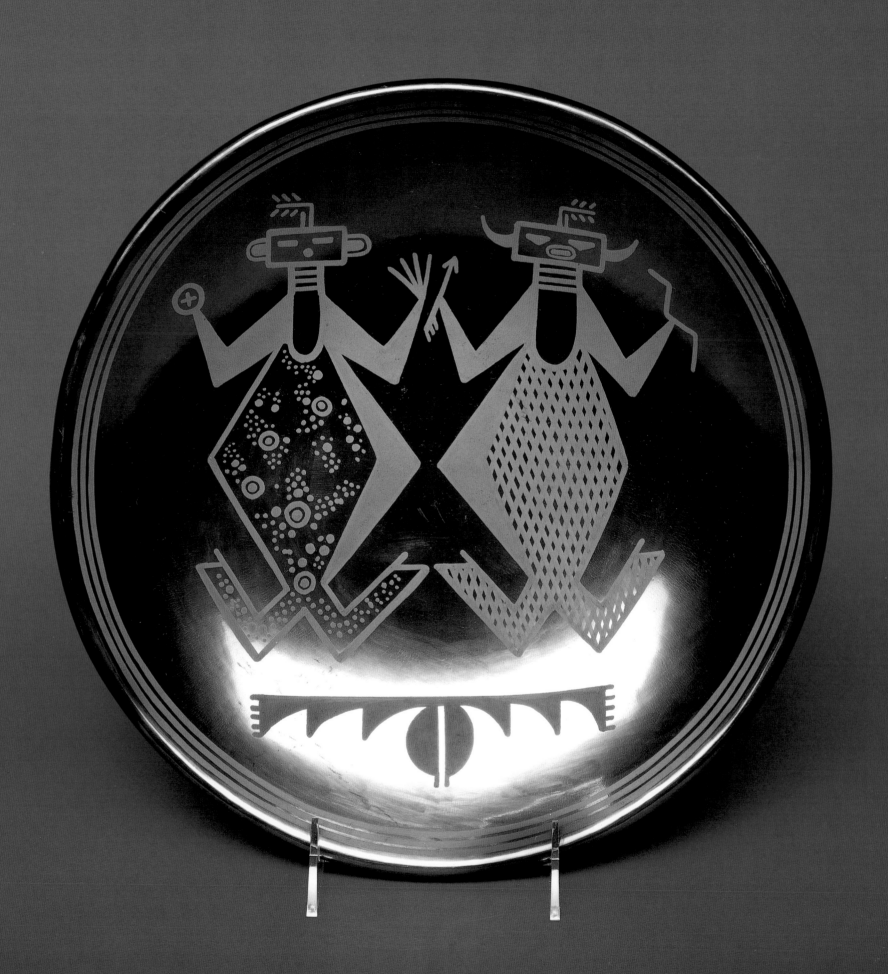

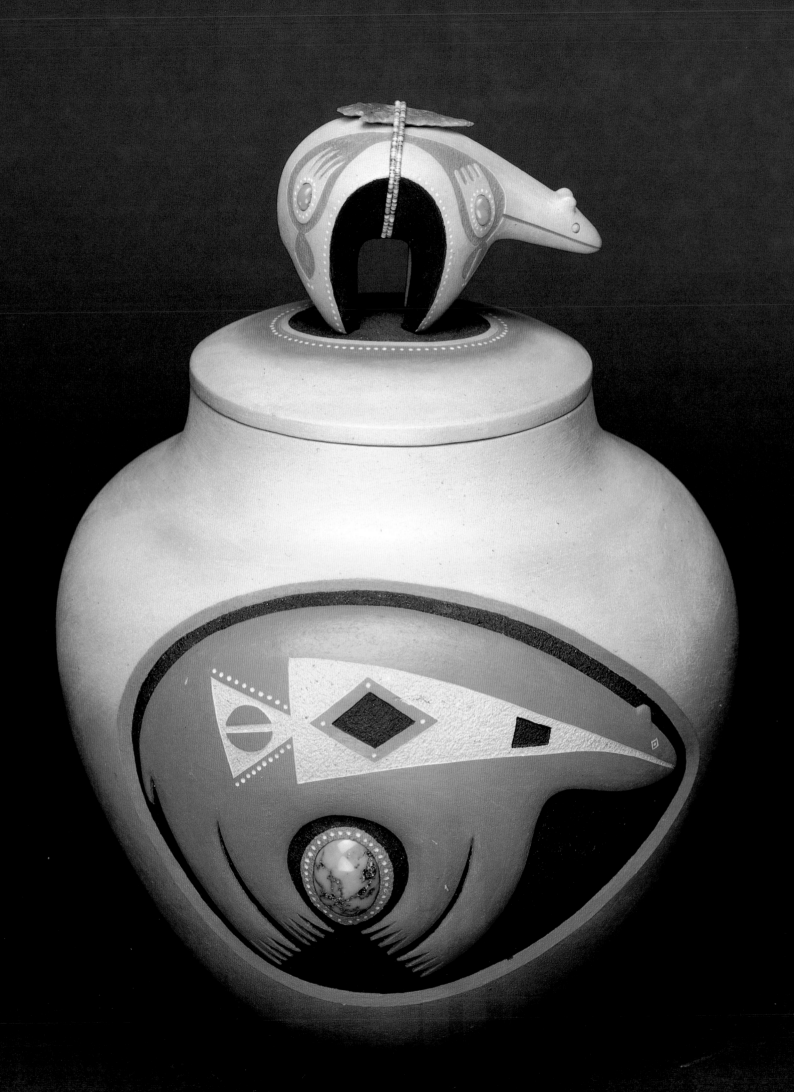

Tony Da

RON McCOY

Tony Da comes from a long line of illustrious pueblo potters. His father was the inventive Popovi Da and his grandparents the revered Maria and Julian Martinez. Tony readily absorbed what his family had taught him about the potter's art and, while still very young, deftly moved into that realm inhabited by the most mature talents. Exerting the force of his own driving vision, he expanded unpredictably upon his training, creating new precepts in pueblo art — ultimately blending his talents as a potter, painter, and jeweler into a highly original, inspiring, and artistically successful body of work.

In order to appreciate fully what Tony Da accomplished during his remarkable and tragically short career, one must consider how his family had already influenced San Ildefonso pottery. Pottery-making waned at San Ildefonso after the railroad brought durable mass-produced containers and cooking vessels to the pueblos in the 1880s. Then, in the early twentieth century, Tony's grandparents, Julian Martinez and his wife Maria, helped transform the existing tradition of wares intended for prosaic purposes into one dedicated to the creation of works of art. Initially, non-utilitarian pueblo pottery satisfied tourists' need for souvenirs of the exotic Southwest. Soon, though, appreciation broadened for the high degree of aesthetic judgment which a few potters brought to their work. A small nucleus of master potters

— among them Tony Da's grandparents— created a legacy that still affects the developmental course of Pueblo art today.

Starting in the 1950s, Maria and Julian's son Popovi Da infused his own spirit into pottery. He began painting magnificent polychrome pieces reminiscent of his father's early work and then went on to experiment with turquiose inlay, which his son Tony eventually perfected, and even developed entirely new finishes for his wares.

Tony, who was born in 1940, began experimenting with jewelry and painting in his youth. In high school he studied with Hungarian-born Joseph Bakos, one of *Los Cinco Pintores* — the core group of five Santa Fe painters whose abstract landscapes established New Mexico modernism as a vital force in American art during the 1920s.

In 1964, after a stint in the U.S. Navy, Tony returned to San Ildefonso, where he found his father and grandmother immersed in their productive partnership, working in gunmetal and the other new finishes that reinvigorated Maria's long career. Tony apprenticed himself to his grandmother, and his artistry developed with exceptional speed.

Tony drew easily but selectively on his experience with both painting and jewelry. Early on, he worked in the two-tone black-and-sienna style which Popovi Da introduced. He moved rapidly into the setting of turquoise into some of his wares, such as lidded vessels, bear fetishes,

39. *Lidded jars, although technically difficult, were not unusual for Tony Da. In this piece a sculpted bear fetish mirrors the incised image of a bear on the body of the jar. Stone inlay quickly became a trademark that would influence future generations of pueblo potters.*

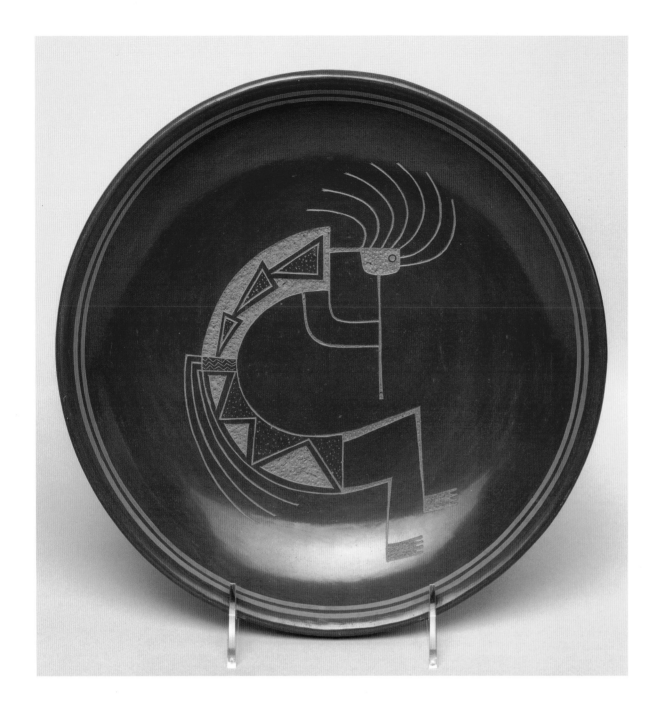

40. *Here is a modern twist in depicting the humpbacked flute player, whose image goes back to rock drawings and ceramics of prehistoric times. The incising technique is employed with a strong and steady hand to create circular movement and a balanced composition.*

and sculptures of turtles. Indeed, Tony was the first pueblo potter to make extensive use of turquoise inlay in pottery. He next produced magical combinations of clay and wrought silver, as well as pottery inlaid with shell beads (*heishi*). Tony's work is immediately recognizable, and viewers have compared his more complex pieces to such objects as Middle Eastern jewelry boxes and Byzantine reliquaries.

Tony soon excelled as one of the pace-setting pioneers in incising designs into pottery surfaces, combining delicately etched images with inlay and red, sienna, or two-tone finishes to create works with wholly novel effects. A favorite incised motif was the *avanyu*, the plumed water serpent associated in pueblo lore with summer rains. In other pieces he used a buffalo with heartline, or motifs inspired by the prehistoric Mimbres culture, including the feather motif popularized by his grandfather. As a measure of his rapid progress, in 1967, just three years after beginning his apprenticeship with Maria, Tony's works appeared with his grandmother's and father's in the definitive "Three-Generation Show," an exhibition honoring the pottery art of the Martinez-Da families at the U.S. Department of the Interior in Washington, D.C.

Ever since, Tony Da's inspired, innovative body of work has exerted an enormous impact on the look of pueblo ceramics. An artist of conspicuous ability and clear vision, he came upon an art scene very much in flux — thanks, in large part, to the efforts of his own family. Tony built something new upon the foundation provided by his predecessors. Without the appearance of such inspired individuals on the creative horizon, art eventually turns in upon itself and atrophies. Tony was one of those rare figures who rise up from the artistic continuum, a gifted innovator whose work signaled significant changes in the mainstream of pueblo ceramics. When such contributions find favor, as his did right away, they work their way into the accepted vocabulary of the art form and within a generation come to be thought of as "traditional."

As Edwin L. Wade, formerly curator of non-European art at Tulsa's Philbrook Art Center, has written: "Much of what was once controversial in Indian art has become the expected, and what appears to be a radical departure today may well be seen as traditional by future generations. Indian artists are moving in many different directions: some are retelling the old legends in new ways, others are inventing new legends."

Tony Da exhibited a capacity for inventing new legends built upon the artistry established by his forbears and was consciously driven to do just that. He once told an interviewer: "I incorporate the traditional with the contemporary with my own interpretation of the way I feel it should be done. I'd like to stay within the tradition, using traditional pottery-making methods with contemporary techniques."

Once, in an introspective mood, Tony spoke to a friend about his love of abstract design: "I find abstraction particularly challenging because of its infinite possiblities," he mused. "Perhaps this also explains why speculation about time, space, and man's position in the universe has always been a preoc-

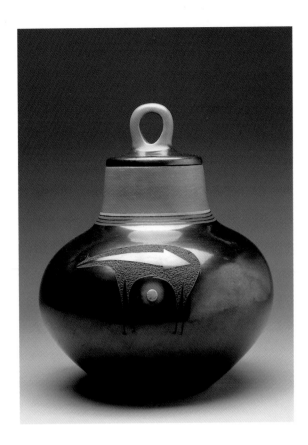

41. It is generally accepted that Tony Da was among the small group of pueblo ceramists who developed the incising technique, here used to emphasize the form of a deer, shown with a "heart-line" from the mouth through the body. Also important are the use of stone inlay and two-tone firing, which remained hallmarks of Da's work throughout his active years.

cupation of mine. I can only wish my work will remain in the future as a cultural testimony of these times."

Those remarks seem darkly prophetic, for a shroud of tragedy clings to the Da artists. Tony's father Popovi died young, at the pinnacle of his career, and next Tony's own career eclipsed. An off-road motorcycle accident resulting in serious injury precluded his return to pottery making.

Tony Da's work stands as a reaffirmation of the dynamic changes in southwestern pottery which can be seen in works created by three generations of a single family. These aesthetic developments, each revolutionary at the time but clearly evolutionary in retrospect, began with the work of Maria and Julian, expanded dramatically under Popovi Da's hand, and attained new intricacy and harmony with the maturation of Tony Da's art. What else he might have accomplished will never be known, yet in a sense his creative spirit remains alive in the work of those who turn to him, either for sources or for reassurance, in their own artistic explorations.

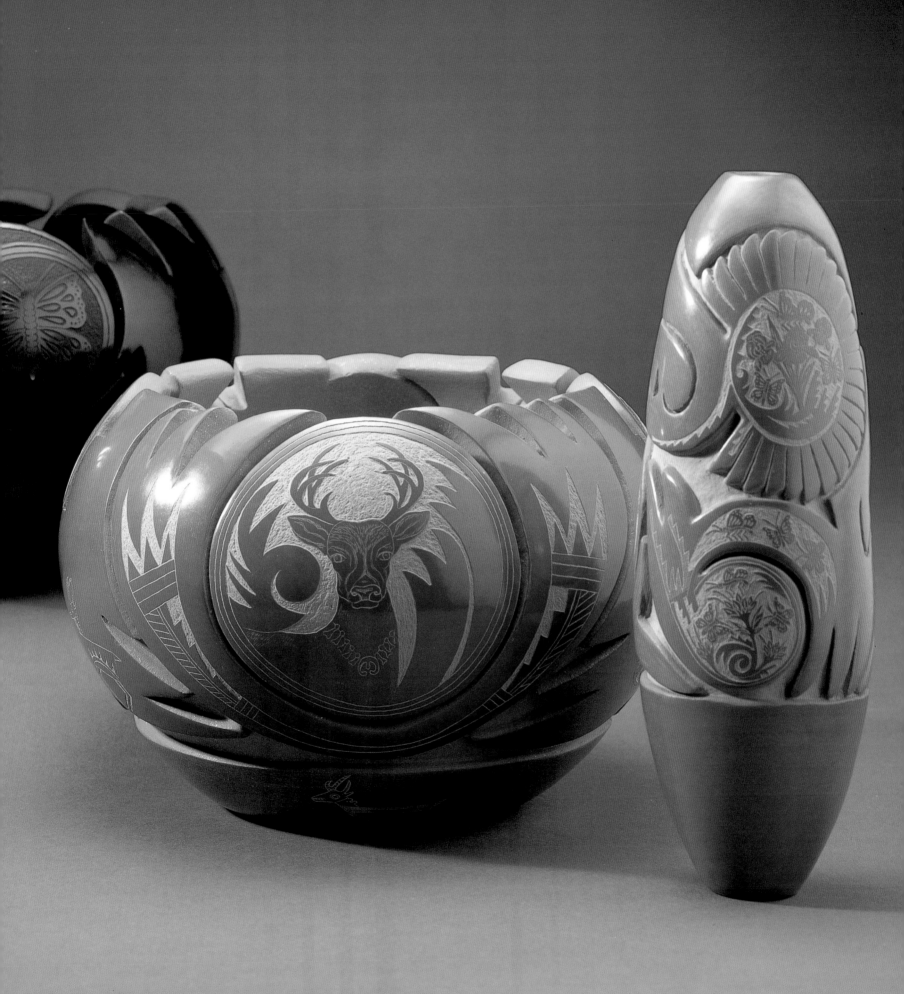

Grace Medicine Flower

ELLEN REISLAND

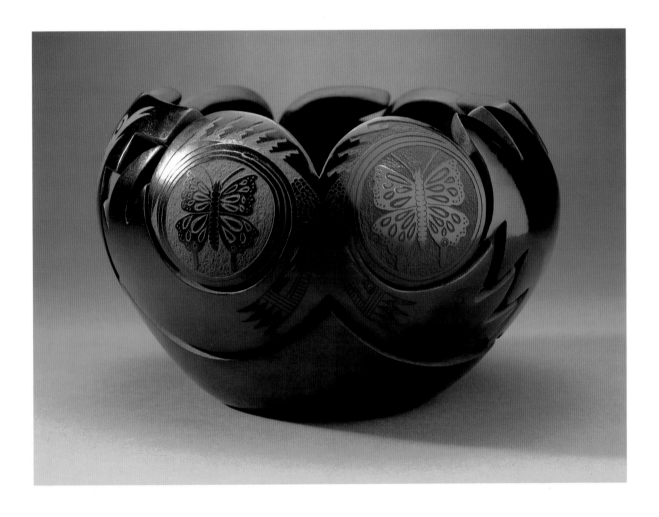

42. (Opposite) Mastery of technique is essential to the creation of a difficult and intricate form. Grace feels herself to be imbued with both the spirit of the Clay Lady and the design sensibility of the ancient Mimbres.

43. In pueblo lore, the butterfly signifies the beginning of the life cycle. Here it is delicately rendered on a vessel that marked the beginning of a new style for the artist, one exploring larger, more sculptured bowls and jars.

Upon meeting Grace Medicine Flower, one notices first her great physical beauty. A woman of elegance and calm, she enters a room with regal carriage, radiating self-confidence and sophistication. As conversation begins, however, it becomes apparent through her soft-spoken, gentle tones that she is modest, self-effacing, and a little in awe of the spiritual process that helps her bring into being the wondrous ceramics that are her art. Grace has lived nearly all her life at Santa Clara Pueblo, surrounded by, and immersed in, the creation of beauty and homage to the spirit of the Clay Lady.

A member of the renowned Tafoya family, Grace was born in 1938. She learned to make pottery at an early age. Her grandmother Sarafina had been instrumental in translating the utilitarian pottery shapes of the historic period into the classically proportioned vessels that we associate with the best of twentieth-cen-

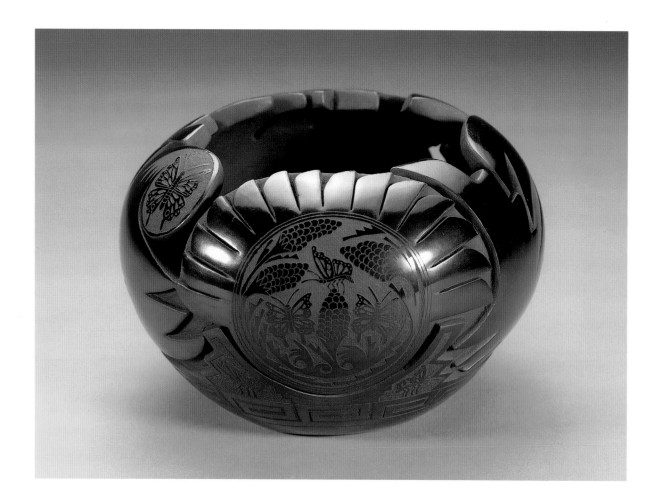

44. *Grace has studied the lessons of nature as handed down by the Mimbres. The carving as displayed here was learned from her family. She combines it with the innovative incising that has come to influence many other artists.*

tury Santa Clara ceramics. Grace's parents, Camilio (Sunflower) Tafoya and the late Agapita (Yellow Flower) Tafoya, were well-known potters in their own right. In the pueblo tradition, she watched her family work, and she in turn began to try it herself. A favorite childhood memory is an experience many of us can relate to: "Playing with the small pieces I made and playing store. It wasn't long before my friends and I were selling the pieces for a few cents to the neighbors. Some of those pieces are still treasured by a former teacher."

Pottery making at Santa Clara, as at most of the pueblos, is a family affair. Grace, her father Camilio, and her brother Joseph Lonewolf, all gifted potters, worked closely together in the early years and were at the forefront of innovation during one of the most exciting periods of stylistic change in this century. In the late 1960s they introduced a style of very delicate carving, sometimes called intaglio or sgraffito — precise etching into the clay surface — integrated with a combination of highly polished and matte finishes.

The delicacy of the sgraffito technique allowed design imagery to become more intricate and detailed than ever before. The pottery forms also changed. Where before the forms were based on older utilitarian shapes, now small spheres of highly polished clay became three-dimensional canvases on which Grace could carve her favorite subjects — those of nature, such as butterflies and hummingbirds floating against backdrops of flowers. Later, intricately carved and lidded perfume bottle shapes appeared, conveying a daring sense of fragility combined with a cohesive aesthetic vision.

Much of her early work was small, owing to her focus on intricate incising and detailed design. In about 1988, however, Grace began to move in a distinctly different direction. She began creating large open bowls with heavily carved design elements — sometimes permeating the clay wall with cut-outs, allowing the interior and exterior surfaces to merge and giving one the impression of flowers opening to sunlight. Smaller design areas, like pictorial

cameos, are sgraffito-incised over the deeply carved background. The contrast between the deep carving and the sgraffito gives the whole design a complex rhythm — one might say a counterpoint — which makes the work unique among carved ceramics.

Some of her early work was done with her father, Camilio, and bears both their signatures. Her earliest signature was simply "Grace"; it became "Grace Hoover" after her marriage to Jack Hoover; and finally, in the early 1960s, "Grace Medicine Flower" with a small flower logo. Pueblo people are typically given both European and Tewa names at birth, and Grace arrived at her professional name by combining hers.

For Santa Clara potters, the "Clay Lady" symbolizes the essential connection with the earth; she is the spiritual thread that links the technical and creative processes of pottery making. She is acknowledged at each step in the process through special prayers asking for her inspiration and guidance.

In the tradition of her ancestors, Grace uses clay found in pits on Santa Clara Pueblo. As the clay is removed from the earth, the first special prayers are offered to the Clay Lady, and the long, arduous process of preparation begins. First, the clay is left to dry in the sun for several days. Next it is crushed and put in a container with water to soak for a few more days. It is then screened very finely to remove the impurities, for even the smallest foreign particle, such as a bit of rock, can cause a pot to crack in a later stage of production. The clay is then mixed and kneaded with hands and feet and set aside for several days to "strengthen," as the potters say — that is, to gain the proper texture.

When the clay is ready, it is time to begin construction of the vessels. But first, Grace says, "I thank God for giving me the hands to create the pottery. I talk to the Clay Lady and promise to do my best to make her beautiful." Again in the traditional way, Grace uses the coil method to form her ceramics. The clay is rolled

45. An innovative use of materials enables the artist to separate design zones in new ways. Here, a micaceous clay slip has been applied over the mid-body design band. Complexity and bold simplicity unite to make a graceful work.

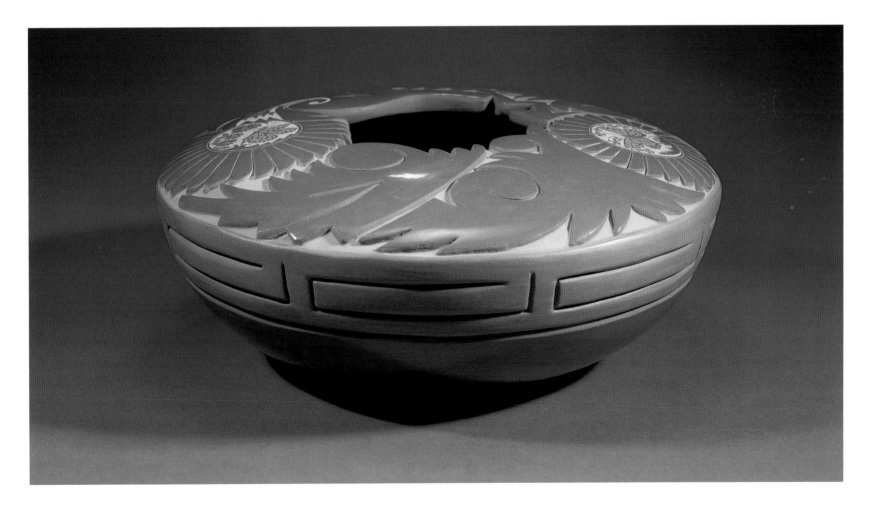

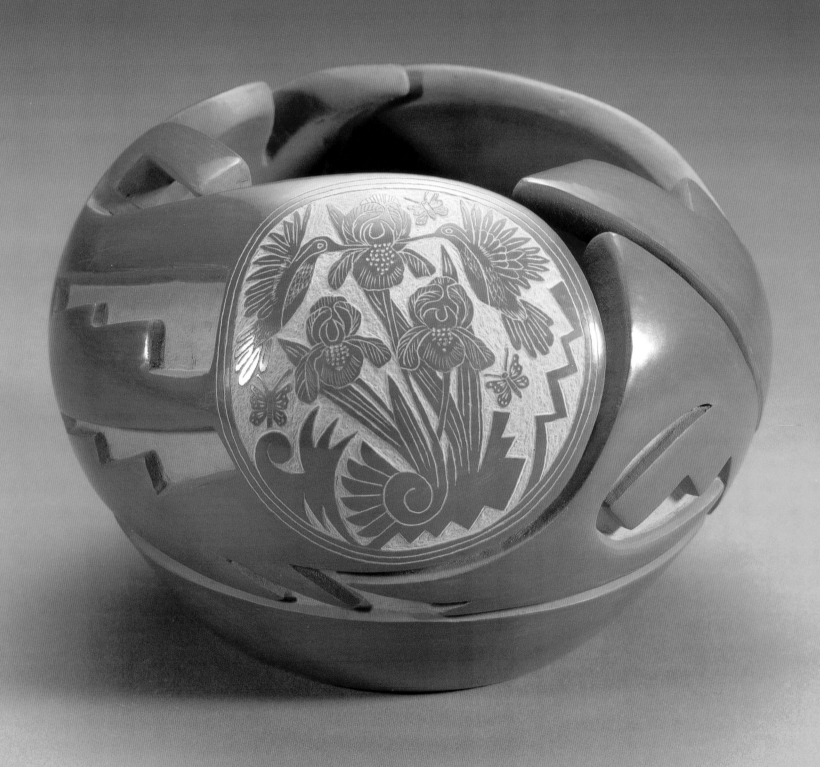

by hand into long snake-like strips, which are laid one on top of the other in concentric circles. Small pieces of gourd are used to blend the coils together, thin the walls, and smooth the surfaces. The pots are left to dry for several weeks, then sanded smooth before application of the slip. The slip is a watered-down red clay that is applied with a brush and polished by hand with smooth river stones. Grace uses a special polishing stone that belonged to her mother Agapita. The pottery is now ready to be incised.

Using a knife or a specially sharpened nail, Grace etches her designs into the polished surface. It is at this stage that artistic expression becomes most personal. Grace generally chooses subjects from nature — birds, butterflies, deer, and other wildlife, as well as the Mimbres designs of prehistoric times. She is drawn to the delicate, fragile elements of the world that reflect the integration of life cycles and the balance that supports all living things. Many of these designs are symbolic, illustrating the gifts that nature provides to the pueblo people. For example, the butterfly represents the beginning of life, while the serpent (*avanyu*) is life itself. The birds, wildlife, and ancient Mimbres designs reflect nature's provision of clothing, food, and beauty. Grace says simply, "Every pot I create is special to me. It comes from my inner being with the help of God and the Clay Lady."

The last stage of production is firing. Pueblo-style firing is done outdoors and is fraught with risks from the elements of wind and moisture. All the preparation, hard work, and anxious attention to detail become subject to the vagaries of natural fuel and the weather. Despite long experience with these variables, veteran potters including Grace still lose pieces from time to time.

The ceramic art of the pueblo Indians has evolved over many centuries. Initially created for utilitarian and ceremonial purposes, it has undergone a transition in the twentieth century to become, at its best, fine art of the highest quality. As in any art form, many will strive but only the few most gifted artists will possess both the technical prowess and bold aesthetic innovation to stand out above the crowd.

Grace Medicine Flower is one of these artists. She has integrated the traditional methods of pottery construction and firing with a strong sense of personal identity. And that is just how Grace wants it to be; she feels comfortable staying close to tradition, but as times change so then should her shapes and designs. She is constantly working on innovations herself and watching the younger potters as they are inspired with new ideas. Grace observes, "There will be more changes, but pottery should be around for a very long time." The dynamic of life surrounds all of us; but as is said of Grace's life by her peers and other admirers, "The Clay Lady approves."

46. The old and the new are harmoniously balanced in this piece in Grace's recently evolved style. Deep carving, sculptural cut-outs, polishing and incising are combined in a lively rhythm.

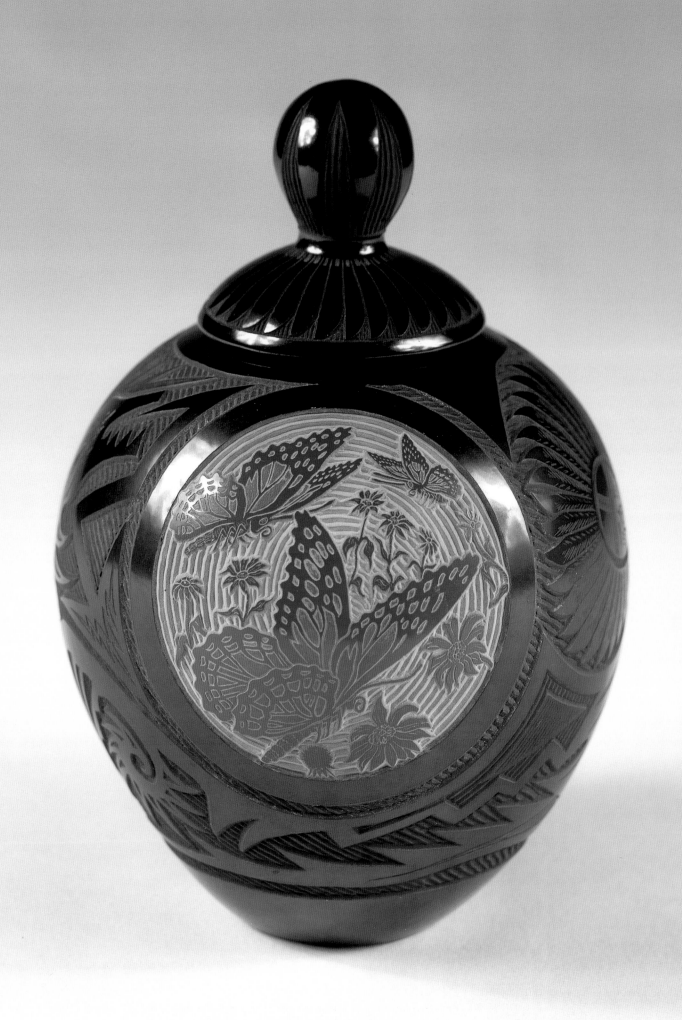

Joseph Lonewolf

RON McCOY

Joseph Lonewolf, a gifted man possessed of powerful creative impulses, embodies an artistic precept intrinsic to the finest pueblo pottery. He is one of those major figures who seeks significant sources of inspiration, by both embracing the past and refining its ethos into a sort of artistic expression never seen before. In so doing, he negotiates that difficult passage between understanding an ancestral aesthetic and establishing an entirely new style.

As a nephew of Margaret Tafoya, son of Camilio Tafoya (one of Santa Clara's first male potters), and brother of Grace Medicine Flower, Joseph Lonewolf's birthright includes membership in Santa Clara's most consistently brilliant pottery-making family. Both his father Camilio and his mother, Agapita Silva Tafoya, earned reputations as accomplished potters. Other members of the Tafoya family — particularly Camilio's sister Margaret and their mother Sarafina — have been hailed as creators of original and beautiful bodies of work.

Around the turn of the century, Lonewolf's grandmother Sarafina Tafoya showed such talent in creating wares of consistent excellence that the attention of connoisseurs from the Anglo world focused intently on Santa Clara Pueblo. This stimulated the village artists' inner growth, for creativity and taste were now greeted with tangible rewards and persistent encouragement. As a result, a favorable climate for artistic growth was well established by the time of Lonewolf's birth in 1932, and the pueblo continues to be regarded as something of a regional center for the creation of artful pottery.

This striving for excellence by a number of talented Santa Clarans has led to many artistic innovations. Before the turn of the century, for example, Santa Clara pottery was typically globular in form, although a certain fluidity was nevertheless evident in the curves and decorations of oblique ridges, spirals, and scalloped rims found on some pieces. But in the early twentieth century, Lonewolf's grandmother Sarafina and his aunt Margaret introduced new standards of sculptural elegance in form, finish, and imagery, with works that impacted forcefully upon Santa Clara's ceramic tradition. A half-century later, another shift occurred when Joseph, his father Camilio, and sister Grace Medicine Flower introduced their stunningly detailed "sgraffito" etching on the pottery's highly polished, lustrous surfaces.

Although his family's involvement with pottery obviously influenced Lonewolf, even a cursory survey of his work clearly demonstrates that his renown does not rest upon lineage. For membership in a creative clan to be more than a matter of name, Lonewolf has had to fashion distinctive reflections of his own unique vision.

During his youth, Lonewolf harbored strong yet diverse artistic instincts and ambitions, and thus learned about beadwork, drawing, painting, woodworking, and pottery. This

47. Framed in a circular medallion, this butterfly motif is one of Lonewolf's interpretations of the Mimbres sensitivity to nature. Celebrations of nature rendered with precision of technique typify Joseph Lonewolf's work.

somewhat unfocused approach ended after a back injury prevented him from resuming his trade as a journeyman machinist. In 1971, at the age of thirty-eight, Lonewolf found himself turning with compelling curiosity and a sure sense of artistic commitment to the Clay Mother.

The Clay Mother is an age-old figure in the pueblo pantheon. Venerated since prehistoric times, she personifies the spirit of the living clay from which potters draw the material for making their wares. With the Clay Mother's cooperation, potters know much is possible. But if she is in any way offended, or dissatisfied with potters or their work, no good can come of it: a piece falls apart while being formed, cracks while drying, or shatters into oblivion in the fire. Thus the potter's art, as Joseph Lonewolf learned it at Santa Clara, does not represent a triumph of individual genius, but — like pueblo life itself — a cooperative effort, and a decidedly unequal partnership between the supplicating potter and the powerful Clay Mother.

"I believe the clay is a living thing because it comes from Mother Earth, a living thing," Lonewolf once said, expressing his understanding of this delicate relationship. "I talk to her, pray to her, before I take clay from her. And I believe the clay I remove is a living thing itself and has feelings. I hurt the clay's feelings when I talk of a pot that hasn't been done yet; the clay talks back by cracking or breaking. So I have learned to respect its feelings and never talk of a pot until it is completed, until it can speak for itself."

Lonewolf's allegiance to such traditional concepts as the Clay Mother is manifested in his work, the visible result of his intimate and demanding relationship with the spirit he sees as the controlling factor in his efforts. Yet his work is also the product of diverse, seemingly antithetical elements as well. Lonewolf's pottery is at once highly contemporary yet infused with the mystery and aesthetics of his predecessors along the continuum of this pueblo art form. The most notable contribution to Lone-

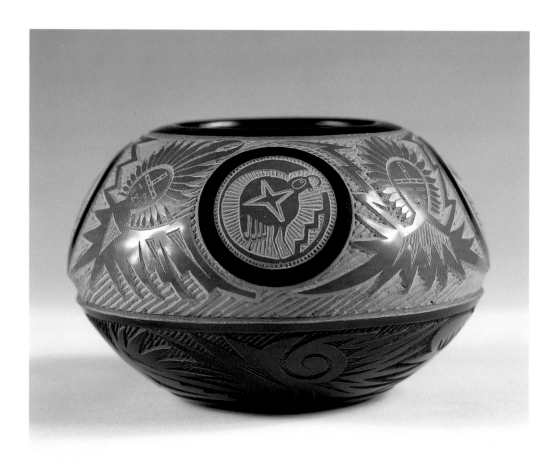

wolf's imagery comes from the anonymous geniuses of the ancient Mimbres culture.

The Mimbres, a prehistoric pueblo-type people, lived in villages, tended fields, gathered seeds, and hunted in the area embracing southwestern New Mexico, southeastern Arizona, and northern Mexico. The height of their artistry in ceramics came during the culture's Classic period, a relatively brief phase from roughly A.D. 950 to 1150. The Mimbres are known for exquisite bowls — hemispheric vessels decorated with intricate black-on-white geometric designs or with fascinating pictorial scenes. These picture bowls are often narrative in concept, depicting animals, people, and mythological creatures in intriguing combinations, participating in scenes whose meaning will never be fully understood. These painted designs of people, wildlife, and geometric shapes on the white surfaces of thousand-year-old bowls still exert a pull on most of us. With good reason, many scholars consider Mimbres pot-

48. This piece is instantly recognizable as contemporary, yet the Mimbres quail—here rendered true to the ancient style—reminds us of the abiding influence of the ancients.

tery one of the finest achievements of the Native American ceramic tradition.

Joseph Lonewolf makes no secret about the irresistible pull Mimbres pottery exerts on him, and he has studied it extensively. Indeed, he sees himself as the recipient, the inheritor of Mimbres ideas — as someone from the present whose inclinations are such that he is capable of reinterpreting the Mimbres dreams of so long ago. Many collectors whose own sensibilities allow them to feel immersed in the ethereal visions of the vanished Mimbres culture agree that Lonewolf displays an uncanny sensitivity to the period.

For years, Lonewolf's favored designs have included naturalistic hummingbirds feeding on flowers' nectar; butterflies; rabbits highlighted in frame-like cameos; antelope, mountain sheep, and deer rendered with the same geometric lines which inspired Mimbres potters. The universe molded by Lonewolf and the Clay Mother is filled with other creatures of the mountains — the eagle, turkey, and bear — and populated also by creatures of the desert — the roadrunner, lizard, and scorpion. It brims, as well, with creatures of the water — fish, turtle, frog, and dragonfly. Some of these beings appear alone, in solitary grandeur, while others are grouped in scenes like tableaux that occur only when humans are not present to disturb the communion of nature.

From every point of examination, Lonewolf's wares command appreciation. The form of each vessel is fluid, and the pieces are slipped to fire into bursts of orange, red, yellow, blue, green, purple, sienna, even an unlikely iridescent gray. Each is meticulously carved and incised, then expertly polished. Lonewolf often travels as far as Colorado in search of the proper clays for making his colorful slips and spends as much as two or three years working on a single piece as he strives for his self-imposed standard of perfection.

Joseph Lonewolf's ability to reflect his abiding celebration of the world around him imbues his work with a compelling magic. Small wonder that the word "jewel" often springs to the minds of those viewing it, whether for the first time or after long familiarity. Indeed, Lonewolf's pottery reminds one of a prism through which we rejoice in the separate appealing parts of nature's inspiring whole.

In an historical sense, Joseph Lonewolf looms large in the world of pueblo pottery because he embodies both its revolutionary and evolutionary tendencies. In Native American art, love of tradition — such as Lonewolf's for the Mimbres culture's ways — does not require endless duplication of previous generations' accomplishments. Instead, Lonewolf succeeds as an innovator by combining a mastery of technique with the breadth of artistic vision to redefine the past. Molding the universe as he sees it, Joseph Lonewolf helps define the artistic present while offering new challenges to the future.

49. Polished and matte finishes, as well as different depths of incising, create the variety of surfaces in this piece with Mimbres style ram.

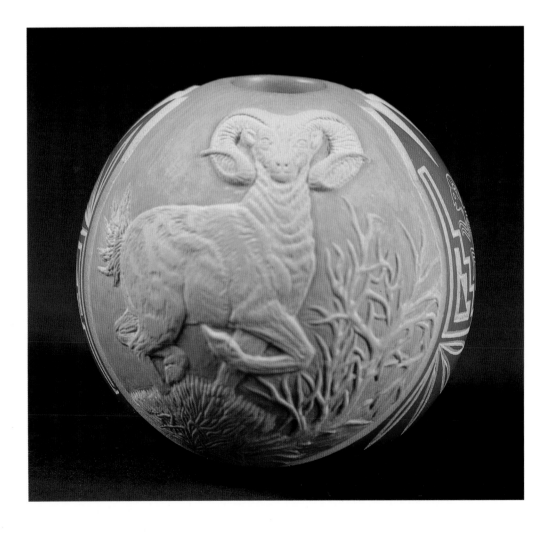

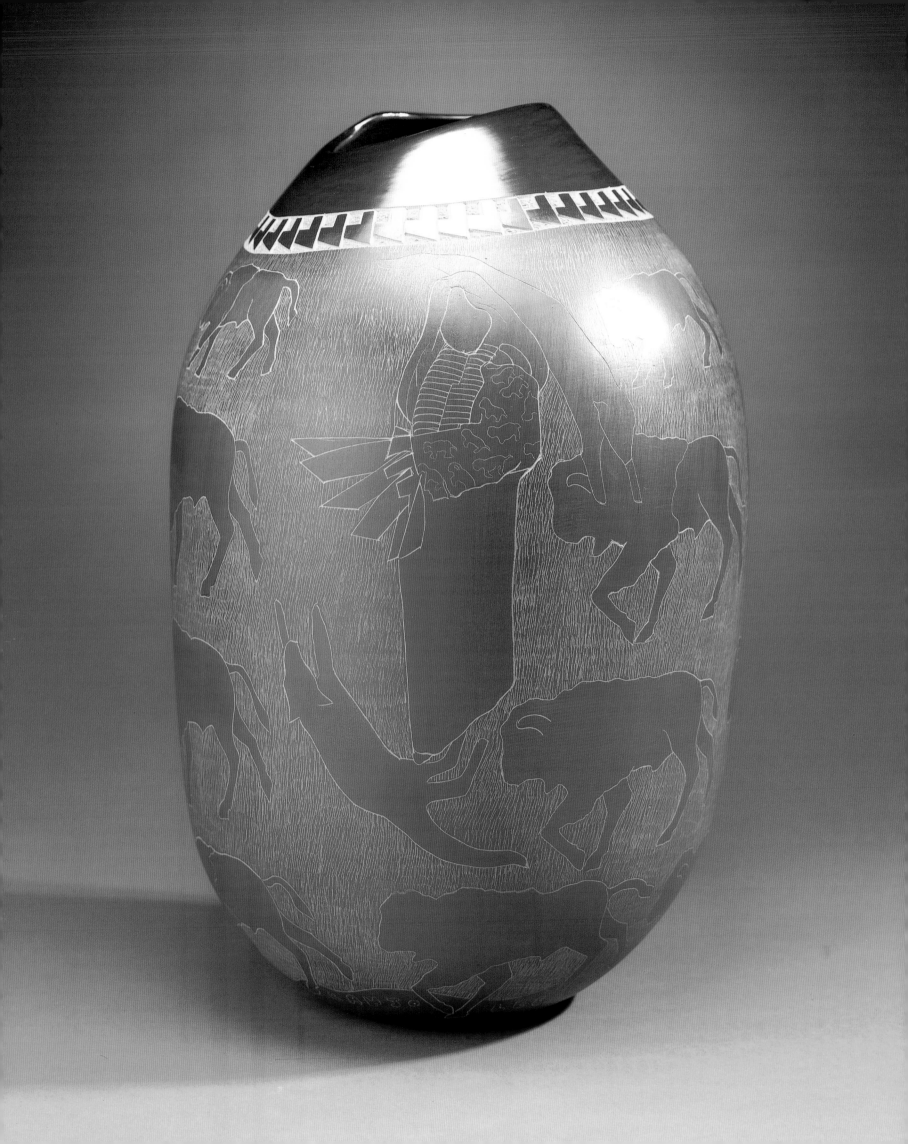

Jody Folwell

ADELE COHEN

Imagine, if you can, strolling through the Plaza in Santa Fe during Indian Market weekend of 1975 and reaching the point of overload. After hours of mingling, making your way through the crowds that are pushing up to hundreds of artists' booths to see the work, you might by this time have difficulty focusing on individual pieces, and your attention may have become fuzzy.

For years, tourists have been coming to Santa Fe in August to see and buy pottery of the Indian artists who have been working since winter to create as many pieces as possible. These artists are the raison d'être of the highly successful annual Market — held since 1922 — and they work hard to create pieces fine enough to enter in competitions that could enhance their reputations. A few blue ribbons can send the desirability of an artist's work soaring.

This year, 1975, sitting in her booth, Jody Folwell had before her several pieces of pottery that would catch the eye of even the most weary, over-stimulated Indian Market regular. The reason that her work stood out so easily from the hundred or more pottery booths was that it differed greatly from all the pueblo pottery usually seen at Indian Market. At that time most all the potters were repeating themselves and each other, and although they had developed superb technical skills to create beautiful pieces in a tried-and-true style, there was no major effort toward innovation. When most

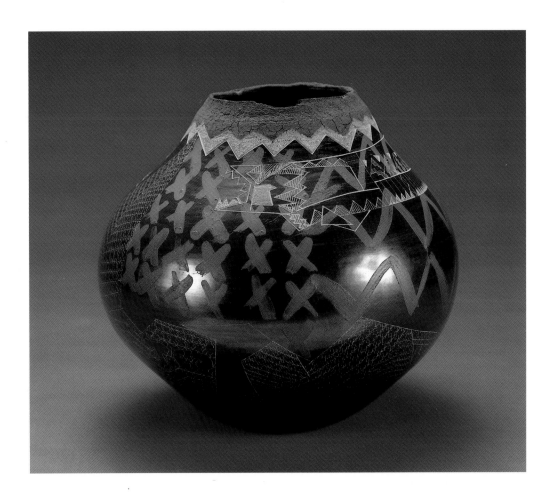

everything seems like more of the same, after a while nothing holds the eye except the excitement of something very different.

At this time, there were no prize ribbons for Jody because she would not enter any of her work for judging. To her way of thinking, it made no sense to submit her work to be judged by people who did not understand or appreciate what she was doing. The criteria for judging traditional pottery were shape, polish, and design — and one of the most important elements of shape

50. (Opposite) In this piece Folwell compares the extermination of the buffalo with the mistreatment of the pueblo's dog population. The artist, an activist in animal rescue, is a savior of sorts for the abandoned and mistreated animals of the village.

51. This elaborately worked jar shows Jody Folwell's experimentation with abstraction, compositional movement and surface texture. Lest a viewer forget the original nature of the clay, Folwell allowed the lip of this jar to crackle randomly in the fire.

was the symmetry of the overall piece. Jody was determined to show us that asymmetry could be beautiful and even more exciting to the senses.

Because of her experimentation with different slips and firing techniques, her polished pieces took on different colors and shades and textures within the same ceramic. Because of her abstractions in design and different surface treatments, the overall appearance of the finished pot was like nothing seen before in Indian ceramics. In the early years of showing her work, Jody was not supported with much positive feedback. Most of her peers as well as dealers of Indian pottery were telling her not to do what she was doing. She often heard: "Don't expect to sell something so different. Just do it the way it's been done — that's what the buyers expect and understand and purchase."

But Jody was not made to be a copier. Her experiences and personality made her see things in a different way than was prevalant in her culture at the time. Although she still had a spiritual respect for the traditional way that the clay should be used, her aesthetics regarding the appearance of the finished piece had no limitations.

Jody was born in August 1942 at Santa Clara Pueblo to Michael and Rose Naranjo. After she finished elementary school, her father moved the family to Taos Pueblo to take a new assignment in the ministry. Jody graduated from Taos High School and attended the College of Santa Fe, where she majored in history and political science. In 1961 she married Henry Folwell, an artist, and soon settled into raising a family of three children. They were living at Santa Clara, where Jody was teaching kindergarten and working as a counselor for the Equal Employment Opportunity Commision (EEOC).

Since her mother and many neighbors were potters, Jody had been brought up with everyday exposure to the traditions of clay. She had worked at pottery from time to time, but now that she was raising three children, she thought she would be better off with a career she could pursue at home, instead of being out teaching school. Pottery was a natural pursuit to someone born and raised in the pueblos of New Mexico, for the process of preparing the indigenous clay for pottery making had been absorbed in childhood — by observing what was going on around her and beginning to imitate what she saw. But that is as far as Jody would go with imitation.

She had been married to Henry Folwell for over ten years before she began to think seriously about creating pottery as a full-time occupation. Those years of her marriage were very influential on how Jody would approach the aesthestics of her medium, for when you live with an artist, you cannot help but expand the ways you see things. Seeing art being created in her home on a daily basis definitely influenced how Jody approached the shapes of her pots and the designs she would apply to the surface. She learned also how unexpected colors could be developed by experimenting with slips and firing materials.

Mix these influences with her majors in history and political science and her work with the EEOC, along with the insatiable curiousity and strong sense of justice that are parts of her personality, and you begin to understand what motivates and inspires Jody to create as she does. Most of her major works make statements — sometimes very seriously motivated by anger over injustices and deceptions, and other times amused comments on the foibles of present-day society. Experiences that grow out of relationships, whether they be family, personal, or business-related, also provide her with food for thought. In the process of working out these relationships sometimes a magnificent ceramic is born. When you have admired and acquired pottery by Jody Folwell, you become touched by her experiences and moved by the beautiful and sensitive way in which she tells her story.

For those who have become interested in contemporary pueblo ceramics, the importance

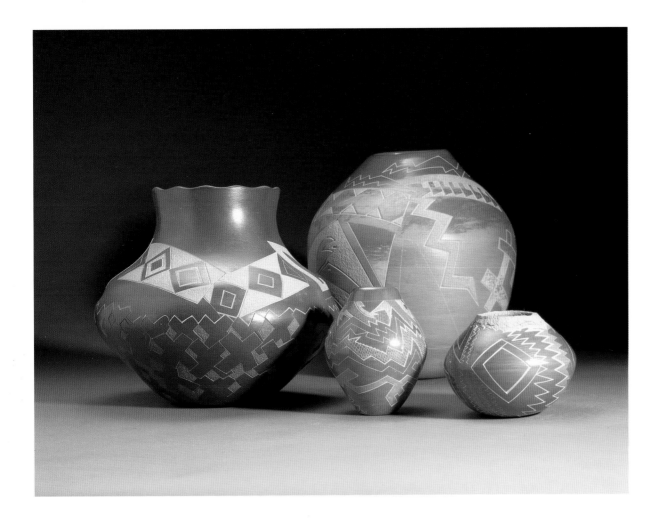

of Jody's innovative success is now a matter of record. She was finally convinced by some enthusiasts who loved and appreciated what she was trying to do to enter her work in juried shows in order to achieve the recognition her originality deserves. Much to her amazement, when she finally entered a competitive show for the first time — the Heard Museum Guild show of 1979 — she won first place in contemporary pottery. The *Arizona Republic*, when interviewing the director of the Heard about the 1979 Guild show, reported his excitement over what he saw to be the wave of the future in Indian ceramics. That prize-winning piece was purchased by the Heard Museum for its permanent collection, and the award let Jody know that there were finally people who understood and would enthusiastically support what she was doing.

No longer afraid of rejection, Jody began winning awards in all the competitions she entered. Best of Show, the grand prize at Indian Market in 1985, was an especially important

achievement after many first-place awards in the contemporary pottery division. Her work is now in major museum collections, and she has been an important influence on many potters who have benefited from her innovations and her perseverance in breaking down the barriers she faced in the early 1970s.

One of Jody's own favorite pieces can be seen in the most important pottery exhibition that has been organized so far by the Museum of Indian Art and Culture in Santa Fe — "From This Earth: Pottery of the Southwest," which opened in the summer of 1990. The mischievous sense of humor in this large brown-black ceramic jar, which is titled "Roober Stampede," is an attempt on her part to provoke all those who have resisted change and continue to rubber-stamp their lives and their work. The tall vase-shaped piece is polished at the top with horses carved into the surface in very creatively drawn images. The remainder of the pot is unpolished and totally covered with black ink-

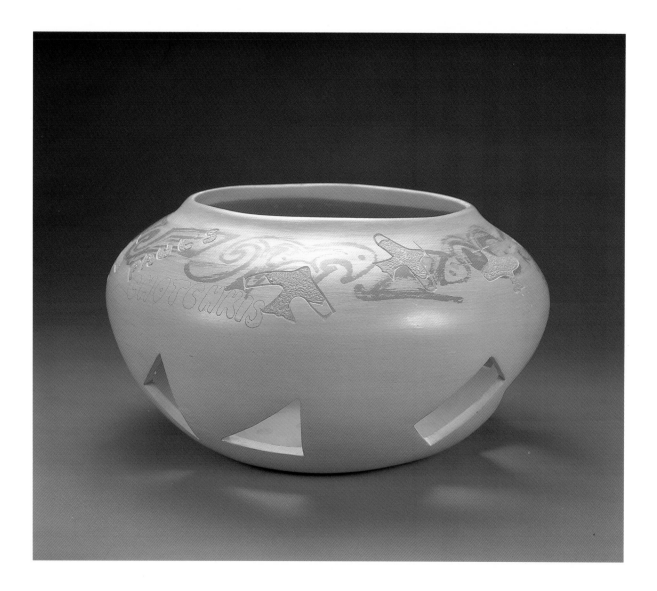

53. Paul's Tchotchkis was born of the artist's longing to see her son, who was in the Air Force overseas. Tchotchkis, a Yiddish word often used by one of Folwell's most avid collectors, refers to the incised collage of toys — from Paul's infant shape-sorter to the big-boy toys of war.

stamped horses all identically created from a rubber stamp. With tongue in cheek, Jody has given the public what it thinks it wants, and with humor and skill has created a magnificent ceramic.

When you wander through the Plaza during Indian Market weekend now, nearly twenty years later, the changes in Indian ceramics after Jody's inspired innovation are obvious to the experienced pottery viewer. As time goes by, Jody will be regarded as the initiator of a new tradition. It will certainly be exciting to see what new innovations her work draws forth from other artists, for Jody's courageous deviations from the traditions of her time will give inspiration to the talents of the future.

54. (Opposite) With its strength of incising and bold abstract treatment of traditional design elements (such as the avanyu), this jar was considered radically avant-garde when first exhibited. Its raw power offers a contrast to the delicacy of some of Jody's other works.

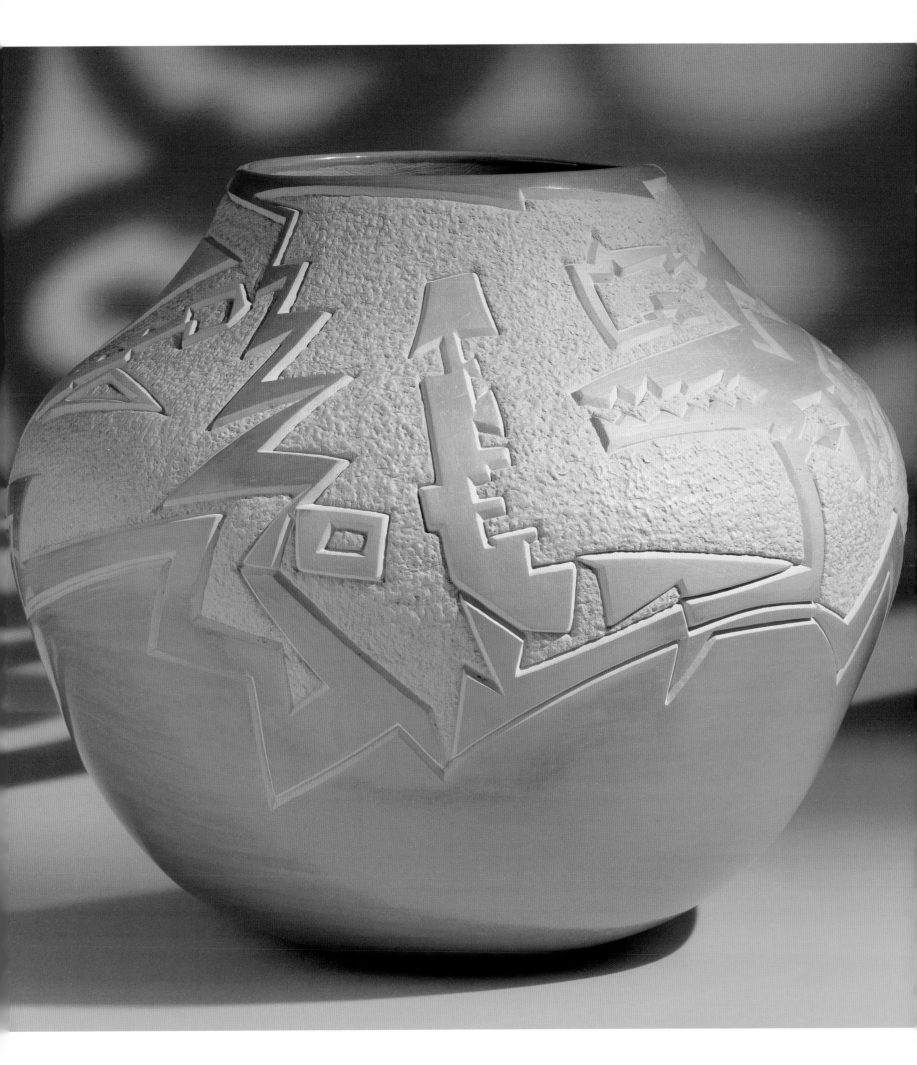

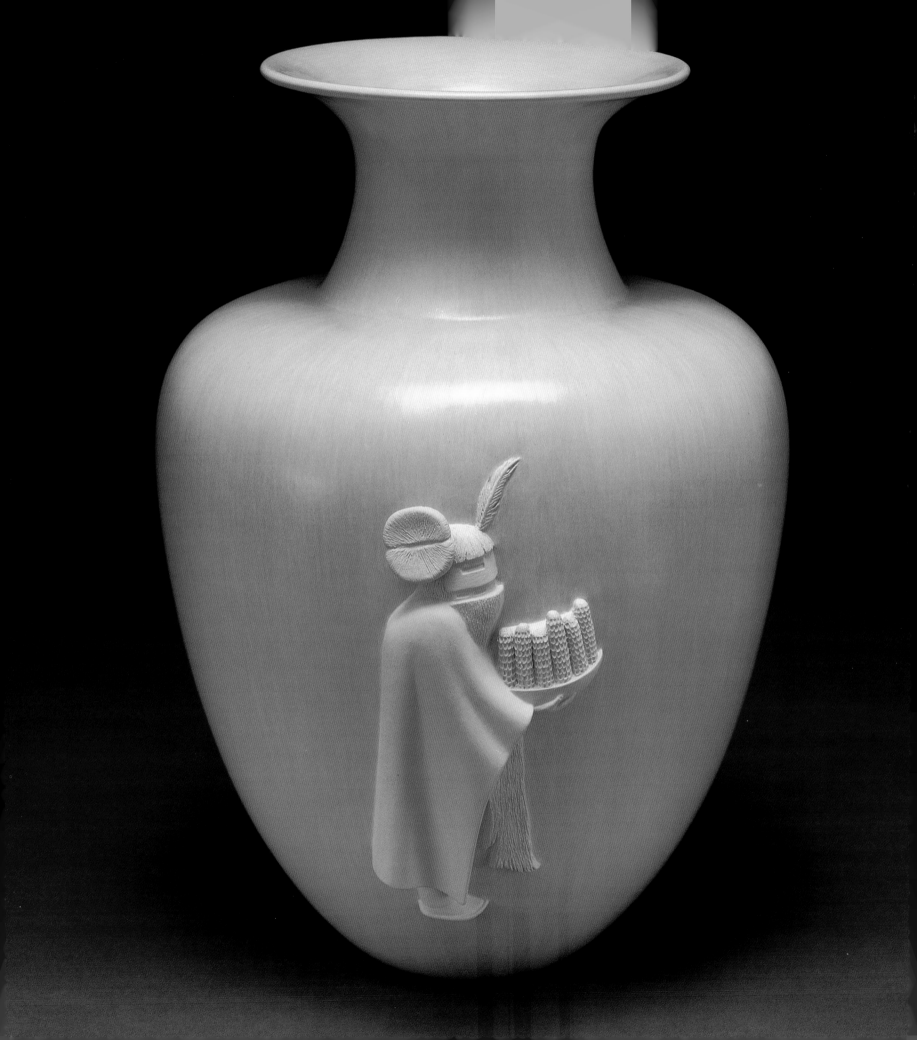

Al Qöyawayma

RON McCOY

Nothing quite like Al Qöyawayma's pottery has ever existed before, though his work could not possibly assume its sublime form without the artist's profound appreciation for the ways of his Hopi ancestors. This is actually a paradox, in which two apparently contradictory points both emerge as true.

This paradox is perfectly attuned to the life and ways of the artist himself. For Qöyawayma (pronounced ko-YA-wy-mah), whose Hopi name means Gray Fox Walking at Dawn, is a thoroughly modern man, equally at ease in the high-tech and tribal worlds. He creates clearly contemporary wares which perfectly mesh with a deep appreciation of the tradition of classical elegance Qöyawayma so clearly reveres.

Like all the artists who labor within the milieu of the Southwest's ancient pottery-making tradition, Al Qöyawayma owes an enormous creative debt to those who preceded him. Among them was Qöyawayma's own aunt, the late Polingaysi Qöyawayma, better known as Elizabeth White. A diversified talent — potter, educator, writer — it was she who first introduced Al Qöyawayma to the possibilities presented by working within the world of pottery.

That realm of experience is reserved for those who mold clay with their hands and transform the seemingly mundane into objects worthy of high regard. It is nothing less than a portable universe which an artist may enter, secure its essence within his mind, and continue on to

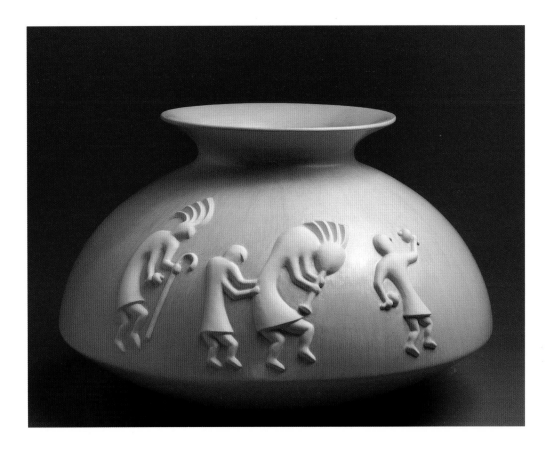

whatever places life may take him — just as well, particularly for Al Qöyawayma, whose life includes some rather unexpected roles and locales.

Born in 1938, Qöyawayma did not grow up in a Hopi village, surrounded by kivas, cornfields, and dancing kachinas. Instead, he was born and raised in Los Angeles, far from the Hopis' mesatop settlements in northeastern Arizona. His parents had left the reservation in the 1930s, in the days when the federal government tried to shatter tribal identity by sending Indian youths to boarding schools far from ancestral homelands. Although residents of

55. (Opposite) Qöyawayma's aunt, Elizabeth White, always encouraged him to take the best from other cultures while utilizing the best of his own. This jar, shaped like a Greek urn, is decorated in bas relief with the Hopi corn maiden.

56. An elegant form referred to as "Gila-shoulder" is inspired by the prehistoric Hohokam culture, and the humpbacked flute player is equally ancient in tribal lore.

what Hopis called "the land of oranges," Qöyawayma and his family regularly visited relatives in Arizona. Thus the umbilicus connecting Qöyawayma to his inherent Hopiness was never completely severed.

Qöyawayma's father worked as a painter for Walt Disney Productions, and two uncles, Homer and Matthew Cooyama (a shortened version of Qöyawayma), demonstrated accomplishment in oils and water colors. It was his aunt, Elizabeth White (Polingaysi), however, who provided him with what Qöyawayma refers to as unifying or guiding principles. "We do not walk alone," she once told him, putting words to the first of the three principles. "Great Being walks beside us. Know this and be grateful." Another element of his outlook follows Polingaysi's writings: "Your foundation is in your parents and your home, as well as in your Hopi culture pattern. Evaluate the best there is in your own culture and hang onto it, for it will always be foremost in your life; but do not fail to take also the best from other cultures to blend with what you already have."

Although he worked with ceramics in junior-high school, it would be many years before Al Qöyawayma turned his full attention to the potter's art. Instead, he focused on a field sanctioned by the surrounding Anglo culture in which he was immersed. Possessed of a keenly analytical mind — one dedicated to understanding the underlying structures of things through complex analytical exercises — Qöyawayma enrolled in California State Polytechnical University. After graduating in 1961 with a bachelor of science degree in mechanical engineering, he went to work for Litton Industries in Woodland Hills, California, where he helped develop high-tech inertial guidance systems and airborne star trackers.

Al went on to receive a masters degree in mechanical and control-systems engineering from the University of Southern California in 1966. Then, in 1971, he left California for an executive role with the Salt River Project, central Arizona's primary electric power and water utility. As Manager of Environmental Services, Qöyawayma assumed responsibility for preparing and evaluating environmental impact statements for the next eighteen years. His efforts were aided by studies at the Westinghouse International School of Environmental Management. A founder and the first chairman of the American Indian Science and Engineering Society (AISES), Qöyawayma helped establish chapters of the organization in numerous reservation high schools to offer significant encouragement to Indian youths interested in pursuing engineering careers.

Yet there is a good deal more to Al Qöyawayma than the Scottsdale home, corporate offices, suits, and ties. In reality, all of that lies in the external world, and while it is related to Qöyawayma's internal being, it could never stand as the sum of all his parts. Beneath that mainstream veneer lurks the soul of a man whose ties to the Hopi world remain strong, whose compelling need to express himself in an aesthetic arena would play an increasingly important role in his life.

More and more, Qöyawayma found himself devoting attention to the potter's art. As a youth, he often visited Elizabeth White at her Kykotsmovi (New Oraibi) home, in the heart of the Hopi country. There, he watched as she worked her own miracles with clay. Eventually, Qöyawayma made his own attempts at attaining some sort of relationship with Mother Earth's essence.

Like his forebears, Qöyawayma learned how to obtain clay from deposits at the foot of the mesas where Hopis have lived so long that they peg their entry into that country as taking place "at the beginning." He also repeated the age-old formula of mixing the clay with the strengthening temper of old shards. With luck, the tedium of mixing and kneading yielded "ideal clay," which Qöyawayma defines:

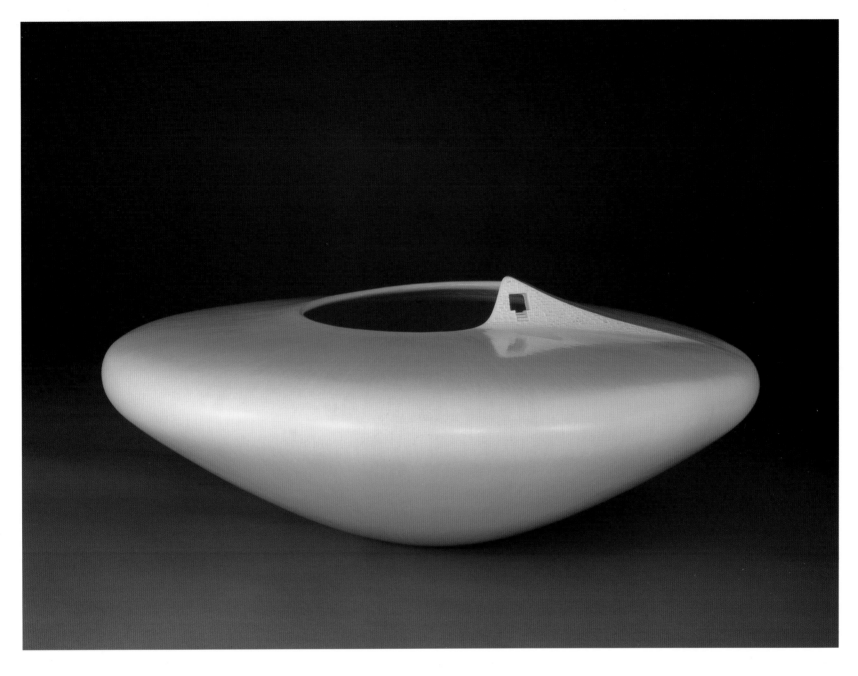

"You know it's ideal clay when you put it in place and it stays there. It won't slump or fall, and it strengthens easily." He also seeks clays that are low in shrinkage and have a wide range of workability.

Responding to Polingaysi's encouragement, Qöyawayma engaged in constant experimentation. He forms his vessels by the standard pueblo technique of coiling. His own practices diverged from the norm, however, when he set aside scraping in favor of pulling the clay like taffy — a process he sees as probably closer to the ancient Hopi potters' technique. Finally, when Qöyawayma was in his late twenties and working with Polingaysi, she paid him the supreme

compliment — an understated, "You've got it."

By the late 1970s, Qöyawayma's pieces appeared in public venues where they were immediately accorded critical acclaim. The reason for this lightning flash of interest in Qöyawayma's work is identical to the feelings which influence his admirers to this day. Both are rooted in the artist's immersion in a creative tradition of universal application.

Qöyawayma's pieces exhibit almost impossibly exquisite fluidity of form as well as a pristine, sculpturally perfect classical elegance. They transcend any particular, commonly worked category. In some ways, his work reflects the artist's engineering talents for

57. The slope of this vessel is inspired by the ancient Hopi at Sikyatki. The drama of this "flying saucer" results in part from stretching the technical limits of the form.

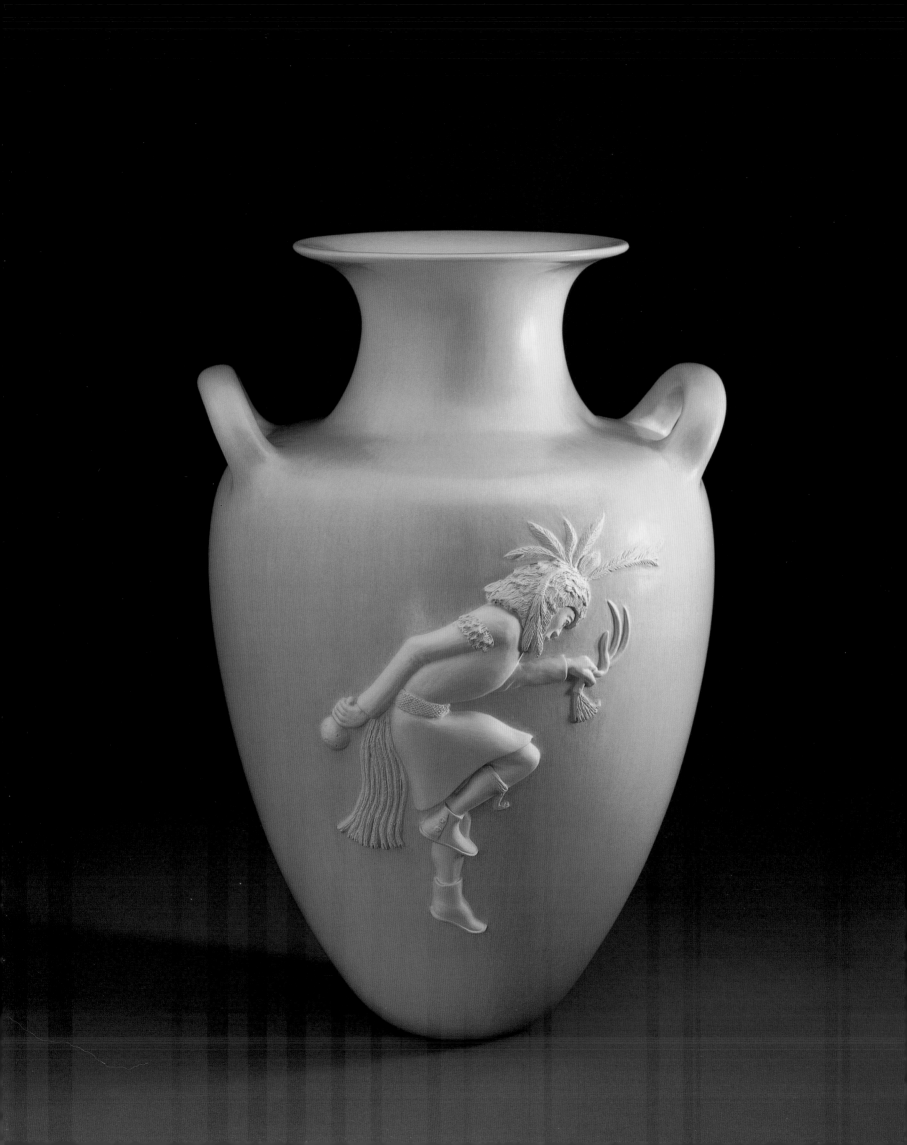

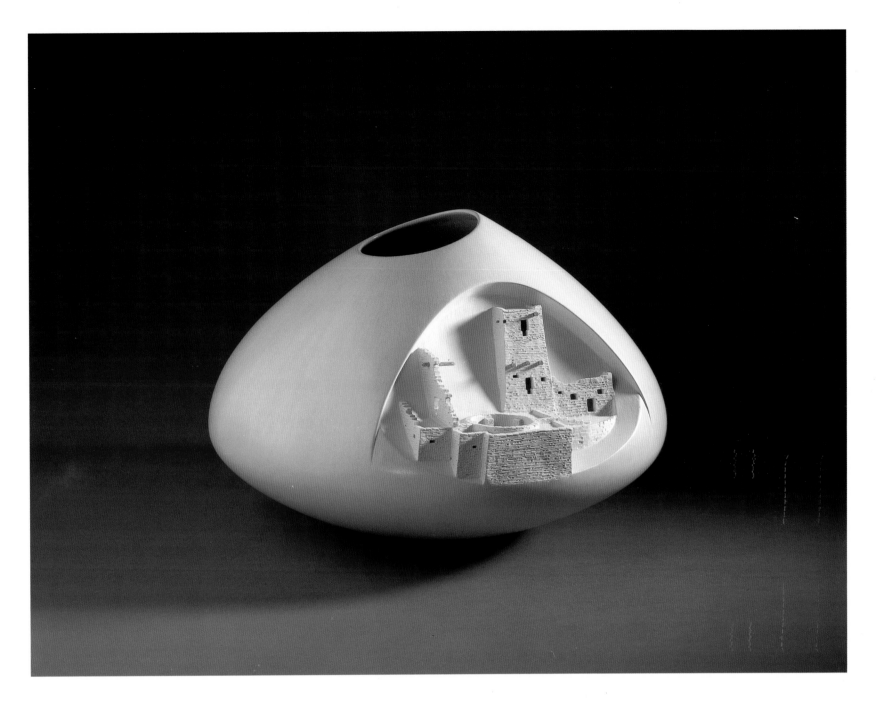

stretching materials across fundamental build-ing-block concepts. Somehow, almost unconsciously, Qöyawayma fashions walls so thin that they seem to have been taken a step beyond what is really possible. The proportions and relationships between the parts of his pieces are so obviously correct and in such clearly proper relationship to one another that the entire effect is one of sublime form. Had Al Qöyawayma decided somewhere along the course of his life to become a sculptor, he would undoubtedly have been a great one, for the sculptural elements of his pottery are an exercise in classic perfection.

Over the years, Qöyawayma's name has become synonymous with monochromatic wares decorated with bas-relief imagery created by pushing clay outward from the vessel's interior. The result is a collection of finely sculpted motifs, the designs' edges given a crisp sharpness by the artist's deftness with handmade wooden tools. Motifs associated with Qöyawayma's work include such ancient images as Kokopelli, the humpbacked flute player; ears of corn, the Hopi staff of life; and butterflies and dragonflies, long associated in the arid Southwest with the presence of water.

Although no exact comparisons exist, one

58. Qöyawayma feels that we all respond to universal forms and finishes that transcend regionalism. The smooth polished surface of this urn-shaped vessel is set off by the precisely carved image in relief.

59. The timelessness of Qöyawayma's work comes in part from combining ancient references with highly modern sculptural form. This low-shouldered shape is inspired by Arizona's ancient Hohokam ceramics, while the careful scale of the cliff dwellings keeps the piece in visual balance.

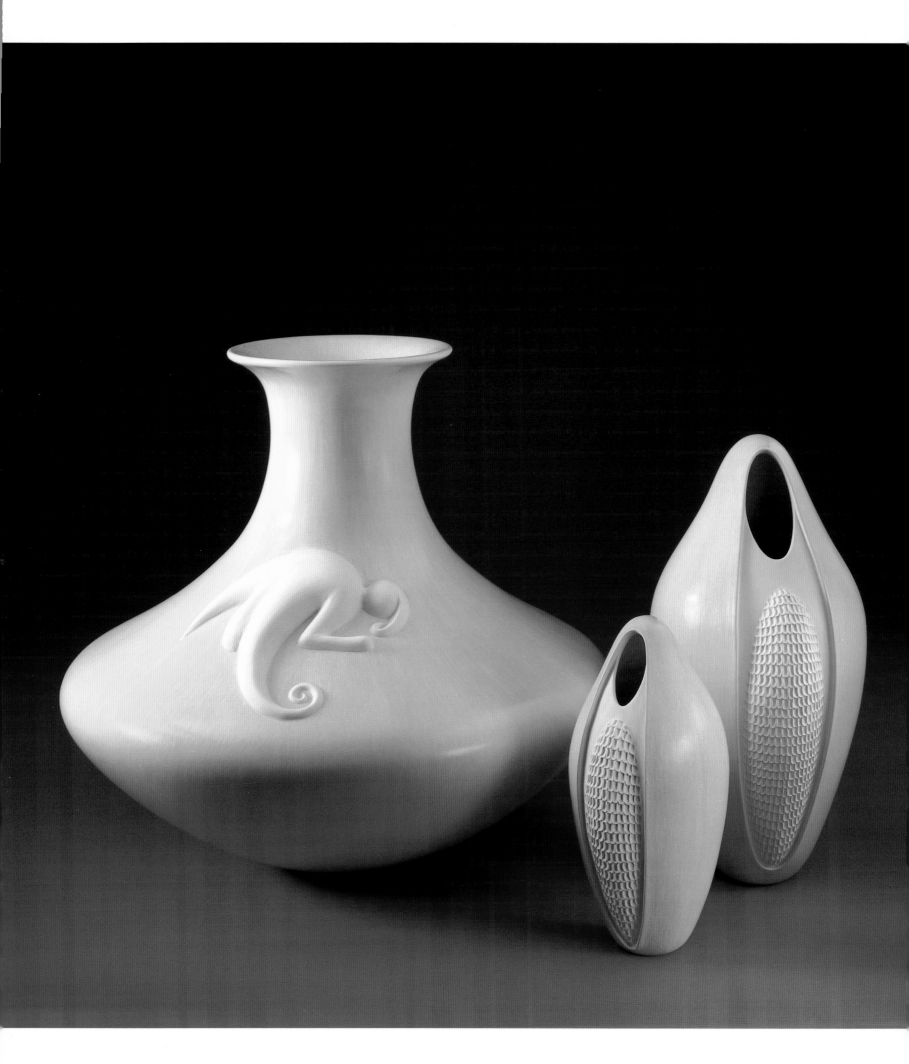

must travel far back in time to the days of prehistory to find anything even remotely like Qöyawayma's work. From about 1400 to 1600, the Sikyatki period — a name derived from the most famous of the villages in which the form flourished — Hopi potters attained what many knowledgeable students of the subject consider the zenith of premodern southwestern pottery.

It is not the exquisite painted designs on Sikyatki pottery that remind us of Qöywayma's efforts, but rather their supremely graceful form, truly classical in the timelessness of their appeal. Like Nampeyo (1860–1942), the pioneering Hopi-Tewa potter, Qöyawayma found inspiration in potsherds lying amidst the rubble and ruins of yesterday's villages. And, again like Nampeyo, he did not imitate the accomplishments of the past but expanded upon them with the unmistakable flair of his own fiery genius.

Qöyawayma, who sees the realization of his artistic vision as challenging as the most advanced courses he ever took in analytical mechanics or tensor analysis, remains acutely aware of his artistic links to the past. "There's history in pottery — it radiates the Creator's original intent," he once observed in characteristically thoughtful fashion. "Personalities show through. Potters have a commonality among ourselves that is almost unspoken. I have a little time machine. I just press a button and I can go back 1000 years. Take everything that I have today and let me go back — I wouldn't be out of place. There might be a bit of culture shock. But I don't think I would be lost."

Since 1982 Qöyawayma has served as one of the four principal scientific investigators for the Smithsonian Institution's efforts to identify the original clay sources relied upon by ancient Hopi potters at Sikyatki, Awatovi, and Jeddito. This endeavor features neutron activation and vector-analysis techniques coupled with ethnographic research and on-site inspection of clay deposits. In 1991 he journeyed to New

Zealand as the recipient of a prestigious Fulbright Fellowship awarded in connection with the TePokepoke Ukua Program designed to promote cultural exchange between American Indians and Maoris through the South Pacific Arts Commission.

"I have had the advantage of an education and gained a knowledge of the modern technical world," Qöyawayma reflects. "Yet I have found the challenge of the clay equal to any experience in that world. And as I meet the challenge of the clay, there comes peace and satisfaction which is not normally associated with meeting challenges in the modern world."

Although Al Qöyawayma may be seen to live with a foot planted firmly in two worlds, one rooted in that of the Hopi and the other positioned within the technologically oriented mass culture, he adroitly negotiates his way through a life in which each of those elements plays a critical role and neither assumes complete dominance. He is, at heart, a great artist who happens to be a Hopi — a fact of ethnicity that broadens and enriches the tradition of significantly innovative pottery in the Southwest.

Qöyawayma once wrote:

We, the potters, are respectful of our clay.
I know that some of this clay may even contain
the dust of my ancestors. . .so . . .
how respectful I must be.
And I think, perhaps, I, too, might become part
of a vessel, some day! What a thought. . .
to become useful again and to reflect the
Creator's beauty and love!

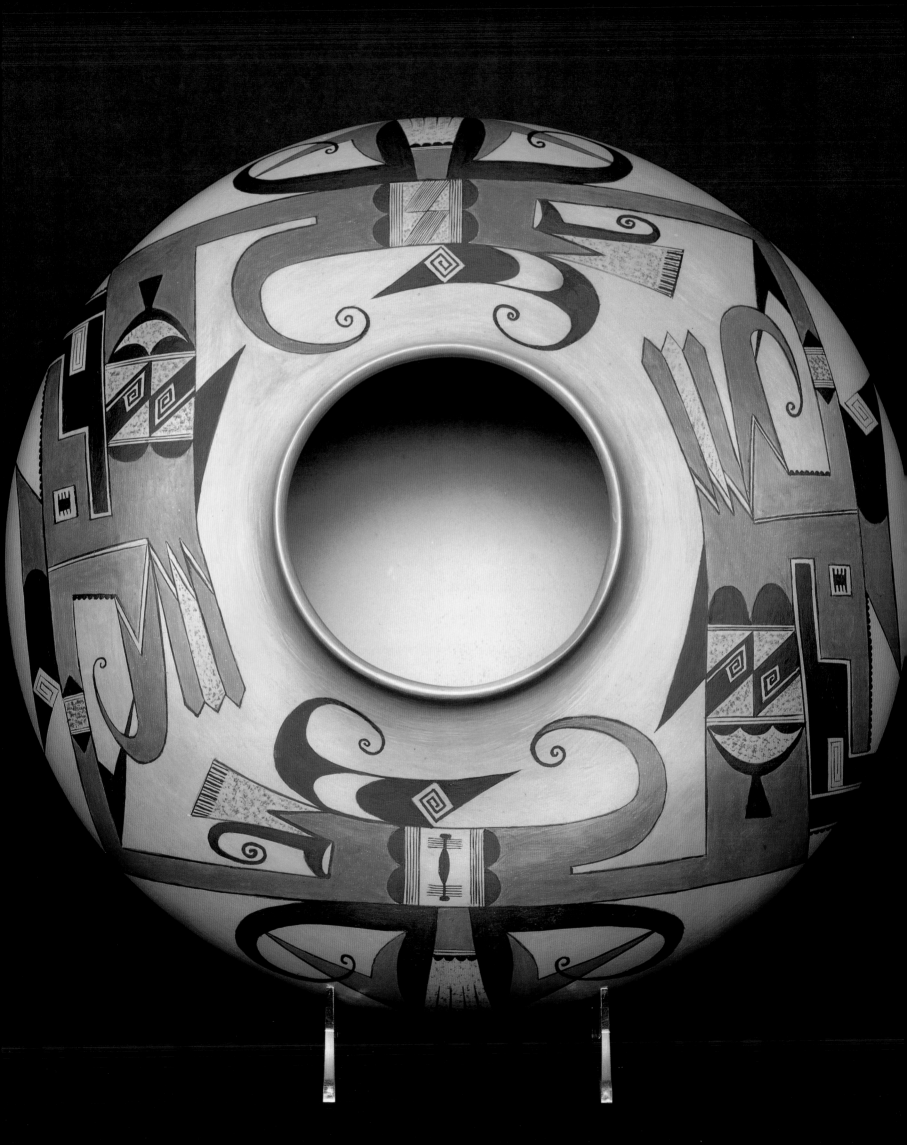

Dextra Quotskuyva Nampeyo

BARTON WRIGHT

Over one hundred years ago a single woman, Nampeyo, revitalized the flagging pottery tradition of the Hopi on First Mesa by producing new shapes and decorations. Her contribution to Hopi ceramics continues unabated to this day, not merely in her innovations but in the credo she instilled. A major part of Nampeyo's legacy became the line of descendants who developed into potters of merit. She wanted her children to be excellent potters and to carry on the tradition of fine pottery making that she had labored so long to perfect. The extent to which she succeeded is reflected in the achievements of her family.

The children of Nampeyo and Lesou were two boys and three girls. The oldest child, a boy, died during the flu epidemic of 1918. Her other son was Wesley, who with his wife Cecelia cared for Nampeyo during her final years. Despite the fact that Cecelia was her caretaker she never became a part of the Nampeyo decorative tradition but instead used the designs belonging to her own relatives.

It was to her three daughters that Nampeyo devoted her efforts to teach the finer points of pottery making and to urge them always to continue the craft. To them she also left the fabled "Nampeyo design book" filled with her carefully copied and distinctive decorations. Reputedly, Lesou obtained permission from the clan that had formerly occupied the ancient Sikyatki site for his wife to make and keep copies of her adaptations of the designs she took from the village, thus giving Nampeyo alone the right to use the designs. Strong feelings are aroused when any other families attempt to use the motifs believed to belong to Nampeyo through this circumstance.

In discussing any single potter in the family, one must take into consideration the fact that they all make use of this set of designs even though they are not limited by it. It is often difficult to know whether the individuals are simply skilled potters who are using someone else's creative efforts or whether the work reflects their own artistic talent.

The members of the family who have become potters and continue Nampeyo's tradition number slightly more than two dozen individuals spanning four generations. Nampeyo's daughter Fannie became a potter, and her five daughters and three sons have produced excellent pottery. Reputedly Fannie was the person who first recorded the designs for Nampeyo and handed them down to the rest of the family, although this has been disputed by other relatives. In any case, Fannie's work is more often taken for her mother's than is anyone else's.

Nampeyo's oldest daughter Annie, before her untimely death in 1968, bore three children, Daisy, Beatrice, and Rachel, and taught all of them to make good pottery in the traditional way. Rachel's four daughters, Priscilla Namingha, Elenor Lucas, Lillian Gonzales, and

61. The sophisticated, polished, contemporary look of Dextra Nampeyo's pottery is distinctive. This piece is a skillful adaptation of an ancient Sikyatki design.

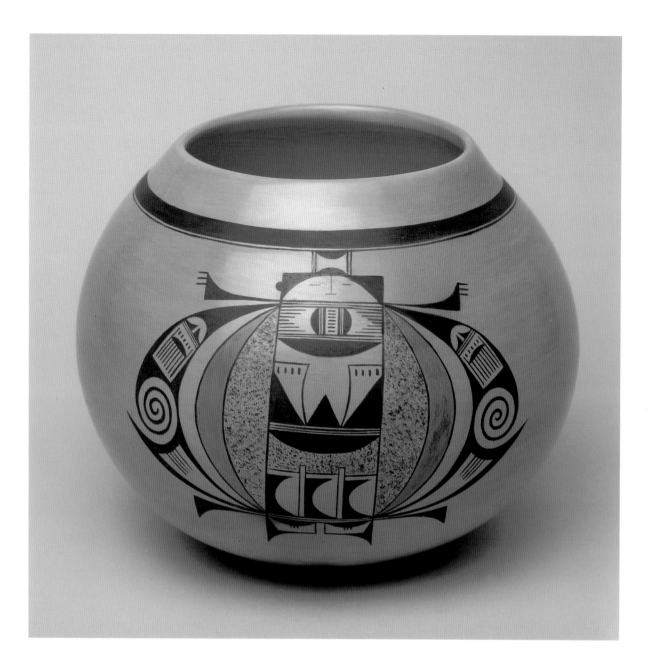

62. *Designs painted on a stark background are characteristic of Dextra's art. If at first this design appears only geometric, keep looking — a human figure emerges. The roundness of the overall design image complements the vessel's shape.*

Dextra Quotskuyva (born circa 1928) are all potters of great merit as are Priscilla's four girls and Dextra's daughter Camille. All of Nampeyo's descendants use her name in the manner of a hallmark.

Among this small group are individuals who have become master potters and have clung to the traditional styles, repeating given motifs such as the "migration pattern" until they have become more characteristic of themselves than of Nampeyo. There are the men who in recent years have abandoned tradition completely by engaging in what is considered to be a woman's craft among the Hopi, but who have developed their own styles of decoration. Their carved pottery takes inspiration from elements in Hopi

life but does not portray them in the manner of the women potters. Still others in this family, both men and women, have become technically excellent potters though their designs lack somewhat the spark of creativity. If there is a single potter within this group whose artistic talent can be considered as outstanding as that of Nampeyo, it is Dextra Quotskuyva.

She first tried her hand at pottery making around 1967, using her mother's clay. When Rachel became aware of her daughter's interest in working with clay, she encouraged her to mold a variety of vessel shapes. Because Dextra had always helped her mother with the difficult process of firing pottery, before long she was able to fire her own work. By the 1970s she was suffi-

ciently skilled to be producing notable pottery.

Even her early vessels sit squarely upon their bases and display the clean lines and symmetry of well-made pottery, indicating Dextra's mastery of the art of molding and shaping her clay. In these earlier years the shapes she produced were somewhat limited in variety, but they are characteristic of the forms being made by others of the extended family during the early 1970s. The designs she used to decorate her bowls and jars were the traditional ones that other members were utilizing in the same period.

It is interesting to note, however, that many of the designs she chose more closely resemble those favored by relatives other than her mother. This may be because Rachel more often than not selected a static design rather than an active one, whereas her daughter's preference appears to be the opposite. In particular Dextra's designs at this time are done in a manner most similar to the styles of Leah Garcia and Daisy Hooee (Nampeyo), with their use of open space and delicacy of line. The ever-present "migration pattern" so characteristic of Fannie Nampeyo appears often in Dextra's work, but it is notable for a finer and more precise use of cross-hatching and the incorporation of larger blank areas. Even when a curvilinear design is intentionally bold, Dextra creates a more graceful flow of forms. Dextra also develops the use of a wide but closed band of decoration around the circumference of a vessel. There are also occasional glimpses of her future design directions in an occasional bowl or jar made with a single motif such as a kachina head.

Like her great grandmother, Dextra mastered the technical aspects of building her jars and bowls and firing them fairly early in life. Then seemingly bored with the possibilities offered by available decorations, she began to look elsewhere for inspiration. In the 1970s she began to experiment with inlaying shells and turquoise in her pottery in the manner then fashionable at San Ildefonso. The results, how-

ever, were not particularly satisfying or pleasing to her and as her mother was not happy with the break in tradition either, she ceased to make this type of pottery.

Returning for a time to the older style, she continued to explore its possibilities. She is often quoted as saying, "I keep experimenting. I use a lot of my own designs, though I don't want to get away from the traditional." Some of the results of these experiments are seed jars so high-shouldered that they appear to be almost closed vases, completely spherical bowls with relatively small openings; low-shouldered jars with conical unlipped necks; and jars with double openings and expanding flanged lips. Among the multitude of shapes Dextra has made, most of the changes are a minimal rearranging of angles and curves to produce the pleasing results that are characteristic of her work.

The designs she used on this pottery are distinctive in their simplicity and precision of line as well as in the subtle choice of motif. Many of these elements are at first glance a geometric pattern, but a closer examination will show a highly stylized human face or some other facet of the world around her.

The quality of this work won her such acclaim that she was asked to demonstrate and address interested organizations across the country. Collectors have sought out her work, and numerous art galleries hold shows of her classical pottery. Possibly spurred by this recognition as well as driven by her own creative urge, she has continued to develop and explore new directions and inevitably has transcended the boundaries of tradition. Thus, despite her stated desire to continue making traditional pottery, in recent years her work has become almost completely contemporary. It is not a version of any pottery that is fashionable elsewhere but is uniquely her own.

Many artists have difficulty expressing their subjective standards for their own art, but Dextra's views on making ceramic art are clear and

she has little difficulty in stating them. "You must first pick up the basics of pottery making," she states, "and then really learn how to make your pots. Experience is the best teacher of all. All around us there are things to give us inspiration. There are people and things, nature, everywhere there is something to help you. Sometimes I use my dreams. I just see what I want to do in my dreams. I like to go off by myself and just meditate, just think and see what is around us."

What is around her is often difficult for a non-Hopi to comprehend. Life on the Hopi Reservation is not easy, and many times it is extremely difficult to "go off by yourself" or find the time to meditate. There is a constant procession of community, clan, and family affairs that must be attended to or participated in. The sources of supply for all but the most basic necessities are many scores of miles away, and many of the services taken so for granted by the outside world are nonexistent on the mesas. Yet this is where Dextra, the ceramic artist, is most at home and where she finds unending inspiration. As she says, "Arts, I think, are a blessing for us. It is given from our God and we are glad we are given that gift." It is a gift that fortunately she shares with us.

63. (Opposite) Never quite satisfied with repeating the family style, Dextra is always seeking new avenues. In her intricate "shard" pots, each segment portrays a different motif, like a puzzle shaped into a complex work of art.

Dora Tse Pé Peña

ADELE COHEN

Dora was born January 17, 1939 at Zia Pueblo, one of the seven Keres-speaking Pueblos, which explains why she still speaks that language fluently. Her mother, Candelaria Gachupin, and grandmother Rosalie Toribio were major early influences on Dora's development as an outstanding potter.

By the time she was six, Dora had been taught the sacred and spiritual significance of the clay, of Mother Earth, Father Sun, and of the life-giving water. Her mother and grandmother made sure that she understood the importance of these forces in creating pottery. The clay must be treated with respect, such that every phase, every step of pottery-making is done only after prayer and thanksgiving for the gifts of clay, water, fire, and artistic talent.

Since 1961 Dora, through marriage, has lived at San Ildefonso Pueblo. Nearly everything she learned growing up at Zia applies to life at San Ildefonso as well. Because pottery, both in clay type and in style, are somewhat different at the two Pueblos, Dora adapted with the help of her former mother-in-law Rose Gonzales. Rose was a well-known San Ildefonso potter who had introduced carved decoration there at a time when it was associated almost exclusively with neighboring Santa Clara.

During her marriage, Dora collaborated with her husband on some of the pottery that was created; but by the late 1970s when the marriage ended, Dora had begun to follow the more common practice in contemporary pottery of creating work on a solo basis. At first, Dora started out with strictly traditional forms. But after the first year, inspired by the late Popovi Da — potter, painter and jeweler — she experimented and developed some innovative techniques of her own. She now does two-color firings, combining black and sienna finishes in one piece, and inlays most of her pottery with turquoise, coral stones, or *heishi* (fine beads of turquoise or shell). She began decorating some pieces with a sparkly micaceous slip in the early 1980s. While the micaceous clay is not indiginous to San Ildefonso, veins of it can be found at Nambe and Taos Pueblos.

Dora's philosophy regarding creating ceramics and the place it takes in her life are simple yet profound. Summing up her feelings, she says: "Ceramic art to me is not only creating beauty for others to enjoy, but is very satisfying and therapeutic to the mind and soul. Clay has life, therefore I treat it with much reverence and respect. I feel much pride in making pottery in the primitive style. By gathering my own clay, forming my pots by the old coil method, and firing them outside on the ground, my feeling of harmony with my environment is sustained."

When working with clay, Dora speaks to the "spirits"— the spirits of her grandmothers and her aunt Trinidad Medina, for they too created ceramic beauty that many of us love and appreciate today. As the pots are formed and fired

64. Dora's instinct for integrating design with form is expressed here through the avanyu, *or mythical water serpent, which encircles the piece, moving diagonally to symbolize rain rushing through the arroyos of the desert.*

65. *Dora Tse Pé Peña's mastery of technique shines in this example of a bear-lid jar. The exacting standards to which she forms, carves, and polishes each jar are among the highest in contemporary ceramics. The use of the undulating body of a serpent is a central theme in her work.*

Dora embraces all the loving memories of her ancestors from whom she learned so much.

Dora considers her talent a gift given by her ancestors, who encouraged and nurtured her interests with a firm but loving hand. She now feels it is her obligation to pass this tradition on to her children. When asked what is of primary importance, she firmly says, "I feel that in transferring my knowledge and skills to my children I must be tough and demanding. We have to strive for more perfection today than our ancestors did in the past because today our goal is to create a work of art. The pottery made by our ancestors was basically for utilitarian purposes. Very early in my apprenticeship to my elders, I had a God-given instinct to put my hands inside a pot and feel if it has even walls and is symmetrical. I do not think I have as yet been able to pass this ability on to my children."

It gives Dora great pleasure to know that she has contributed to the appreciation of fine ceramic art. For more than twenty years, she has been receiving awards at all the major juried shows which Pueblo potters enter. She appreciates this recognition from both her peers and her collectors, and she is particularly active in museum workshops and gallery talks both in New Mexico and nationally.

In order to continue achieving the very high standards she has set for herself, Dora will not

66. *Balance occurs in nature, and so it is with harmoniously applied red and micaceous slips. The use of mica as a decorative addition is one of Dora's innovative contributions. The turquoise inset has become practically a trademark.*

take any shortcuts that might diminish the quality of her work. It may take her much longer to complete her work than it does most potters, because she cleans her clay more thoroughly and takes the time to layer on many applications of slip until the clay can absorb no more. Only the flat side of her polishing stone will create the perfect polish that will satisfy her. She strives for quality instead of quantity. The superb quality of her perfect shapes and polishing radiates from every piece that is signed on the bottom, Dora of San Ildefonso.

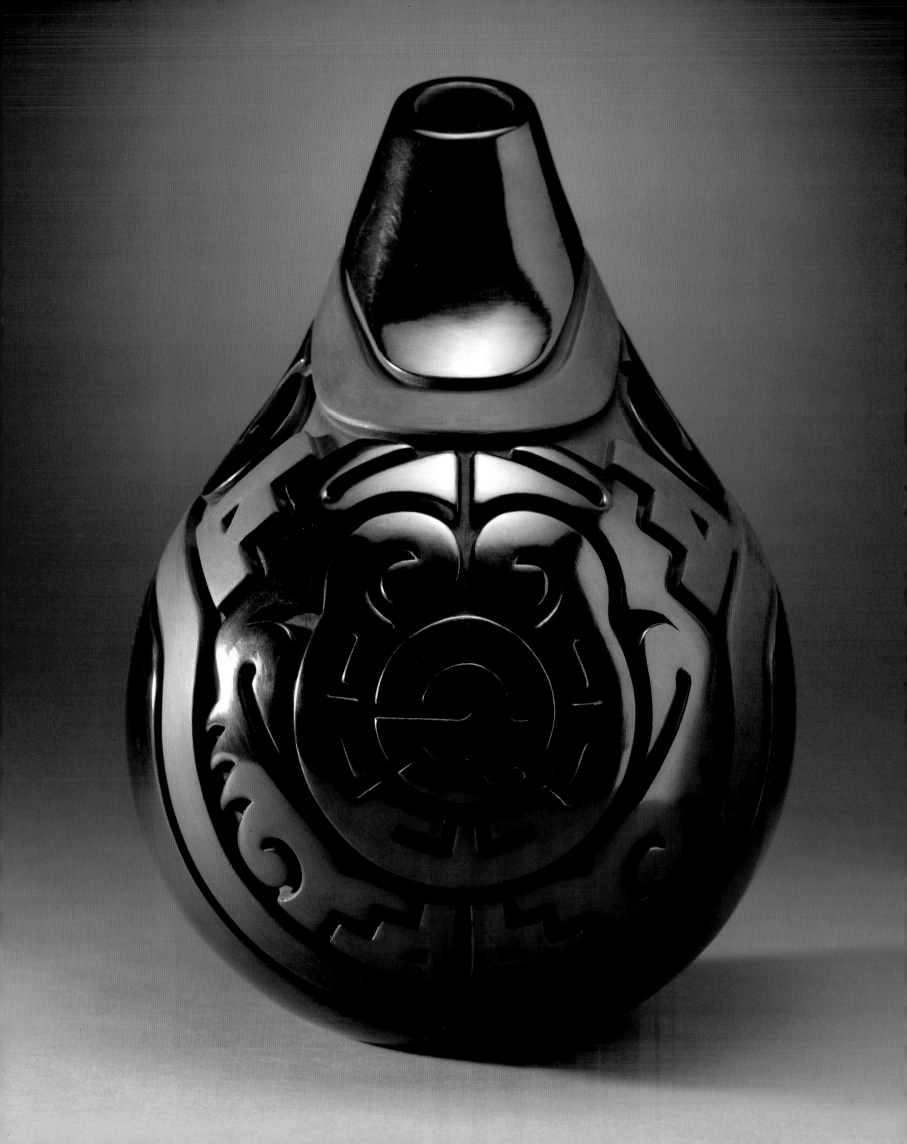

Nathan Youngblood

PHILLIP J. COHEN

It is difficult to fathom that anyone could, by bringing substantial refinement to an art form, add significantly to the growth of so rich a legacy as that of the pottery-making Tafoya family. But such is the case with Nathan Youngblood, grandson of Margaret Tafoya of Santa Clara Pueblo and son of the accomplished ceramist Mela Youngblood.

From an early age, Nathan has put himself in the path of diverse influences. He has always had the ability to see objects, assimilate their visual and emotional content, and use them to inform his own work. Here is an American who derives inspiration from Japanese art and expands upon it — a contemporary artist who saw the Forbes collection of Fabergé eggs in New York and thought, "How would this aesthetic translate into a storage jar?" This kind of assimilation and translation is his life's ambition.

Surprisingly, Nathan Youngblood did not grow up around pottery making. His father was in the army, and as a result of his regular restationing, the family lived away from the pueblo. Indeed his mother Mela, who was already an excellent potter, gave up her art during these years.

Nathan was born in 1954 in Colorado, where his father was stationed at Fort Carson. Walton Youngblood had met Mela Tafoya at a local hotel, and they married soon after. Nathan was about two weeks old when the family moved to Fort Lewis, Washington; it was San Diego after that, followed by other

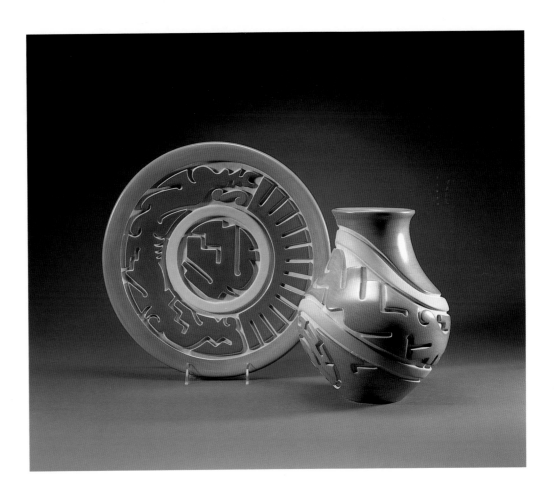

assignments in the United States and Europe. Nathan remembers that as a child moving from city to city he was fascinated with art and museums. Almost as if pre-ordained, he was already formulating ideas and images, preferences and insights based on the diverse works that caught his eye.

In 1968 the family moved back to Santa Clara, but without Walton. Nathan's father had fifteen months left on his army hitch and had to spend thirteen of them in Vietnam. Mela,

67. (Opposite) This large black carved jar illustrates Nathan's use of the form of the vessel as a basis for overall design. It also reflects his interest in Oriental carving.

68. In the plate on the left, Nathan takes advantage of the circular form to incorporate the curved body of the water serpent in tandem with a section of the puname, or feather circle. The jar at the right displays a strong diagonal movement accentuated by the two lines separating the major design fields.

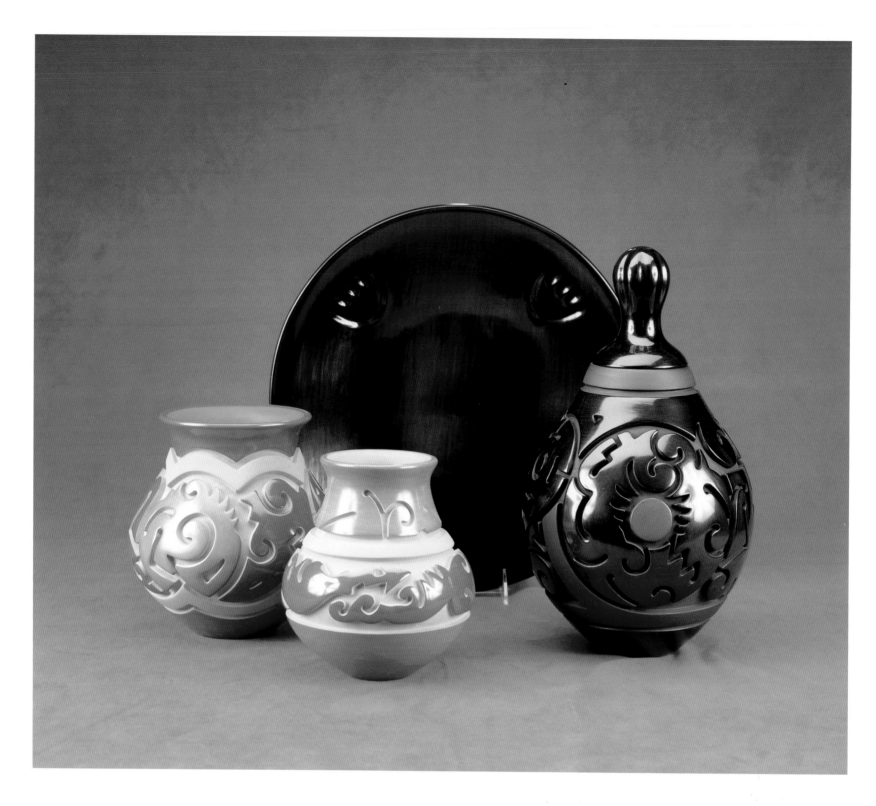

Nathan, and his younger sister Nancy began the reintegration into pueblo life.

At the age of fourteen, Nathan found himself at Santa Clara for one year in the midst of a family of exceptional potters. His grandmother lived down the street, and at home Mela had taken up potting again. Having returned safely from Vietnam, Walton was preparing to take the family to the Gallup Ceremonial in 1969. Nathan recalls, "Dad gave me $20 to make a pot. I won second place for that pot, as did my sister Nancy, who got the same $20 from Dad. I also won first place for a pipe that I made, and Joseph Lonewolf bought that pipe and still has it today." (Lonewolf, Mela's first cousin, is acclaimed for his delicately incised pottery miniatures.)

Nathan felt a magical spark ignite when he worked with the clay that brought his first children's award. "But," he said, "it wasn't until

69. *Each of these carved vessels exemplifies the complexity, mastery, and clarity of Nathan's carving technique. The plate in the background demonstrates a classic restraint in design, using only four "bear-paw" imprints evenly spaced.*

I was nineteen or twenty that I seriously started to make pottery. I moved in with Grandma [Margaret Tafoya] for two years and she encouraged me to start making bigger pots."

Nathan remembers long hours sitting across the table from his grandmother and mirroring what she was doing. As a result Nathan coils his pots in the reverse direction from Margaret. Possessing innate talent and being around the master helped his technique blossom rather quickly. His first efforts were simple, traditional works inspired by Margaret's close tute-

lage. It was not long, however, before Nathan was compelled to move on; "expanding the envelope" is a way of describing Nathan's constant driving inspiration.

The first development that represented a major challenge to his work came when Nathan sought to utilize the earlier "S" pattern melon jar forms, which were occasionally made in previous years at the pueblo. His grandfather, Alcario Tafoya, introduced him to the form, and Nathan skillfully developed and adapted it, guided by his unusual sensitivity to shape

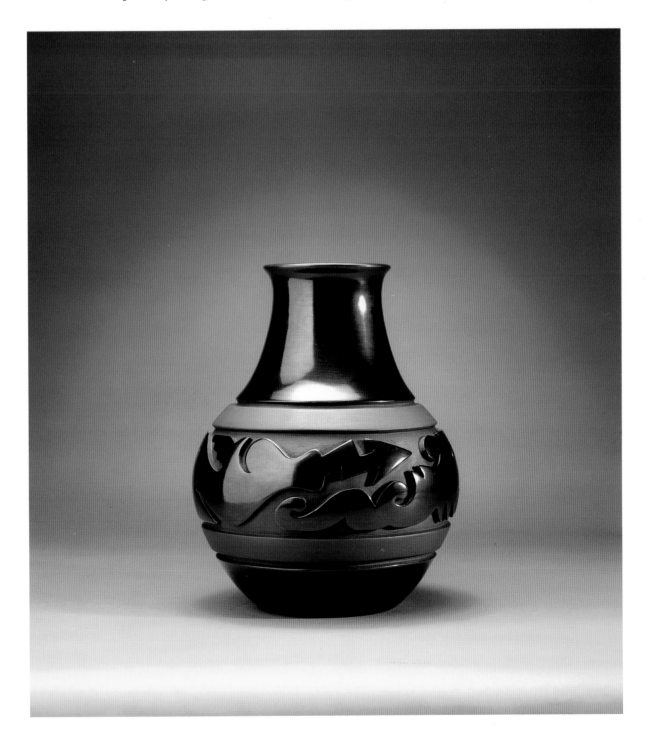

70. *This black carved jar reflects the influence of Nathan's grandmother, Margaret Tafoya. The time he invests in each work shows in the skilled carving and lustrous polish.*

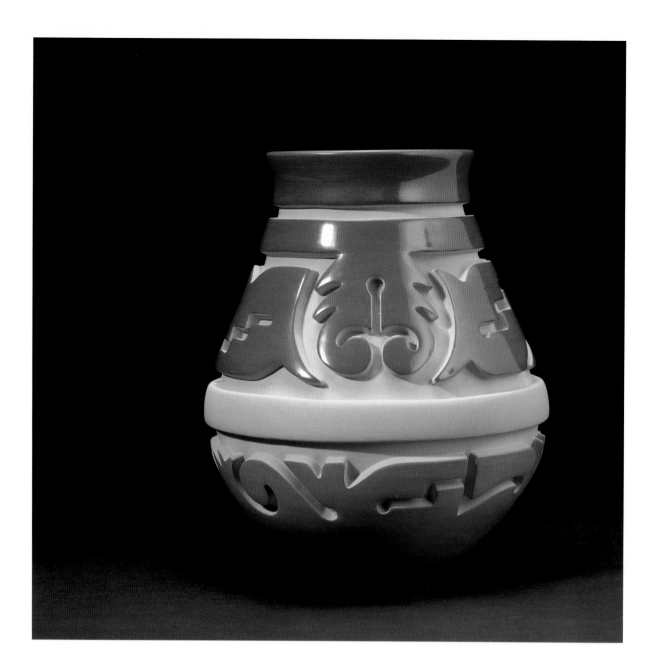

71. *Here the red-and-sienna color combination accentuates the clean edge of the carved designs. Nathan has achieved the sienna without applying slip by polishing the natural clay surface with water.*

and high technical standards. "I wanted something that really distinguished itself," he says of this pivotal time.

This realization about uniqueness came about in part because of a powerful memory from his boyhood stay in Holland. Visiting museums there and admiring the old master paintings in those extensive collections, he remembers thinking that the famous artists in museums all have recognizable, distinct styles. Van Gogh was his favorite. This perception would have a positive influence on the evolution of his own style.

In Nathan's work, the dynamic interplay of curvilinear design and geometric abstraction creates a beautiful movement across the sensual curves of his vessels. Indeed, collectors and appreciators of his work have commented on an almost Oriental sensibility of design. Having been fascinated with an exhibition of Asian bronze sculpture and carved jade he saw at the DeYoung Museum in San Francisco, Nathan freely derives influence from the harmony of form and design that struck him in that show.

He then saw the next step toward distinguishing himself — departing from the established Santa Clara technique of filling in the carved areas of a vessel with a thick clay slip. Instead, Nathan admired the clean, precise incising on Joseph Lonewolf's small pieces and sought to translate this clarity of carving to full-sized works. He wondered, "Why can't I clean out

carved channels for that kind of precision?"

This sharp, immaculate line is now what defines Nathan Youngblood's work, but it did not come quickly or easily. He recalls practicing on broken or cracked pieces to perfect his technique, gradually working up the courage to try it on the larger pieces that would eventually succeed as finished jars.

Nathan feels that what makes his work so desirable and elevates it to previously unattained levels is the extra time he takes to perfect details. To begin with, when pots are formed but still in the green phase (that is, not yet fired), Nathan uses a carpenter's level to make certain the vessel is straight on both its vertical and horizontal axes.

Additionally, most Santa Clarans carve their designs into the clay body when the clay is still of a leathery consistency — not quite dry. Nathan waits until the vessel is completely dry, something he believes enables him to attain great precision when he works with his knife point and the edge of a screwdriver. "Stanley screwdrivers are the best," he says, "because they hold an edge longer than others. Otherwise I would have to keep changing tools or resharpening." This would disrupt the creative flow when imagining and executing designs.

Designs evolve from one another. But the most important factor, he believes, is making sure that designs integrate well with the form of the jar. He begins by drawing directly on the clay surface — first defining the borders of the major design fields, within which there will be elaborate carving. The artist says that he frequently sands off his sketches and re-draws until he feels completely satisfied with the "flow of the design over the piece." As the more elaborate design work evolves, he wets the lines he intends to carve with a brush to soften the excess clay, enabling him to scoop it out of the channels — defining and refining the carved lines.

Also distinguishing his works are the skillfully polished slips that color them. Stone burnishing helps the liquid clay slip adhere to the pottery wall and brings the slip to a high luster. Slip is applied after all the designs are carved — typically painted onto the raised portions of the jar, leaving the deeply carved channels in the lighter, natural color of the clay body. The contrast of the polished surfaces and the matte, unslipped channels between contributes to the drama of the design.

Nathan continues to do some traditional all-black and all-redware pieces, but a distinctive style that he also enjoys is the use of a red-and-sienna combination. The sienna finish, achieved by polishing the clay surface with just water and no slip application, is a delicate one which the artist feels more readily reveals flaws in firing than do colored slips. Many other less ambitious or less risk-oriented artists shy away from the use of the sienna finish.

Stone polishing in itself is an art—one which Nathan takes quite seriously. The finer points of polishing he learned from his mother and from his sister Nancy. "Timing is crucial — it's important not to polish too long, but more important not to quit too soon." This is in keeping with his feeling that going the extra mile with such details is essential to creating a great finished piece.

Nathan has five polishing stones of various shapes and sizes that he uses all the time, and the one he got from his grandmother is still his favorite. He always keeps his eye out for more stones that look as if they might be useful and has a coffee can full of them. He has not used these yet, "But you never know."

A key part of the polishing process involves the use of thin layers of animal fat applied over the slip. He thinks this keeps the slip from drying out too quickly, which can cause later problems such as slip cracking during the curing and firing of a piece. Sometimes the slip spills over into the carved channels as it is brushed on, and the most common method of correcting such flaws is simply to paint over

them. But, taking extra care and time, Nathan opts for a much cleaner, sharper look. The flat head of a screwdriver is used to scrape the channel, removing thin layers of clay and any remnants of unwanted slip.

Out of respect for tradition and for the clay, Nathan always fires with the ancient open-fire technique taught to him by his grandmother. As Bruce Berger wrote in *Ceramics Monthly* (November 1990), "For Mela and then for Nathan and his sister Nancy, Margaret was the decisive influence, teacher of a tradition and its embodiment." Nathan promised Margaret that he would always fire in the natural way. This sort of reverence for and responsibility to the Clay Mother is very serious; he learned early that his talent is a gift and an obligation. The clay should not be played with but rather viewed as a sacred soul to be treated with utmost respect.

The rigorous demands that fall upon an artist of Nathan's stature caused him and his sister Nancy to build a firing shed. Though this might be viewed as controversial by other pueblo potters, Nathan and Nancy no longer wrestle with the matter — particularly since there is notable precedent for using a sheltered firing area, established at least as long ago as the 1930s, when Maria Martinez's husband Julian utilized a firing shed.

Nathan's ambition still carries him forward steadily, for he has always felt that an artist cannot go on successfully to the next stage of development unless the previous step has been perfected. He believes he has attained the highest levels possible in forming, designing, polishing, and carving; now it is time to achieve greater things.

"To do more of the larger pieces is very challenging. I want to do them in a way that the detail and depth of design is unlike anyone else's. I'm on a constant quest to challenge myself. If I'm not, I'm bored, and not an artist but a craftsperson."

It is not surprising that his greatest ambition is to build large storage jars twenty-four to thirty inches tall. It must be in the blood, for it was his grandmother who perfected large jars like no one before her, and so far, no one since. Nathan wants to carve elaborate designs into his planned storage vessels, a daring development not yet attempted even by his Tafoya predecessors. He wants them to be "like giant Fabergé eggs."

Margaret once took Nathan to a site where some clay was found that was well suited to building large pottery. He extracted enough of it to attempt ten storage jars as soon as he feels ready — cautiously noting that if he succeeds with three or four of them, he will consider himself lucky. He also talks of a major trio of "lamp bases" — one black, one red, and one sienna, larger and more elaborate than anything done before. The planned project is just another in a continuing series of challenges necessary to his artistic vitality and growth. Bruce Berger asked, "What does tradition measure?" and concluded, "Most precisely, the degree of change." Change is what Nathan's innate love of challenge will bring about.

"I can't imagine doing anything else," Nathan says. "Everything else at this point is on the back burner." The world is enriched because he does nothing else but create, stretching the boundaries of beauty and perfection. Almost unimaginably, he says he has not found the complete desire until now. Look out, world!

72. *This plate has the Oriental feeling of many of Nathan's designs. The elaborate rendering of the avanyu here is reminiscent of Asian carved jade.*

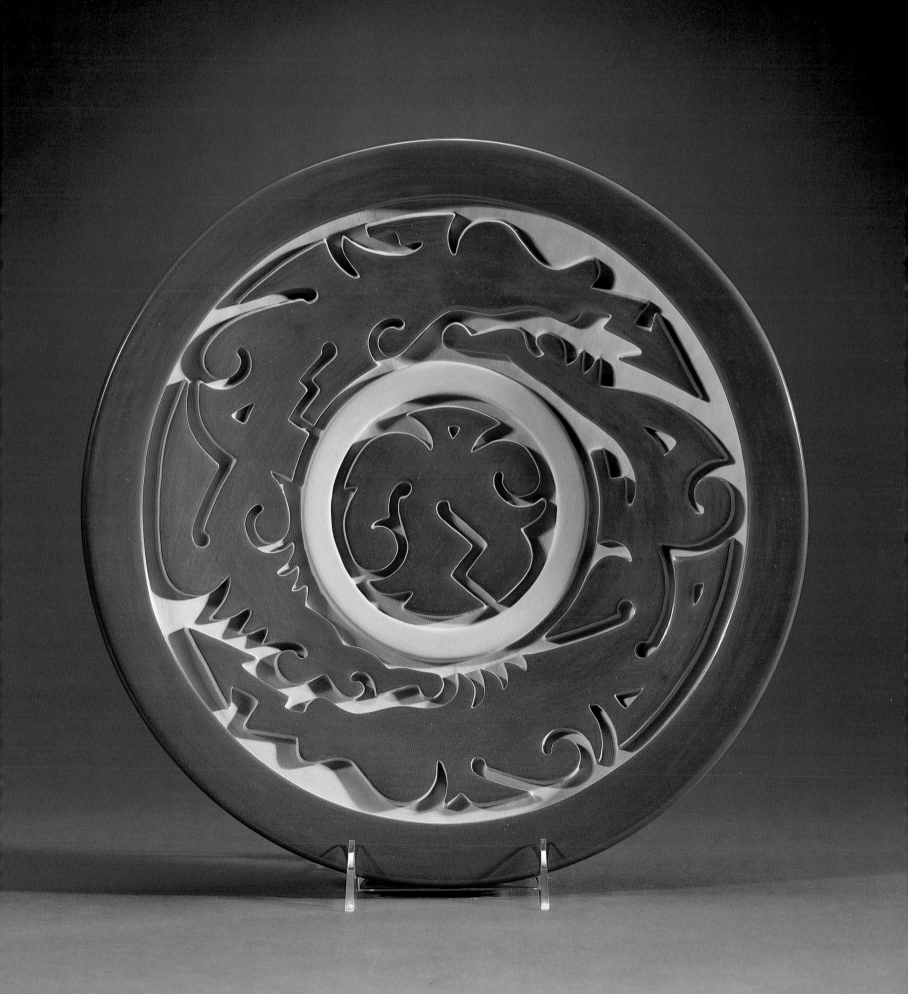

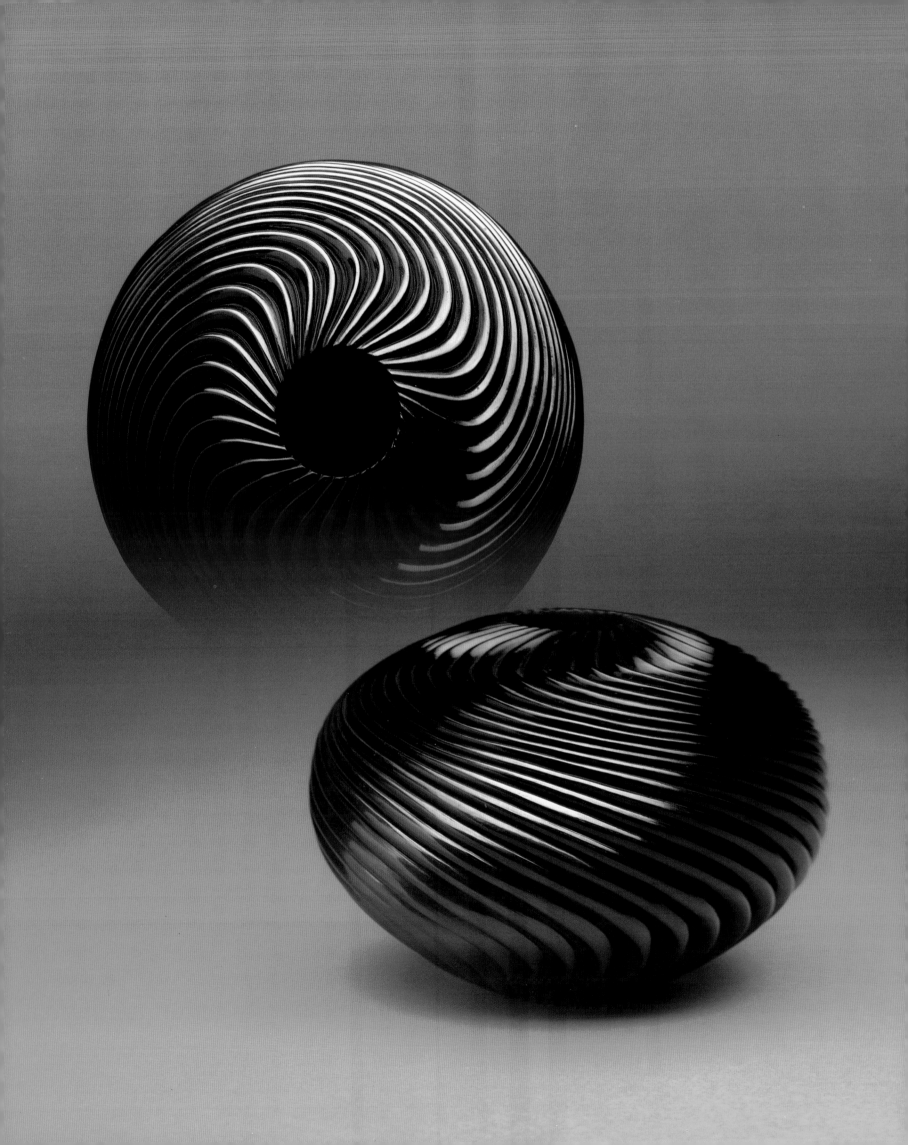

Nancy Youngblood

ROBERTA BURNETT

During the early years of learning her art, Nancy Youngblood was pulled between the path of her predecessors and the advice of her own muse. Certainly, the pressure to conform can be assumed to be inherent in the pueblo tradition of making pottery. Her mother, Mela Youngblood, and her grandmother, Margaret Tafoya, were already well-known potters. Watching her grandmother work was Nancy's primary tutorial in what was to become her calling. As Nancy, who was born in 1955, thinks about the early days of her learning, the messages were clear: to be a potter was to uphold the Santa Clara tradition. To do it right was to use "the old ways." As she watched Margaret, who for decades has been called "the matriarch of pueblo pottery," Nancy Youngblood could see the one way to make things right: No short cuts.

Nancy Youngblood settled into the Santa Clara style of deeply carved decoration which the Tafoya family had pursued. The family had several strengths accounting for its renown — the ability to make large, classically urn-shaped storage vessels, as in the work of Sarafina and Margaret Tafoya; the skills to achieve an almost mirror like polish; a sensitivity to beautiful form; and the integration of the shape of a vessel with the design of its deeply carved ornamentation. Carving in the Santa Clara style often took the form of a band around the widest part of a jar, composed of certain definable pueblo

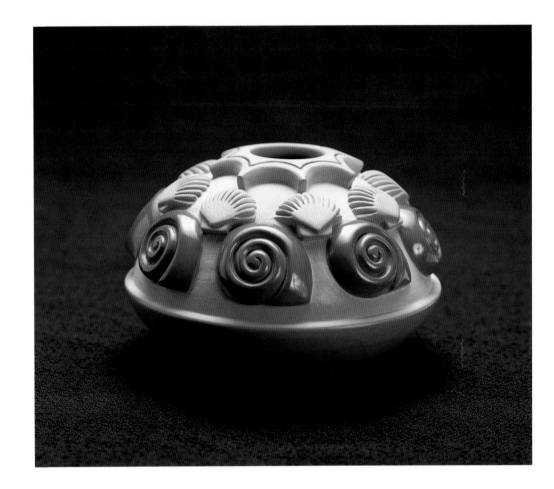

symbols. At its simplest, it might be the impression of a bear paw, a favorite of Margaret's; or it might be a more complex combination of elements, such as the *avanyu* (the water serpent whose tail brings lightning to its own mouth is a Santa Clara good luck symbol), lightning, or kiva steps. The recessed areas of the design were painted matte and the relief elements polished; uncarved ware bore simply matte-painted designs on polished surfaces. The works of the Tafoya family were typically quite large.

73. (Opposite) A top and profile view of one of Nancy Youngblood's swirling melon jars shows at once the complexity and demanding nature of her art. The thirty-two precisely spaced ribs generate graceful motion.

74. Fascinated with nature's complexities, Youngblood has often utilized nautilus and other shell forms in intricately carved relief.

Starting in 1973, Nancy Youngblood began making a name for herself as an exquisite miniaturist in the Santa Clara style. In pottery one-and-a-half inches in height, she produced marvels. Bringing pottery for a show, she would unwrap twenty or more small wonders, like a king's faceted black gems spread across a table. That approach, rich yet casual, was unique to her, for every piece was a perfect creation that fit comfortably in the palm of a hand, so small that curling fingers could nearly cover it. In those years, Nancy became a perfectionist as a carver, increasing her sizes, varying her shapes, and in addition to banding her beautifully scaled miniatures with the *avanyu*, she created an intensified version of a melon jar. At first it was miniature. It often had straight vertical ribs, sometimes a lid, and later the deep ribs were gracefully curved into her "swirling melon" or the even more extravagant "S-swirl melon." In the early days, as now, collectors gathered, anticipating her outpouring.

She made it all look so easy. Yet at the nine-year mark in her career, Nancy was able to say in an interview, "It takes three to four years to get really confident at making pottery, and it takes a lifetime to get really good at it." Now, after almost nineteen years at her art, she's emphatic about her best work: "I haven't produced it yet. That's to come." She describes her working process throughout this span as "obsessive. I wanted to be the best at what I did." Just so, she became the artist that she is—consummate, uncopyable at this time, and a creator of works that can conservatively be called spectacular. That has been recognized in various museum shows and by major collectors throughout the United States. Though she has received many awards at Indian markets and invitationals, her prominence is created by a heavy demand for her work based on its style and quality.

Nancy's decorative styles range from abstract to pictorial. In her mature work is an aesthetic that unifies pueblo pottery tradition and contemporary imagination—an organic unity of form and ornamentation, a feeling for fluidity of carved design as it merges with purity of form. She has incorporated forms other than the traditional globular shape into her work. She is interested in the paradox of the straight line as it moves down over the three-dimensional surface of the pottery so that it becomes optically curved—an effect most obvious on her straight-ribbed jars. Her challenging S-swirl melon jars carry the curve even farther. Embracing all the work is a serene sense of strength and of opulence. The works are an ultimate in aesthetic resolution.

As a designer, Nancy Youngblood is an innovator, not a habitual thinker. The burgeoning of her individual creativity came introspectively. As she began thinking about the tradition of ceramic art that had been paved for her, she began to see that, "At first, I was trying to do miniatures of what my grandmother produces, but I was getting frustrated." She also began to see beyond her immediate experiences as a member of the Tafoya family of potters into a personal identity. She notes, "I saw my grandmother's work from years ago, both in photographs and the work itself, up close. My grandmother was one of the most innovative potters in this pueblo. She may not have understood that, but she was."

An awakening had begun, born of her wide-ranging experience of Santa Clara pottery, an intimate knowledge of her grandmother's work, and also a clear personal and professional awareness. About the same time that she became obsessive about her creations, she began to get significant feedback on them. She then foresaw a dilemma that could arise later. As a mature artist looking back on her work, she would say, "Would I have only produced pottery, or did I want to be proud of what I produced?" Her frustration as a contemporary artist struggling within the constraints of the

75. *This piece with thirty-two S-swirl ribs, is an adaptation of the melon jar in a long-necked vase. Graceful form is accentuated by fluid motion, and the kiva-step lid alludes to the ever-present ceremonial life of the pueblo.*

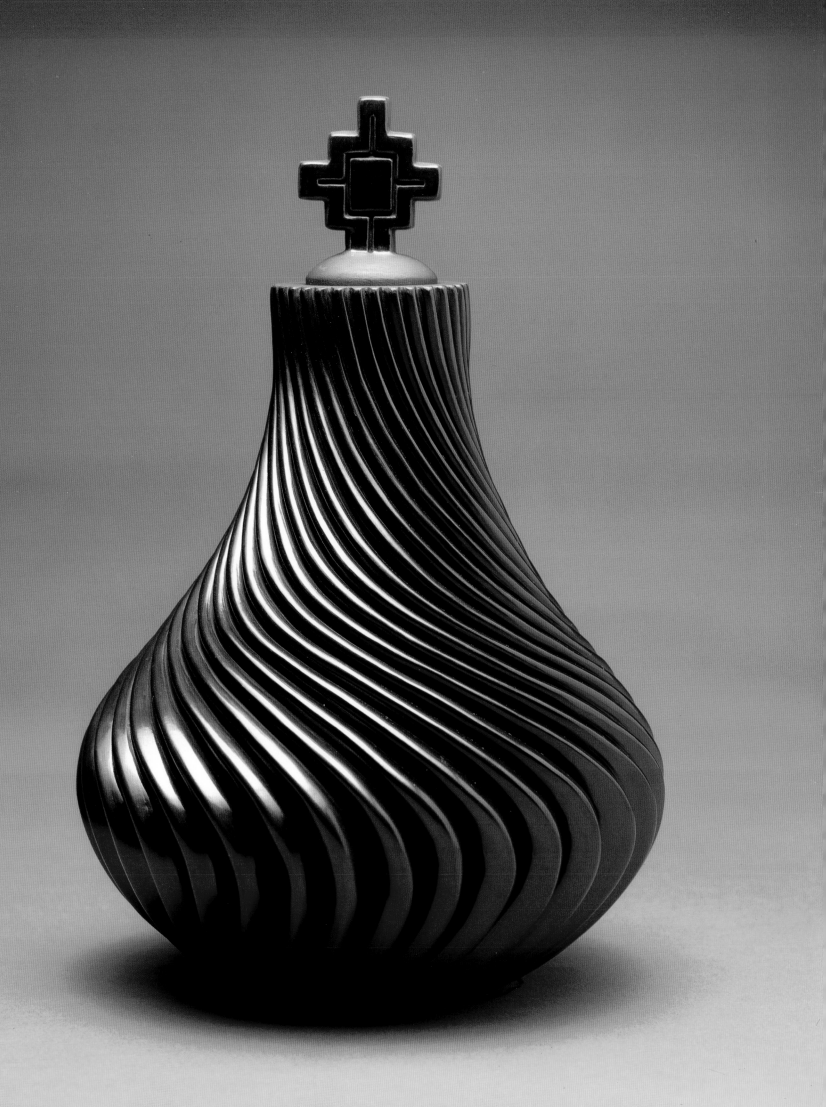

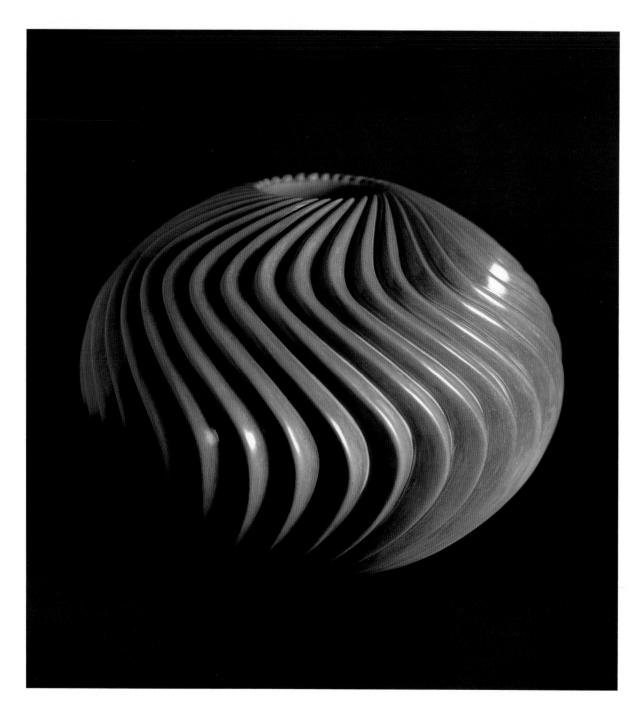

Santa Clara style evoked in her a strong, creative upwelling. "I wanted to express who I am, rather than copying someone else. I also simply wanted to do something creative in my life that would let me be remembered for something other than just taking up space on the planet."

Among her major influences, she lists Teresita Naranjo because she "put so much carving on the piece." She credits "the delicate work of Grace Medicine Flower, the boldness and strength of Margaret Tafoya, such a small woman who produced such big pieces." Especially high on her list is her brother Nathan Youngblood: "We've been very supportive of each other, giving a consistent stream of reliable advice." Their artistic interaction is ongoing, but she tells of a pivotal time when she was making miniatures only and wanted to do larger work. "Nathan took me aside and told me that the only thing that was limiting me was my mind. 'Don't say you can't do it. You can,' he said. It was a big inspiration." Her father, Walton M. Youngblood, threw the challenge out to her, and to her brother. "My father initially didn't believe I could do this. My brother and I felt bound to get better at our art, or else discover on our own that we couldn't do it." Her father was a proponent of formal edu-

cation for them both, and so she finished at McCurdy High School, "a private Methodist school, where my brother and I had some of the same teachers," and enrolled at the University of New Mexico. She took general education courses plus art history, German, and "incredibly competitive" studio art classes in which "people were sabotaging others' work. I spent my time trying to satisfy the instructor (trying to get that A), instead of doing my own work. . . . Ultimately, I knew I was a creator."

For the Tafoya family, pottery begins with an expedition to dig for clay in October of each year. Volcanic ash that the family calls "white sand" and clay are prepared for later use: the Tafoyas dig and hammer, then soak, sift, and sieve. The mixing of the pulverized clay with water is done by stomping on it. A tarpaulin is spread to contain it. Then the mixture is bagged in plastic and allowed to sit until ready to be used. Later it is worked to remove the potentially hazardous air bubbles, which will cause the explosion of pieces during firing if the air pockets are not assiduously removed at this stage.

Most Indian potters (and Nancy Youngblood as well) make their wares at home. Coils are rolled between their palms until they reach the desired thickness. At Santa Clara, a shallow bowl called a *puki* is used to start the base of the ware. Turned upside down, the *puki* forms a stable base; the coils are placed over it and worked together so that they will not come apart. The curve of whatever *puki* the potter selects contributes fundamentally to the shape of the ware. The *puki* is left in place until the finished piece begins to harden, then it is removed, says Nancy. Although she creates mainly larger works today, when Nancy does make miniatures, she does not use the *puki* as a base, but instead uses a coil the size of a Cheerio.

She reflects on her outpouring of miniatures during the 1970s and early 1980s with amazement. "It all seems almost foreign to me now that I could be working so small all the time," says Nancy. In either miniatures or larger jars, the coils can't be too thick, especially if the work is to be carved. After penciling in, freehand, the ridges of a melon jar, the outline of shells, or an *avanyu* band, Nancy then carves across and into the smoothed-down coils. Carving can only be done when the wares are at a particular degree of dryness. Bruce Berger, in an article on Nancy Youngblood in *Americana Magazine* (November/December 1985, page 51), quotes Nancy describing her process of carving the complex S-curve jar:

I divide the bowl visually and mark it with pencil, first in half, then in quarters, then in smaller divisions. For the S-curve, I divide the pot vertically into thirds, carve the top third first, reverse the diagonal and do the middle next, and back to the first angle for the bottom third. The straight ones are actually harder, because you have to get the line absolutely perpendicular and keep it that way, all the way around. The slightest tilt in the line would be noticed.

As she works, Nancy checks to see that the shape maintains its symmetry. Departing from the centuries-old technique of using corncobs to smooth the surface, the Tafoya family uses sandpaper. The piece is sanded and wiped down with a damp cloth until a certain uniformity of surface and edges is achieved. A homemade slip the consistency of paint, made from a finely sieved caramel-colored clay, is applied. Though its color is tawny, "we call it red slip," says Nancy. The polishing of the jar with a hand-held stone is the next step in the process. On Nancy's pieces with deep ribs, the process is laborious and painstaking. The dampness of the ware must be kept consistent throughout the polishing process, and that is controlled by building up the ambient humidity with two huge pots of water boiling on the kitchen stove. "The simmering steam makes it feel like we're in the tropics," says Nancy. Polishing small

wares can take her ten hours. With large works, each section takes two to three hours of polishing. "With a 64- or 32-rib melon jar, I never polish the whole thing at one time. If I'm feeling daring, I'll polish up to five ribs at a time, under normal conditions, I do three ribs," says Nancy. If dissatisfied with the luster or its evenness, she then wipes the jar with a damp cloth and the polishing is begun again. A matte slip is then painted on those surfaces not intended to be shiny. The piece is signed by scratching her name on the bottom. Pieces are set aside, away from moisture, to await firing.

To fire, Nancy and Nathan typically work together. The fire itself looks like a simple campfire. To build it, they put down tin cans, and on them a metal milk crate. They place cedar kindling under the crate and slabs of cedar around the sides. They do not use metal sheets to form an oven. The pots are placed inside the milk crate, with a flattened piece of stove pipe and slabs of cedar over the top. "Actually," says Nancy, "we preheat the cans, grill and stovepipe plate on a separate bonfire to equalize their temperature. If the stovepipe slag from the last firing would pop off, it would cause breakage, so the bonfire helps to remove that, too. We also preheat the pots in an oven to keep them from fire shock. Years ago, we used to use the natural heat of the sun to prewarm the pots." Nathan Youngblood said in a 1985 interview that he allows flames to lick up the bottom and sides of the pot, which must be strong enough to withstand this kind of intense and variable stress. The potters place dry, rough-cut lumber vertically around the well-kindled fire. They switch to using the more uniform lumber at this stage because it contains less pitch, which can pop toward the pottery during firing, and because the lumber's more uniform size helps them control the heat.

The two potters observe elements like smoke and soot to tell them what is going on inside the fire. Too much smoke means it is too

early to remove the jars, for instance, and soot must vanish as well before the firing is finished. Nevertheless, the sister and brother turn much of the ultimate responsibility over to other, more fundamental forces. Says Nathan, "The important thing is not to think about anything, especially not about the pieces being fired. We must have no thoughts about the pieces coming out right. We try to keep our minds totally blank." Says Nancy, "We say our prayers in the ways our families have done for centuries." The prayers get to an elemental truth: "We the human potters don't know whether or not the pottery will turn out, but it's your will, Clay Mother, that will direct it." Once the soot is burned away, the potters can remove ware in finished form, if it is red. The pieces of pottery need only to cool down, the clay hardening into ceramic. If, however, the potters want a piece to be black, they smother the fire with pulverized horse manure. "We cover it half way up to allow the heat to begin to escape. Then we cover it completely." The process is a chemical one called "reduction firing," which cuts off the oxygen source and allows the clay to absorb carbon, turning it black.

In every firing, the artists have learned to leave as little to luck and chance as is humanly possible by consistently pushing the limits of their expertise. Yet, at some point, the spirit of the Clay Mother takes over, and Nancy Youngblood knows when to leave well enough alone. It is also quite true that the aesthetic Nancy Youngblood has developed has grown out of a combination of pueblo tradition and her individual talent. Not to be ignored is her certain and vital connection to twentieth-century experience — one that creates a need in a visual artist to express the unsaid, to show the felt but heretofore unseen. In those sources lie the energy fueling the imagination. In Nancy Youngblood, they become a very well-kindled fire.

77. *In this black sixty-four-ribbed melon jar Nancy has maintained the overall grace of the vessel at the same time meeting the severe technical challenges of the sculpting, the polishing, and the demanding high-shouldered flat-topped shape.*

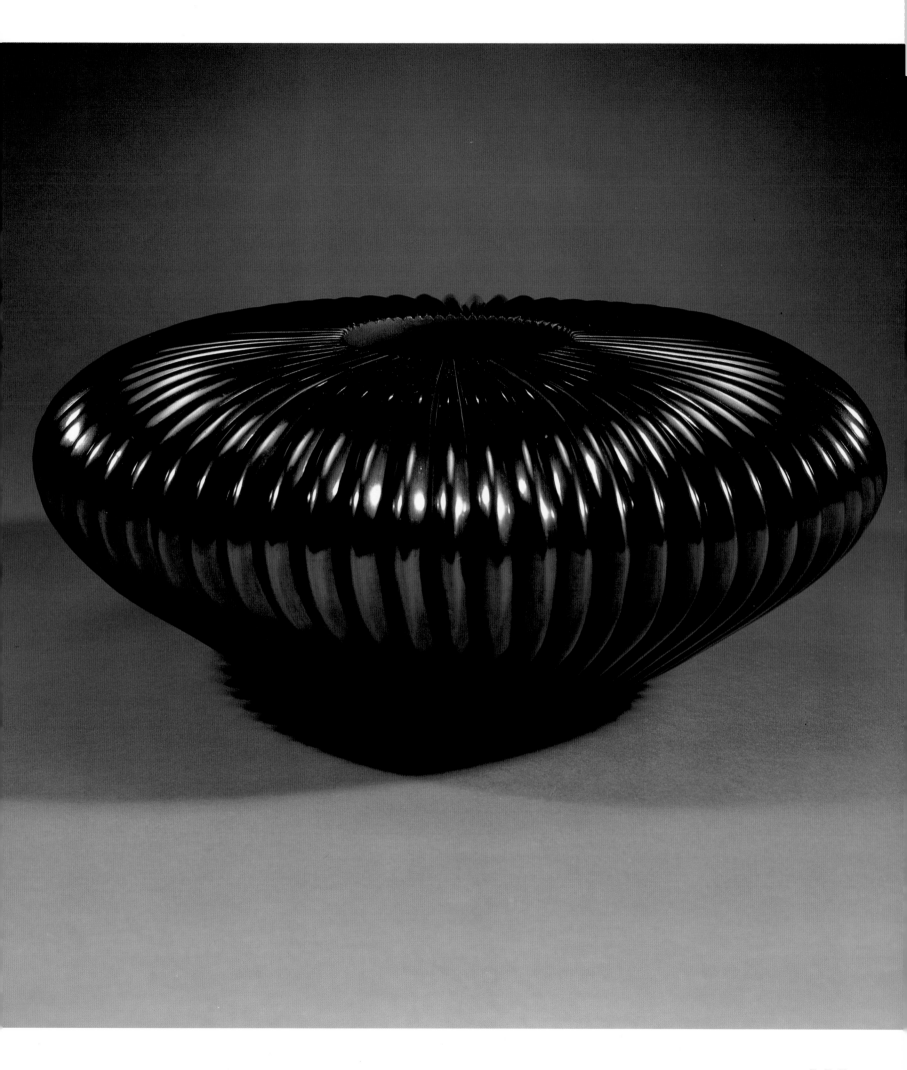

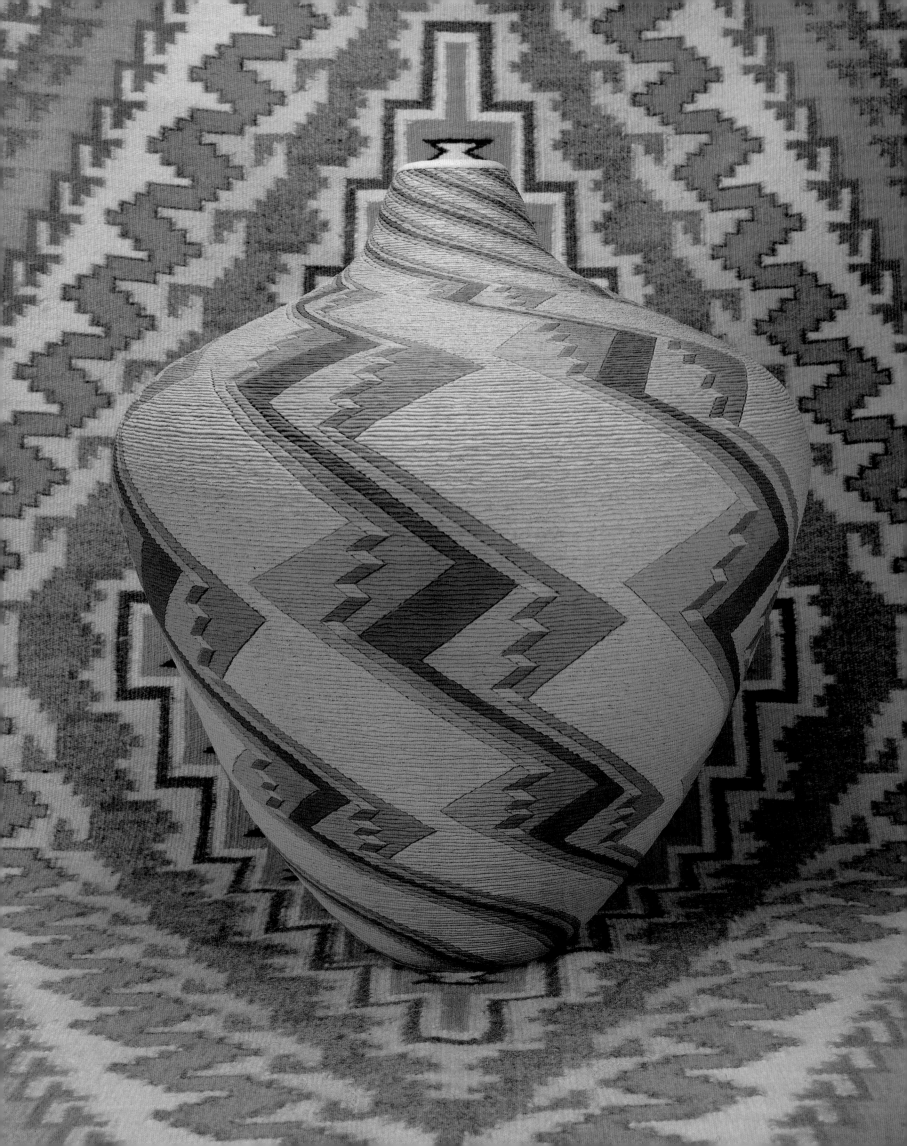

Richard Zane Smith

ROBERTA BURNETT

Viewers who scan art galleries do double-takes when they see the ceramics of Richard Zane Smith. Almost involuntarily, feet start walking toward one or another of Richard's large storage jars. Fingers point, and the next words are, "And who's *this* one by?"

Instantly perceived as strong aesthetic statements, Smith's works are beautiful, elegantly shaped, and articulately constructed. Each is a tour de force, created from subtly and intricately planned elements. Each is an explosion of beauty, yet one that is blessed with classical restraint. Each is created by a man who believes in some eternal verities, for Smith dedicates his work to the glory of God.

A person of the American plains, Smith does not base his identity as an artist on his part-Wyandotte heritage, though he can document his lineage. His work is not marketed as Native American, yet he bases his art on the corrugated ware of the ancient cultures of the Southwest. These old, anonymous voices in pottery gave him the concept of using thin, exposed coils as the structural element for his wares, giving them the textured surfaces that bring basketry to mind. Smith is perhaps the first potter in hundreds of years to bring the delicate, shingle-lapped coils into prominence as a structural device; the designs he combines with them are equally unique among potters the world over.

Richard Zane Smith was born in 1955. When he left art school, he was equipped with

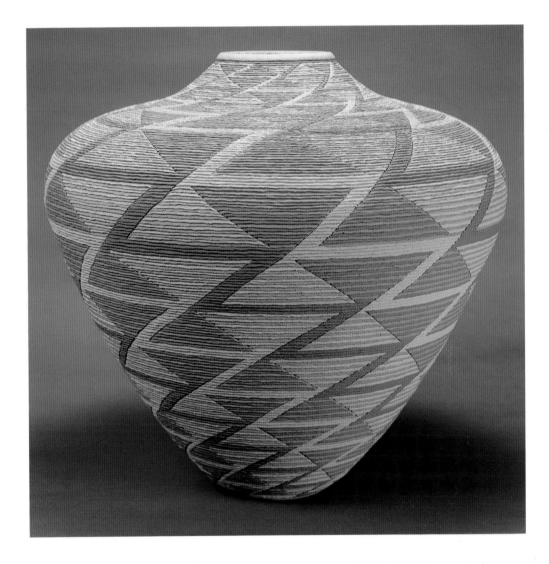

more than technique. Young and idealistic, he knew an artist's ego could get in the way of creating art — so he actively avoided what he considered to be the typical artist's lifestyle, removing himself from what he calls the "haughty, arrogant ways" that have come to be the stereotype of artists in European culture. He volunteered as an art instructor at a Navajo

78. *(Opposite) An example of Richard Smith's corrugated ware, this jar utilizes perspective, color, and space to create the illusion of three dimensions within the clay surface.*

79. *Many of Smith's works recall the feel and design sensibility of old southwestern basketry. The basket weaver's innate sense of form and design is infused into this classically shaped piece.*

mission school that had virtually no money for supplies. The ways of the Navajo were diametrically opposed to the mannerisms of the art school graduates Smith knew, and, while agreeing with the Navajo in thought and principle was easy for him, in practice Smith had to retrain himself to fit in with them.

"True humility," says Smith, "has a very high unspoken place in Navajo culture." Such values must have felt familiar to him, for he had been reared in the context of his parents' "comfortable and hypocrisy-free spirituality." Though the outward appearances of Navajo life were exotically different from middle-class Anglo culture, the nature of life on the reservation felt to Smith like an inner "coming home." Of his eight-year experience living there, he says, "Navajos love joking and teasing. You know you've been accepted when all the formal politeness is gone and you get a trick played on you or you get mercilessly teased. I learned to watch my tongue, especially if I appeared to be bragging in the slightest way. To build any type of monument for yourself, either in words or deeds, was to have it quickly turned into a gravestone." In that atmosphere of personal restraint, Smith began serious creation of the ceramic art that he now dedicates to God.

No less than the Navajo, the ancient peoples of the Southwest left their mark on Smith's imagination. A seminal moment in his direction as an artist came when combing the desert for clays. He came upon shards of all colors and, with a romantic's view, saw them larger than life: ". . . hundreds of pottery fragments, some burnished so smoothly they caught the sun like broken glass. In desolate country, away from other human beings, the 'people-made-thing' catches the eye as if it were painted bright pink. Black on white, black on red, gray and buff with a curious texture I'd never seen before, some shards were partially buried while others were undercut by wind, leaving them exalted on tiny pedestals of sand." In these things, he saw

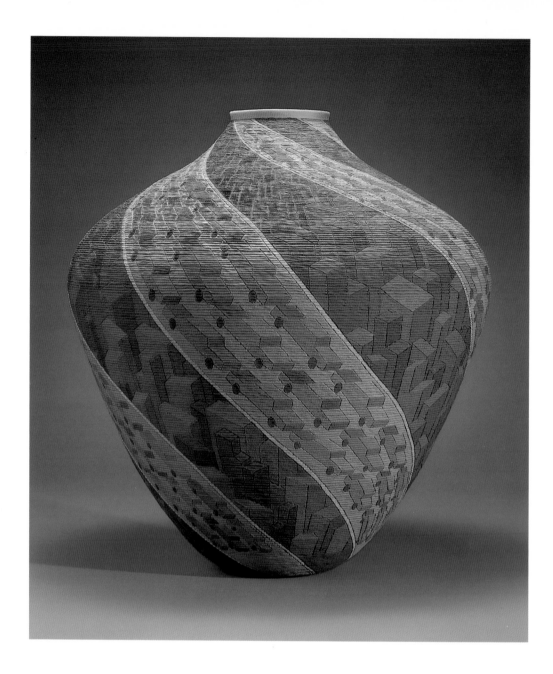

what generations had passed by. In the palest of these shards, the gray and ash-white of the prehistoric corrugated ware, was the inspiration for Smith's indelible new ceramic style.

Smith's ceramics are mysterious in construction; some are virtually inimitable. In building his wares, Smith follows the ancient method of creating corrugation by layering row upon row of tiny coils. For several years now, he has explored a more spontaneous use of the coils — applying them so that they undulate and can be made to create convex shapes. He finds these pieces far more difficult to build, since the working edge dips and peaks in a pattern that must be resolved as the walls go up. This wavy building method can create a tulip-necked jar, a

80. L.A. Freeway. *The subject bespeaks Smith's intense feelings about the contrast between his own country lifestyle and the hectic, congested life in a big city. This work offers a zany but foreboding picture reflecting his own mixed feelings before a trip to California for a show of his work.*

bowl with hollow legs, or a jar with a conventional neck and closure but with an unconventional, raised design in convex relief.

A third kind of construction is found in a jar whose opening is shaped like a star. It lies on its side and is constructed from the mouth, tapering down to the end. It resembles a cross between a star-flower and seed pod, starfish, and vessel. It is an incredible feat that only an experimental potter would conceive and develop; fewer still would succeed at creating it.

One of Smith's newest sculptural shapes is a unique double-walled bowl, a vessel whose starting and finishing edge lie on the same plane. The textured wall rises, curls over, and parallels itself down into a concave interior. Another new shape is a sort of double-walled doughnut that stands on its side in a cradle. The internal core is a cylinder, while a second cor-

rugated wall flares out from the top edge and attaches in a perfect arc to the opposite edge. The form appears to leave no room for Smith's hands to work. He says little about how these are constructed except to indicate that they take great effort. His goal in these new shapes is to create texture on both the inside and outside surfaces of the ware.

In some works, Smith scores additional textures into the shingle-lapped coils to suggest the feeling of basketry. On these pieces, the patterning is usually left unslipped; the jar is thus monochromatic or colored subtly by the interaction of smoke with the clay body. In other works, he scores the outlines of an interlocking geometric pattern that is repeated over the entire surface of the jar. In such designs, Smith uses an illusionistic treatment of space, relying on the European tradition of perspective to

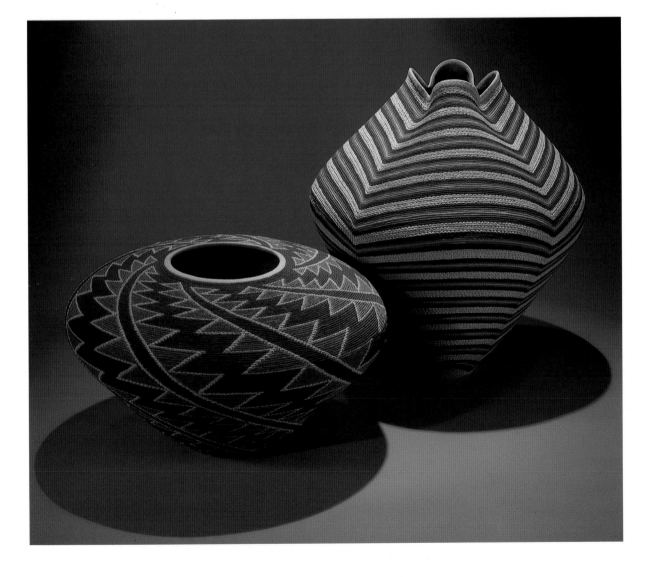

81. In a strong reference to southwestern basketry, designs expand and contract, swirl, and move around the graceful shape of the jar on the left. The piece at right utilizes undulating pinched coils to create a tulip opening.

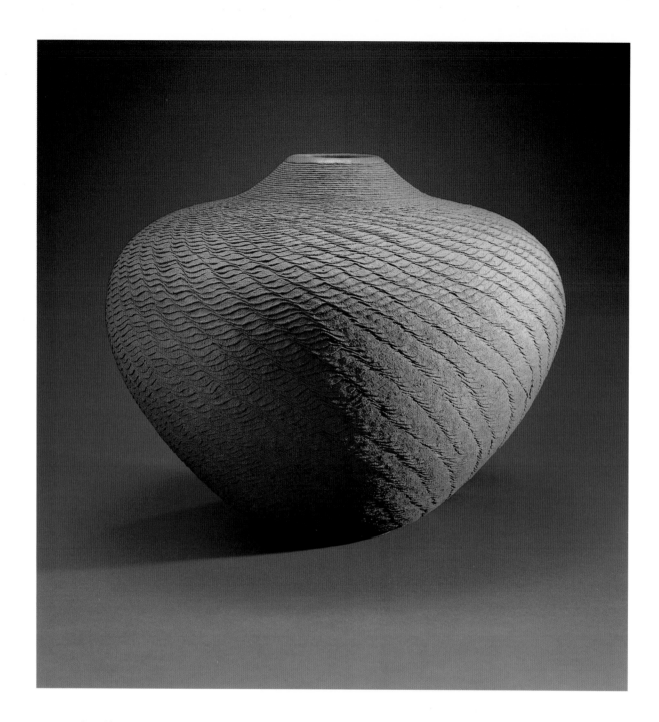

82. In this example Smith has manipulated the exposed coils into a wave pattern, giving the surface of the jar a water-like motion.

create the illusion of a third dimension within the clay surface. When this design work combines with the three-dimensional form of the jar itself, the effect is extraordinary. The viewer's sense of depth is heightened by the way the repeating designs expand and contract in size in proportion to the vessel's shape.

Smith's specific inspiration in illusionism is the puzzlingly complex imagery of Dutch lithographer M. C. Escher. Escher, as well as Smith, defies the principles of simple perspective by creating patterns that suggest either wide stretches of space in a tightly confined area or, at other times, give us entry into planes that could not exist in ordinary reality. The interlocking grids and stairways in Escher's complex schemes have inspired Smith to do more simply expressed flying geese, for example, or freeways full of automobiles, or looped ribbons floating in a deep space filled with cubes, with an effect like an aerial view of Manhattan. It is a riskier business for Smith than for Escher, for Smith is painting on a surface that he has created with infinite patience and that, once marred, must be destroyed. Both artists ultimately create scenes which have metaphysical overtones.

Another aspect of Smith's taking an older technique and turning it into something new is

83. (Opposite) Coils are applied in an undulating fashion, gradually arching and connecting at four points around the jar. The result is a tulip shape, a bud just beginning to open. Pigment zoned into bands of color heightens the effect.

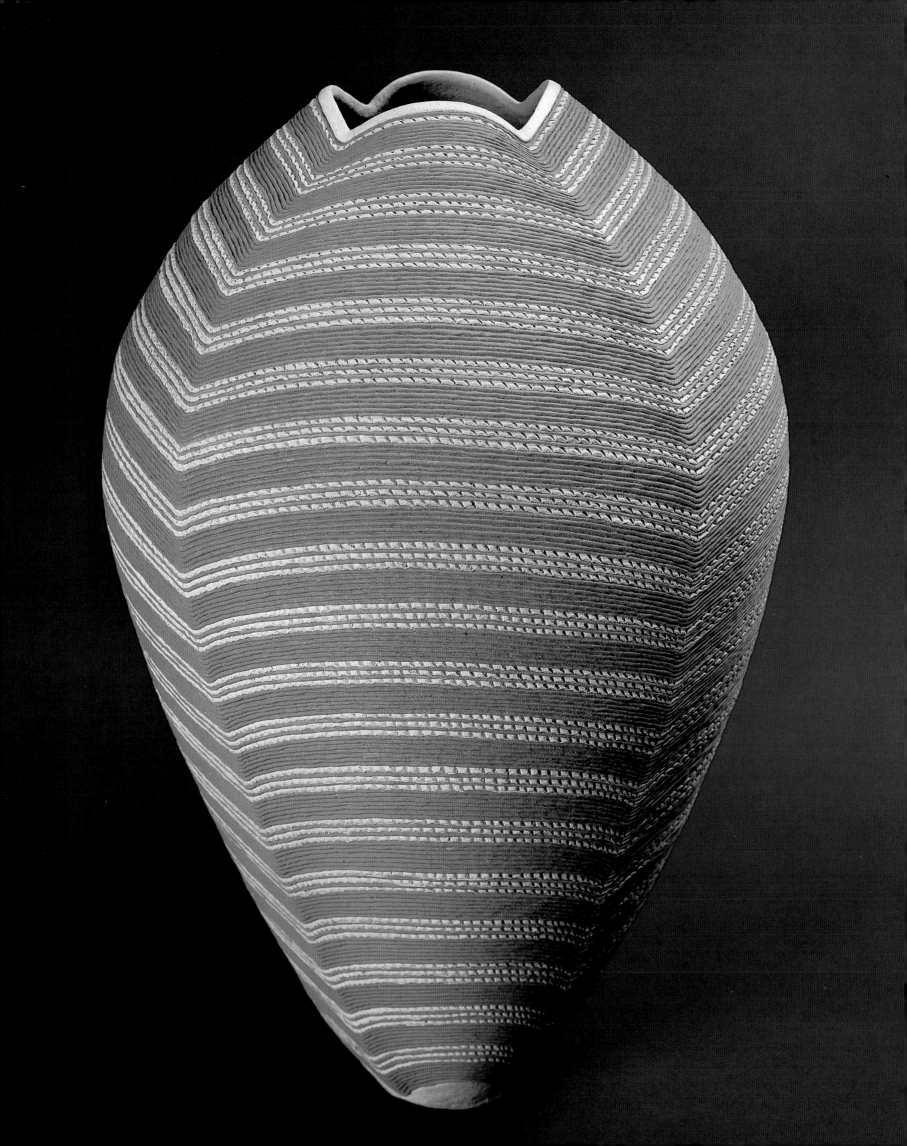

his use of color. To the gray, fire-clouded, basket-textured surfaces which are the pottery legacy of the Anasazi, Smith has added color. He has turned his surfaces into canvases for colorist designs in muted earth tones, bright colors, or pastels. Entirely methodical, he mixes his slips in such a way as to gradate a wide range of shades of a single hue. He begins with natural slips and adds "commercial stains to them to get certain colors like purple and blue." As he works, the ten small containers gradating a given color are laid out before him in a subtly shaded line. Using very fine sable brushes, he applies the slips to his design. The effect is similar to modeling in traditional painting, with the same result of mimicking volume or depth. In his designs, bars, boxes, spheres and cylinders all gain their third dimension from this technique. He can also represent deep space by such shading. But representation is not his only aim, and in the finished work, color, design, and form all share equal billing.

Smith believes that the ancient corrugated ware was essentially gone from humankind's view before he revived its structural idea. "I'm trying to revive the whole spirit that the Anasazi embodied, and when I present it, I'm trying to give it life with contemporary color and thoughtful, contemporary design," Smith says.

His preoccupation with design in nature has led him to the seashell, a significant symbol, he believes, of a cosmic plan. The shell has yet to make its own way overtly into his designs, yet he attests to its essence as something deeply moving: "I love seashells. There is incredible diversity in these 'containers.' From their shapes, textures, color, intricate patterns of order and spontaneity, such extremely imaginative pieces bring me to my knees before the Creator," says Smith.

His integrity and complete credulity when speaking such words is clear. His view of his own work is that, "A certain beauty is worth striving for. Not a decorative, trite, pretty, romantic imitation of beauty, but that deep, powerful, and forceful beauty one feels when surrounded by nature. I have never been interested in 'creating my own reality.' I'm interested in timeless truth and creating work that reflects and communicates values that have existed long before I came along and will exist long after I am gone." His Christianity is devout, and he would have others share in his joy and belief in it. When something momentous happens in his life, he acknowledges it through his work. The death of his sister prompted his use of the willow tree on the bottom of his jars, a symbol of eternal life used on Wyandotte graves in the Ohio homeland, he says, in memory of her.

Smith crosses all sorts of boundaries for his sources. In the normal course of events, he turns for inspiration to a coffee table book on tropical shells, to the Bible, or to an object of American Indian or pre-Columbian art, such as effigies bound to jar lids with leather thongs. Thus Smith's work hails from the prehistoric American pottery tradition through a modern European artist, and from the world of human endeavor as well as the natural world.

While viewers perceive intuitively the influence of the Southwest and its native peoples on his work, Smith's ceramics can, and do, go anywhere in the world as representative of the best contemporary ceramic art. Smith is recognized by avant garde ceramists from all over as an innovator in technique and design. He manages to bring the human past into the technological present and through illusion, to wed them.

To place Richard Zane Smith in the vanguard of the twenty-first century is a delight and a wonder. It is inspiring to see a man of conscience advance in the rarified air of the arts. The world has need of more like him creating objects of beauty.

84. Subtle earth-tone slips were used to decorate this piece, whose repeating geometric design is accentuated by its diagonal orientation.

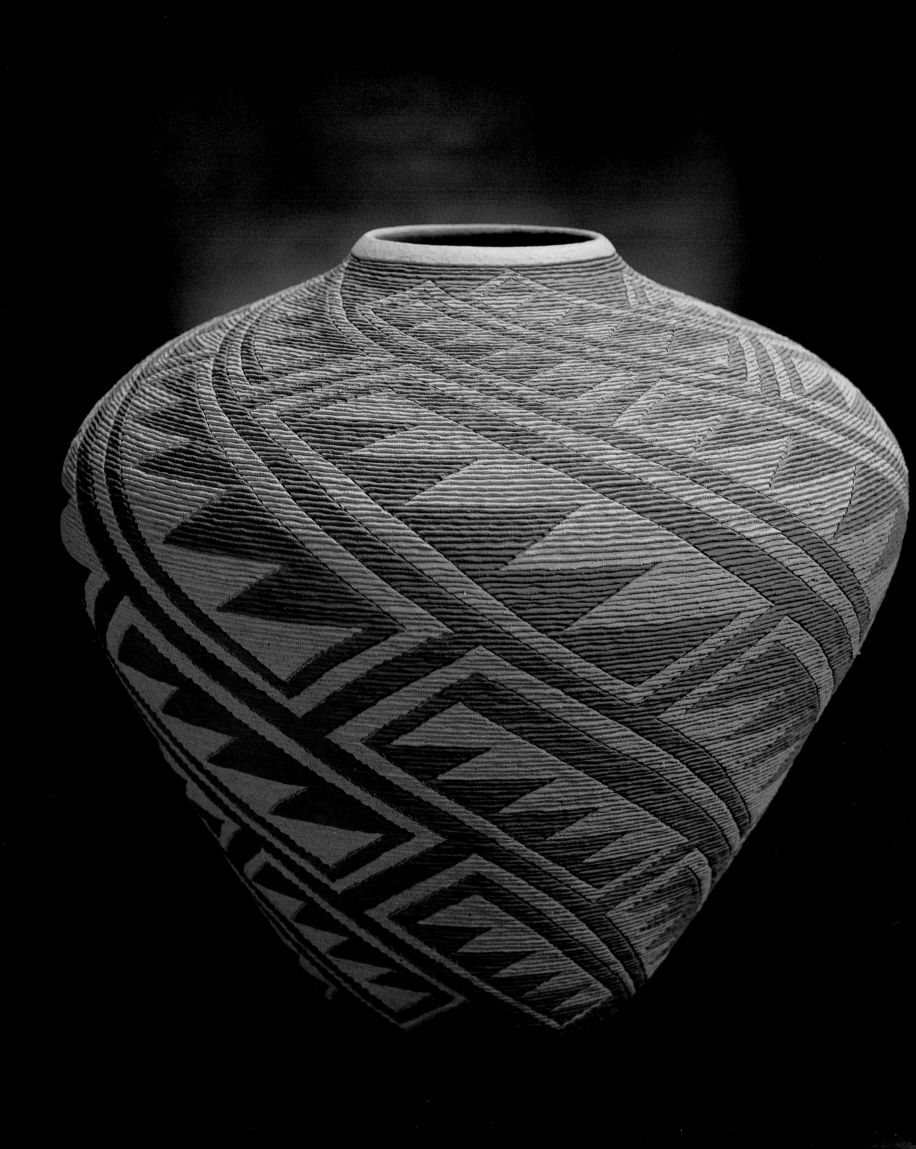

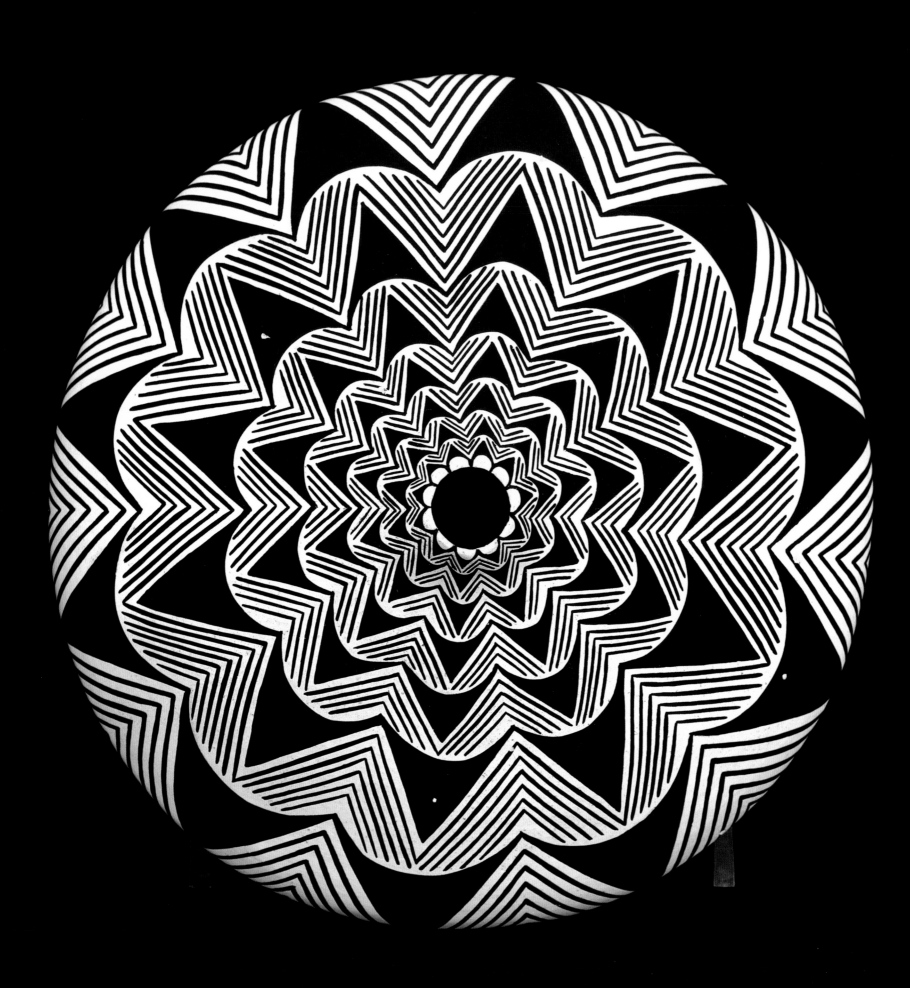

Dorothy Torivio

ROBERTA BURNETT

One of the most abstract designers in Native American ceramics, Dorothy Torivio has worked professionally at her art since 1975. What she expresses in her work is her way of seeing things; then she creates that way of seeing for others. On first impression, viewers sense the harmonious integration of shape and design. As they move closer, Torivio's work becomes an optical experience, for her painting creates vibrations between eye and brain that can touch off a moment of vertigo if one stares too long. These painted designs expand and contract, as if they were an elastic stretched over the shape of the ware. At the same time the designs create an alternation of foreground and background, an effect that intensifies the longer one looks at a piece.

Dorothy Torivio, born in 1946, works within her native Acoma tradition. Her predecessors were decorating their pottery with bold geometric designs in black and white or polychrome — some designs composed wholly of fine-line painting, others with Mimbres-style figures, and others that were fantasias of parrots and flowers. Among these mid-twentieth-century potters were Lucy Lewis and her daughters, Marie Chino and Lolita Concho — artists who influenced Torivio directly, along with her mother Mary Valley.

Since 1982, Torivio has designed and built her own ceramics, but earlier she learned to paint on little molded animals such as deer and

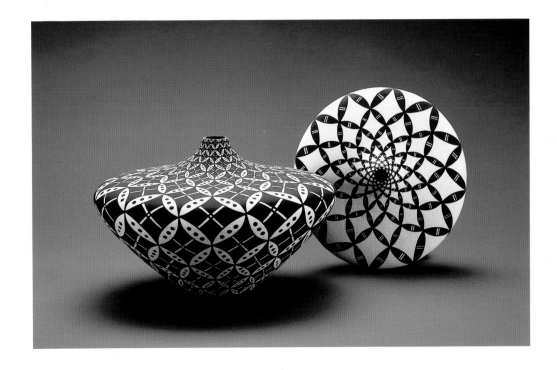

owls that she bought at ceramics shops in Grants, New Mexico, where her husband Peter Concho worked in the uranium mines. At her mother-in-law's suggestion, she began to learn this way. Lolita Concho was responding to Torivio's need to help support the couple's four children — twin boys had been born six months earlier. Concho told her, "Practice your [painted] lines, and then later, maybe, you can make your own pottery." Torivio commented, "So I got good at developing my lines, making them pretty even, and learning curved strokes." On those typical dimestore animals, she was painting "what everyone else was doing, the traditional designs that were passed on," she said. At the beginning of her gallery career, Torivio also did

85. (Opposite) The multiple optical illusions radiate, curve, skip, expand, and contract their way around the surface of this seed jar. Torivio paints freehand, with the white slip applied to the whole piece first and the dark "negative" designs painted over it.

86. Torivio has instinctively developed shapes that accentuate the drama of her elastic designs. Both of these pieces feature the dramatic flare from base to shoulder, the sharp turn and flattened top, and the race into the middle.

her share of fine-line painting. She became excellent at it, but it was not enough.

An interest in innovation has been with Torivio since the early 1980s. "Back in '82 and '83, I was doing mostly Mimbres designs, the animals on the seed pots. One day, I had an idea to take one specific design and repeat it over and over again on the shape of the pot. So I started coming up with those and had pretty good sales, at prices of $25 and $35." A design element could be, for example, an individual yucca leaf from the Acoma floral designs, or a single geometric shape from some other design. As she experimented, she knew she wanted to have a primarily physical effect on the viewer's eyes. While her interest in optical effects is inevitably related to living in the modern world, she does not consciously connect modern references with her designs. She points out her sawtooth design as an outgrowth of a classic motif used to connote the connected mesas around Acoma, in which rows of connected black-and-white triangles abut one another row after row. The result is a stolid overall pattern, which Torivio had seen in the work of Marie Chino. But she combined that traditional pattern with her own penchant for the kinetic image, and by putting the rows of triangles on a diagonal curve, she created a swirling design that contains both radiating and spiral motion. By 1984, she had mastered this "op art" concept and was winning first prizes and Best of Show awards at the Gallup Ceremonial and Santa Fe Indian Market. "I still use two of those designs," she said.

Torivio's twist is the curve. "I see other people's design in a book, and I put [one element] at a different angle or in a curving motion." These designs are "from the old pottery pieces," she said. She relates the story of an invitation which the Wheelwright Museum in Santa Fe extended to her, her sister Juanita Keene, and her mother-in-law Lolita to visit the archives of Acoma pottery. The three potters brought their sketchbooks and cameras. "Ooh,

I could feel all the spirits through me. I knew, It's something to be here. Those potteries were 36 to 45 inches wide. They dug them up a long time ago. From there I got some old designs, some big designs," she said. Some of the design symbols were identified by her mother-in-law — the sawtooth representing the mesas, the red dots and lines representing rain and snow. But Torivio has also developed a personal iconography. For example, a black four-pointed star pattern with two crossing white lines she describes as "my image of stars I see in the night. Their four points are my four directions." (The Heard Museum owns a jar that Torivio painted with the night star pattern for a competition in 1984.) The image of four yucca leaves attached at the center is another of her four-direction symbols, she said.

Torivio's mother, Mary Valley, is also a potter, but Torivio remembers learning on her own. She had watched her mother but did not receive any direct instruction from her. Later, she asked her mother-in-law for guidance on important technical matters: the thickness of the coils and the walls of a jar; where to dig clay; how to refine the white and red slips; the grinding, sifting, and mixing of the clay; testing its feel; and how to use the natural hardening of the clay as it dries to prevent the steeply sloping shoulders of a jar from falling in. "That's the hardest part," she said. "I tried to make the walls as thin and light as possible, but not too thin. When I was learning, I made a hole. So I tried to turn the hole into a part of the design."

Her first attempts were seed jars, two-and-a-half to three inches high. The gratitude that Torivio feels for Lolita Concho, who had won her share of prizes as a potter and is now deceased, runs through her words. Concho's daughter Shirley, who did not learn the potter's art, gave Torivio her mother's legacy of potter's treasures: Concho's polishing stone, four of the base bowls that help to form the bottoms of jars, and "a different color of red paint to make a pink

with, actually four sets of pink and red." Concho had used many of the traditional floral designs in her work, and Torivio is now inventing several abstract designs in which to incorporate these unusual paints.

To paint, Torivio uses a chewed yucca stalk that she fashions into a brush. The yucca grows wild around her home. She cuts from the clusters of shoots. "We take from the yucca just what we need. We don't kill the whole plant. We just take off a few stems, and they're free, from Mother Earth." She uses the tender shoots of the yucca, not the thick tall plants, and shapes them to suit her purpose. She forms the working tip of the brush in the direction the plant grows — that is, with the point of the brush toward the plant's growing tip. She said, "you lose fibers into the paint" if the point is put toward the base of the plant. Of making the brush, she says, "After [the cut shoot is] dry, you soak the tip in water, work with it [with fingers and teeth], pulling off the top fiber. You must get all the excess fiber off, and then underneath is a pretty good brush." "Pretty good" is high praise from Torivio, for she explains, "Regular paint brushes are not as flexible, and they don't hold paint as well. I get more strokes and longer strokes with a yucca brush, and the paint doesn't dry up as fast."

Throughout her gallery-centered career, people have wondered whether the potter, working at close range for hours, was immune to the vibrations made by her designs. "Oh, no," she says candidly, "They drive me crazy, too!" The hardest ones, she noted, are the jars with tall, narrow necks, where the design becomes proportionately very small: "The fine painting at the neck goes very slow." As the shape of the jar expands, the design grows larger. The larger designs "go pretty fast." Using no tools except a pencil, she makes points around the top edge of a piece and divides the jar into quarters. "I picture them in my mind, section them off, and in each quarter I put two

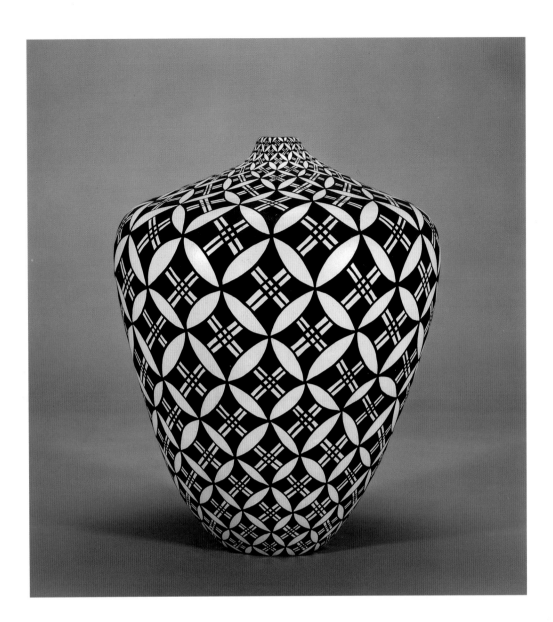

more sections, and so on." With the individual designs, she has a mental image she follows: "I see little squares." As we talked, she deftly drew squares for me on a piece of paper to show how the flowerlike design that is made of the four yucca leaves attached at the center combines with the four directions of the night sky. The flowers form the foreground, the night sky the background, and the tips of the flowers form the outer edge of the night sky.

On a jar, she simply "sees" the design that is to be. With curving patterns, she said, "Sometimes, I go from freehand on down, [but on] the bigger pots I always measure off. I have one that's 22 inches around, and 12 inches in diameter. It's about five or six inches high, with a high neck. I've put a spiral design on it. It's taking a very long time. It gets me dizzy. I work on it

87. To keep design ratios intact with such dramatic expansion and contraction of pattern is remarkable. The black kite-like forms represent the four directions of the night sky, and the white elements are yucca leaves. But foreground and background can switch with a blink of the eye.

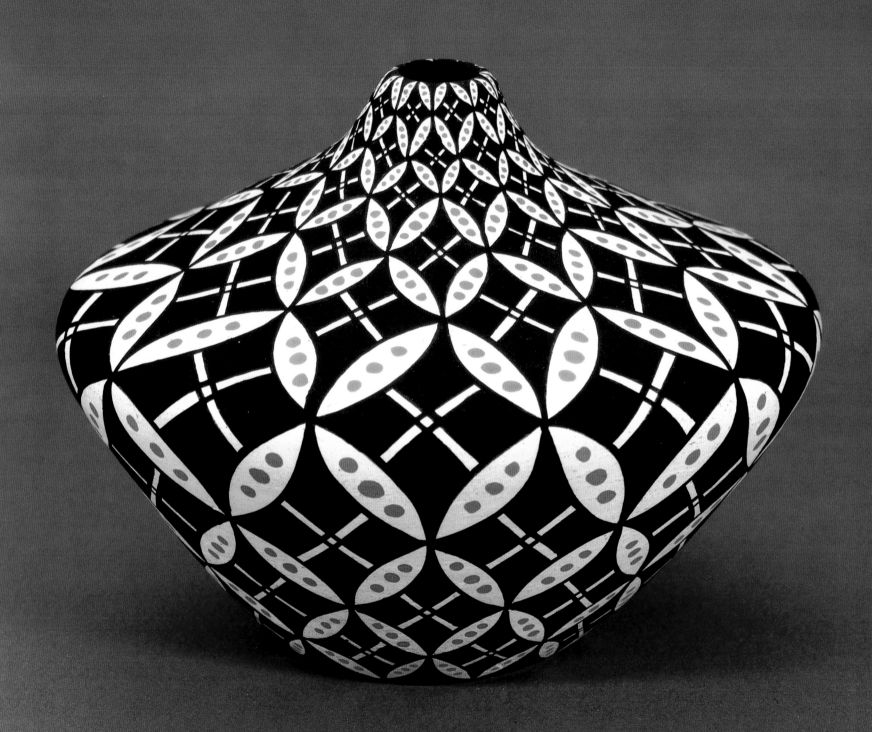

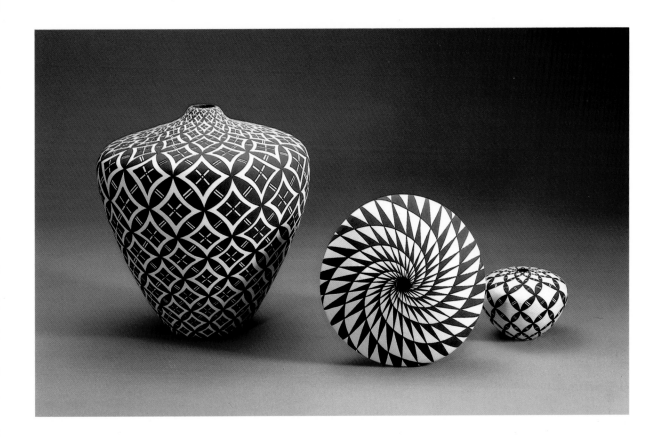

88. (Opposite) Red slip accents this piece with patterns of red dots which represent snowflakes. All designs interlock to generate a dynamic optical play.

89. These are three dramatic variations of optical design sense, each of which provides the viewer with a different visual experience. The jar on the left is an interesting play on perspective and negative space. The central piece (top view) creates a strong illusion of spiral motion.

and I put it back on the shelf. My head swirls or spins when I work on it too long. I have to switch and do something different." It's a matter of survival for Dorothy to be working on several things at once, rotating them to rest the eyes and mind.

Torivio hopes that the work of the younger potters will be in demand as hers has been. The potter's life has been good to her, supportive of raising her children alone, supportive of bringing her Acoma roots back into focus for her own enrichment. "I love the travel and expressing myself about my pottery. But the young people should not do it just for the money, but from out of their hearts. They must put something

of themselves in it, yet try to keep everything traditional, and keep the work as fine as they can. It's not the easy way."

Torivio is inspiring at least one younger potter, her niece Sandra Victorino, encouraging her to enter more competitions such as the Gallup show. Of her fellow potters who are mature in their careers, Torivio says, "We are all artists doing the best we can and we want to make the best that's eye catching. Everybody looks at it in a different way. Some like shapes, or others, designs. We all have our own ways." Dorothy's way, fully developing alternating scale of design to shape of piece, is an innovative and literally eye-catching addition to southwestern pottery.

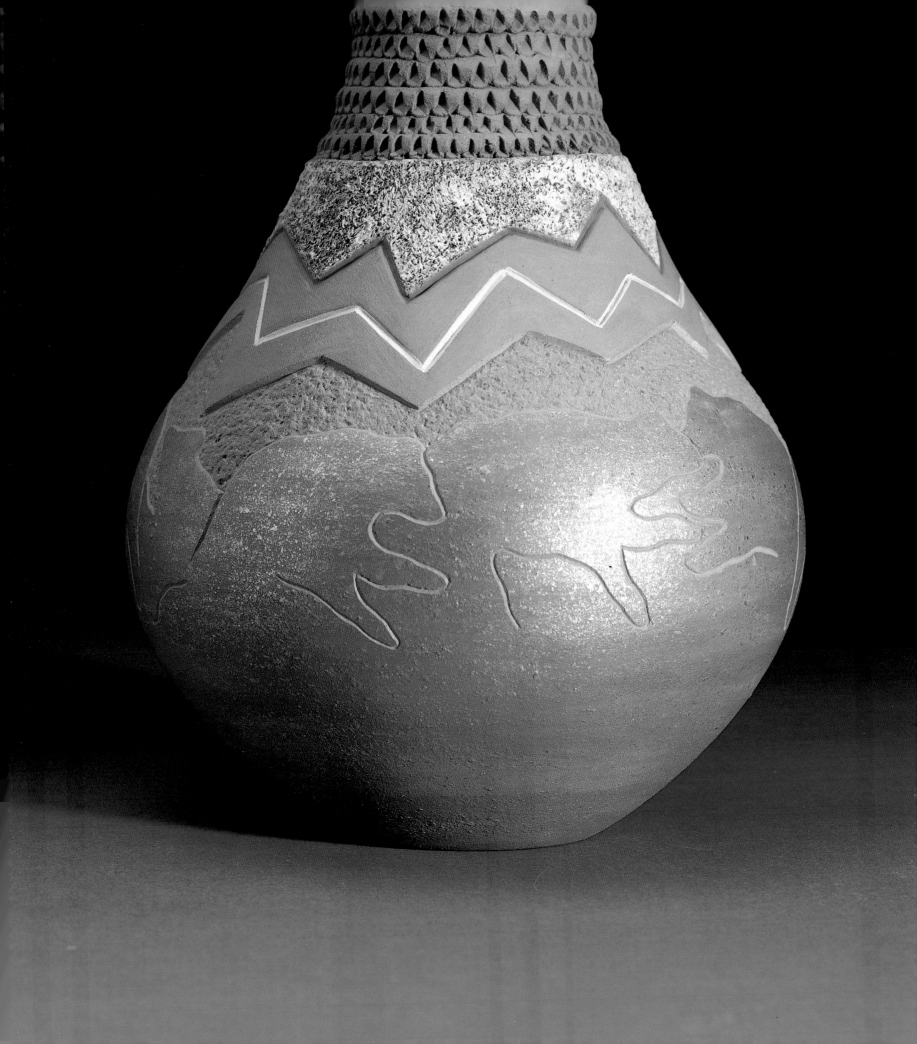

Russell Sanchez

ADELE COHEN

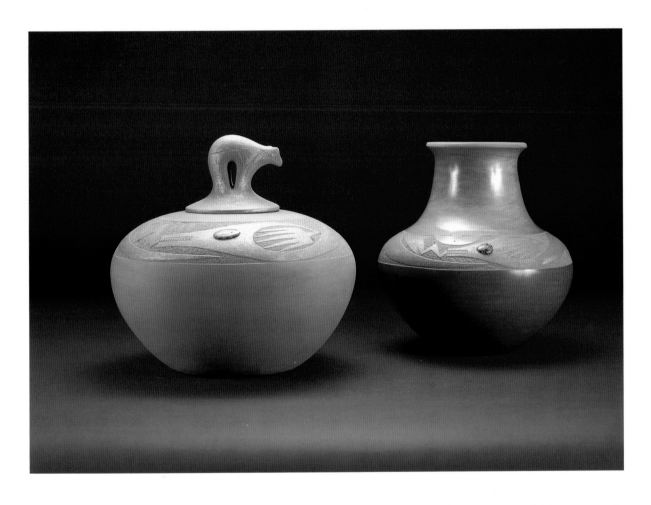

90. (Opposite) Different depths of incising and a corrugated neck give this piece the feel of the rugged but beautiful land surrounding San Ildefonso Pueblo.

91. Combining innovation with tradition, Sanchez reflects both his elders' teachings and his own need for expression. At left is a bear-lid jar with incised avanyu design and turquoise inlay; at right is a classical water jar with multiple colors of polished slip.

Russell has lived since his birth in 1963 at the San Ildefonso Pueblo. Being immersed in the traditions of his environment and culture since infancy, it is no wonder that from early childhood he played with the clay, becoming more serious about it around age twelve under the guidance of his aunt Rose Gonzales. She taught him the skills needed to become a proficient pueblo potter. It was hard work to make a finished piece that would please her. Today he is thankful to his Aunt, Rose Gonzales, and to Dora Peña, who encouraged him yet made him feel he could always do better. As time has passed and he has matured and made the decision to become a dedicated potter, Aunt Rose and Dora have offered constant reminders that he could surpass himself.

It sometimes seems to Russell that he has been picked by the Clay Mother to express his special talents, and he feels blessed to have been thus selected. Whatever he may have in mind as he begins to build a pot, that image may

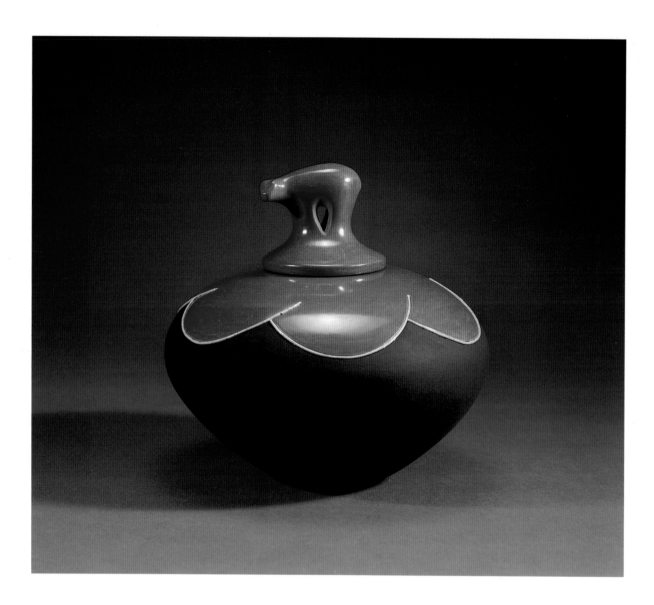

change many times before the work is finished. After spending much time and thought creating what he hopes will be a real accomplishment, Russell may, even after the piece is slipped and polished and ready for firing, rethink what he feels and sees — and then sand off all the painted slip and redo it several times before committing the piece to the fire. When his pots come out of the fire in good condition, it sends him a message that the Clay Mother approves.

People ask him, "What is your favorite pot?" Russell cannot think in those terms when he is in the process of creating. "I have to treat each of my pots equally. Just like children, they would be jealous of unfair treatment, and this could result in bad behavior." Bad behavior by the pot would result in a disappointment, an undesirable conclusion to many weeks of hard work.

At this point in his career, Russell is amazed at all the prizes he has won and at how well accepted his work is by serious collectors of Indian pottery. This approval is far beyond any expectations he ever had. Although recognition is important to any career, what he feels personally about his work is more critical to his growth as an artist. The challenge and excitement of trying and successfully creating something different is the most rewarding thing for him.

Russell has been thinking about how he can introduce different materials into the clay and still stay within the traditional construction and firing techniques of pueblo pottery. Inspired by everything around him, Russell absorbs what he sees and feels and filters it through his own vision. There is so much to see in the vital and changing art community in New Mexico and in the overpowering beauty of the region in which he lives. The influences on his earlier days, when he was

focusing on perfecting basic skills, were the elementary tasks which Rose Gonzales set him to; the discipline and pursuit of perfection which he observed in Dora Pena; and the innovations developed by Popovi and Tony Da during the 1960s, including the use of stone inlay and the sienna firing technique. He has used those influences plus the inspiration of the free spirit of Jody Folwell to create a more personal expression in clay that is at once inventive and at the same time rooted in the traditions, but not the style, of his culture.

It is now not possible to predict what Russell's next work will look like because shape, color, imagery, and firing technique are all subject to his constant experimentation. It is this innovation from which intrinsic worth is forged. Russell feels that the future of pueblo ceramics could be very exciting if his colleagues would take more chances. It is obvious after seeing Russell's work that here is a young potter who has learned his pueblo's traditions well but has also enthusiastically accepted the challenge of pushing beyond the stylistic limitations which tradition can impose.

Russell began winning prizes in juried shows in 1973, with awards at both Indian Market and the Eight Northern Pueblos show, and he has won prizes every year from 1978 through 1991 — including awards from the Heard Museum Guild in Phoenix. His work is in the permanent collections of the Smithsonian Institution (Washington, D.C.); the Millicent Rogers Museum (Taos, New Mexico); the Museum of Indian Art and Culture (Santa Fe, New Mexico); and the Museum of Natural History (Los Angeles, California).

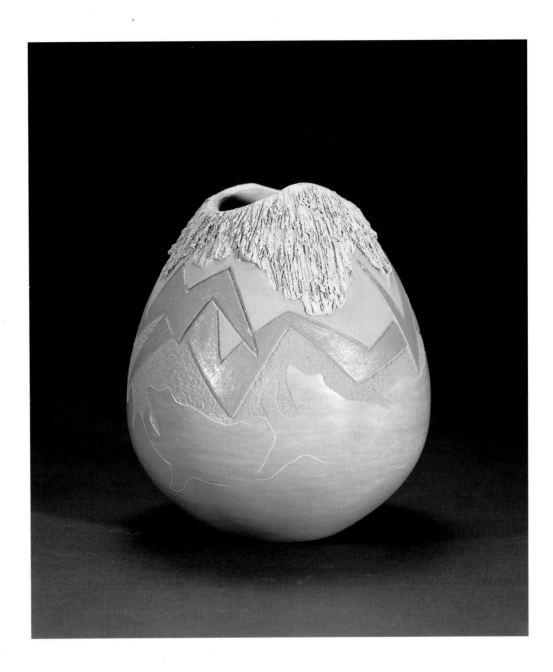

93. Natural, rugged, textured clay spills over the edge of this jar like lava from a volcano. Striving to use unfamiliar materials, Russell has made a polished green slip from clay he found near Abiquiu, New Mexico.

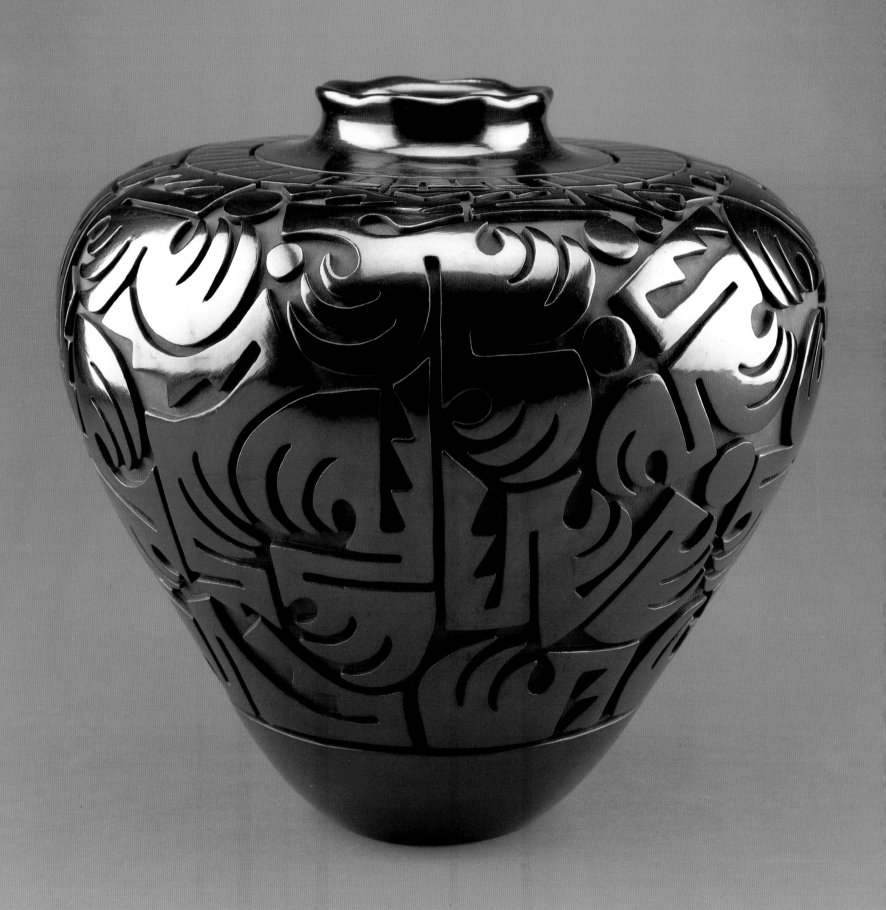

Tammy Garcia

PHILLIP J. COHEN

It is appropriate to conclude this volume with one of the newest talents to make a major impact on southwestern ceramics. Born in 1969, Tammy Garcia comes from the Naranjo family of Santa Clara Pueblo, a long and distinguished line of ceramic artists. Tammy's mother and grandmother are both accomplished potters, and her great-grandmother Christina Naranjo, Margaret Tafoya's sister, helped to transform ceramic art of the Southwest in the early years of this century.

Starting comparatively late, Tammy first began to pay attention to clay at age sixteen. For the first three years her work was bound by the time-honored style required by both family tradition and by some wholesale dealers who pressured Tammy to produce more commercial work. Her works sold well, in part because they were competently done and perhaps also because of her distinguished family connection.

In spite of her commercial success, Tammy soon became restless and bored. She yearned to transform the entire pottery surface, not just small portions of it, into a canvas for her designs. "It's hard to stay in one place, when your instinct is to be free and unconfined." This restless, driving aspiration is common to many artistic geniuses and forms a strong foundation for the risk-taking which is characteristic of Tammy's work.

The initial risk was to break with certain aspects of tradition. Tammy and many other Native American artists have had to stand up to pressures for conformity within their culture. Holding fast to rigidly dictated traditions in technique and style is taught early on. Being different, or perceived in any way as better, is in conflict with the balance and harmony of a people who cherish unity. Yet, even within this culture, free spirits do evolve and flourish when they have committed themselves to personal excellence and found the courage to pursue a path uniquely their own.

Tammy seeks to avoid the "comfort zone," and not to "linger in the safety of the tried and true." This does not mean, however, that she entirely ignores the traditions of pueblo ceramics or the themes that have inspired that art form for millennia. "Even a thousand years ago," she says, "there were dragonflies around for the Mimbres to render in their art. They are still here today, existing in our world, free to be interpreted personally in a style consistent with the times." This insight, which shows the maturity of the young artist, is borne out in the originality of her work.

As has been mentioned, one of the major changes Garcia needed to make in order to follow her own creative vision was to use the whole surface of her pottery as a field for design. She perceived that much of the carved design work at the pueblo was limited to a single band of design which often covered less than half of the vessel. Tammy cites her interest in

94. This black polished jar (approximately 14 inches in height) reflects Tammy's interest in the oriental style of carving. Her penchant for utilizing portions of different designs and reworking and repeating them to form an intricate abstract overall design sets Tammy's style apart.

Oriental ceramics, which were often richly and densely decorated over entire vessel surfaces: "They seem to have felt comfortable with lots of filler designs . . . that created a complicated mosaic." The challenge for Tammy has been "to translate that Oriental aesthetic into a Pueblo sensitivity that is also personal."

Thus, we often see small parts of recognizable pueblo pottery motifs dissected, reshaped, and compacted into a complex composition of kinetic motion. Elements in nature inspire Tammy as well. When these inspirations marry within her imagination, a very personal design sense emerges. Fragments of leaves fill in space between images of birds, perhaps surrounded by feather motifs or rainbow-band segments derived from historic Pueblo design—the whole is pieced together in a lively interplay of subject and form. Tammy has extensively studied the pottery designs of the prehistoric Southwest, and like many other potters has been affected by Mimbres design. She also finds inspiration in contemporary artists, particularly Helen Hardin, the renowned Pueblo Indian painter, whose works often include colorful narratives of pueblo mythology. Tammy may make a subtle reference to Hardin's work by borrowing minute segments of vivid figurative and geometric imagery, and reorganizing, recomposing, and finally translating them onto the three-dimensional surface of a jar.

Artists like Tammy are imbued with that magical quality that spurs on invention, freedom of spirit, and the restless drive for greater things. In Tammy Garcia it is a peaceful energy. She appears, upon meeting, to be at ease with herself, with her place in the development in her life's work, and with her choices. As Ron McCoy has written in *Southwest Profile* (spring 1993), "Anyone who talks with Tammy Garcia cannot help but come away with a sense of having spent some time with an artist who is accomplished far beyond her years. She is at once forthright and modest, a person who

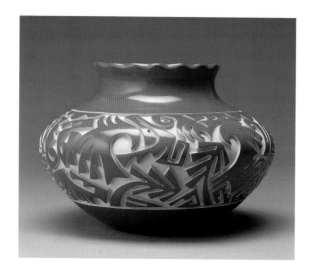

95. *Tammy continues to challenge herself with complexity of design, framing potential chaos within a whole of balance and order. On this redware jar, flora and fauna motifs are segmented, abstracted, and repeated over the polished surface. The shape of the jar is accented by the fluted rim.*

feels very much at home with her art. She is, above all else, a highly disciplined, exceptionally well motivated potter."

Tammy brings a spiritual orientation to her art that reflects her personal relationship to discipline and effort. She does not draw on the traditional spiritual approach to pottery-making, but puts her faith directly in God. "God has given all of the great gifts available to us, including the clay, the volcanic ash and even the talent and skill to utilize the elements to create things of beauty." Many pueblo artists relinquish any sense of personal control of their art to the spirit of the Clay Lady, who in effect, allows them to do their work. Tammy, however, feels she needs to be in total conscious control of her gifts in order to generate a solid finished piece. "God gave us all the elements and talent, and it is up to us as individuals to use it and develop it."

However, in keeping with the respect due to the foundation of an art form spanning two millennia, Tammy follows the traditional method of gathering clay, building vessels, and firing them. The basic technique will always remain the same. To stray from it is to leave behind a history which has come to define southwestern ceramics. Once a pot is completely formed by hand-coiling and scraping, Tammy begins applying design with pencil right onto the pottery surface. She draws spontaneously and free-hand. The composition

96. *This large red-and-sienna piece of Tammy Garcia's, provides a dramatic surface on which to execute her complex designs. On close examination distinct shapes can be seen, including a parrot and a scalloped cloud motif. Each section of design is slipped and polished separately.*

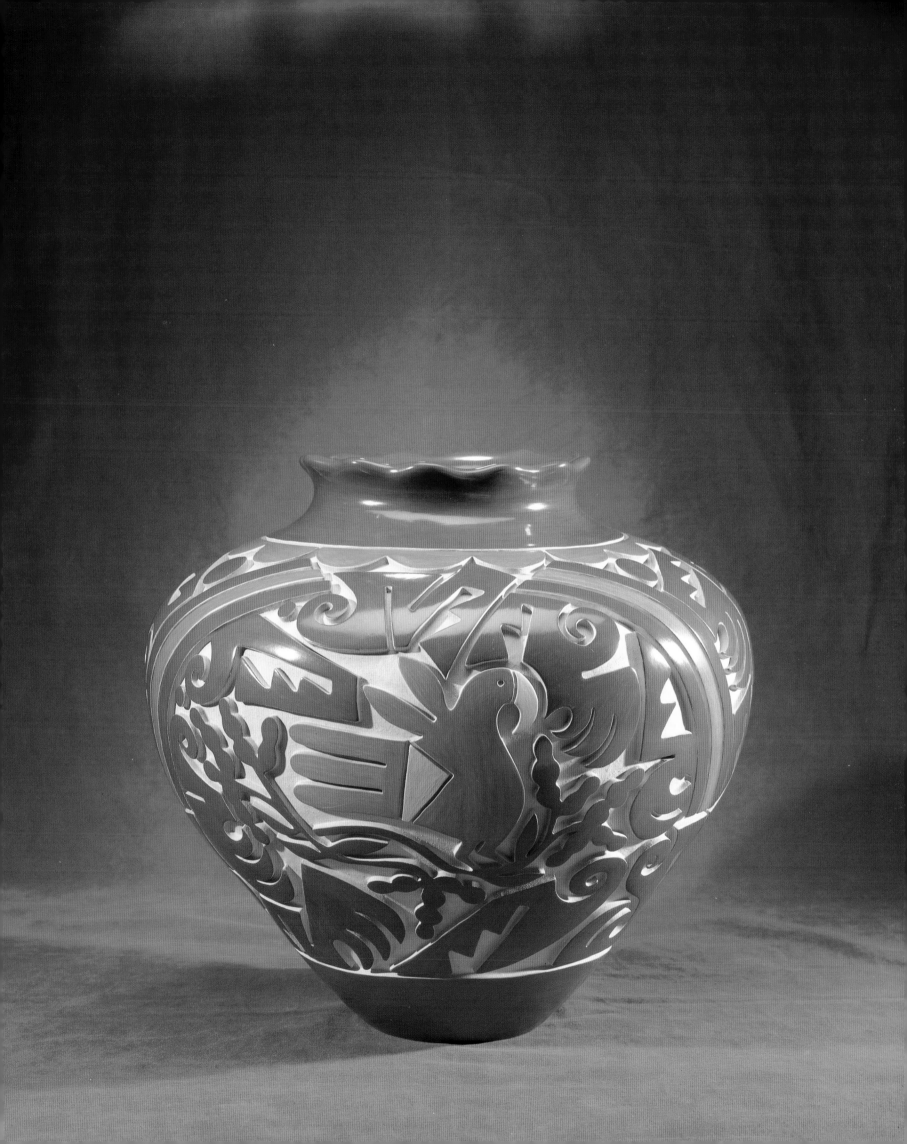

emerges naturally and intuitively based on the cluster of visual references influencing her mind at the time. Sometimes she may begin with a preconceived idea, but the overall design and composition always continue to evolve as she works with the contours of the vessel.

Tammy's designs evolve intuitively during the process of drawing them on her clay "canvas." Like a great performer who seems to accomplish the most difficult feats effortlessly, Tammy, with astonishing ease, envisions and executes her tremendously complicated designs. Tammy says, "I see what I do as simple." Although it seems natural and easy for her, others are aware of an advanced geometry and division of space. Her husband Leroy marvels at the sophistication of Tammy's work but says that he thinks she has no idea how "tough" it is.

Once the design is worked out completely, Tammy's self-imposed, elaborate discipline of carving begins. For the first stage she uses precision screwdrivers of various sizes depending on the size and angles of the channel she is creating. The initial carving is done when the pot is still of leathery consistency (not quite dry). The next carving stage, which is begun when the piece is almost completely dry, clarifies the lines of design. After the pot is completely dry, Tammy moves to a third stage of carving to deepen the channels slightly and further refine the lines and edges. Then the entire surface is sanded smooth. A fourth and final carving refinement is employed after the raised portions of the design are slipped and stone polished. This stage requires Tammy's most critical eye. Slip that has been painted on the raised portions often spills over into the deep channels and thus requires attention. Tammy also uses this last stage before firing to sharpen the edges and clean the lines to best effect.

Tammy next paints slips, ranging in color from white to tan to pink, into the deep channels of carving. Which slip she chooses depends on the color of the polished slip on the raised areas. The goal is to create a dramatic contrast to set off the designs to best advantage.

She regards her polishing technique as highly specialized. On ceramics that have relatively small amounts of carved surface the polishing is usually done all at once—over the entire smooth surface. Tammy leaves little surface uncarved on her pieces and consequently treats each minute section of design as a separate challenge for polishing. The special attention she gives to each section is a double-edged sword. For, while attention to detail creates a better finished product, viewing sections separately can result in variations of luster which need to be reconciled. This is a challenge she accepts as a natural part of her personal style.

Firing is the last step in the process. The firing, from start to finish, lasts about two hours or a bit more. Red pieces finish more quickly. Black pots require smothering the fire in manure in the time-honored reduction process, which cuts off oxygen supply to the fire. In the resulting black, smoky environment, carbon saturates the clay walls nearly all the way to the center. When all stages in the process are completed to perfection, the results are spectacular.

In 1989 Tammy met Leroy Garcia in Taos, New Mexico, and they married in 1990. Leroy's support of Tammy's career has been an important contribution. He comments, "If you think she's good today, wait until tomorrow." Tammy's total dedication to growing in her work, combined with Leroy's ambitions for Tammy's artistic future, have led them to search for the representation needed to provide greater exposure of her ceramics.

Tammy has already achieved a level of technical and artistic skill befitting a master potter in mid-life. This bodes well for her bright future and is an encouraging sign—at the time of this writing—that the spirit of creative innovation is alive and well and will continue to inspire new developments in southwestern cermamic art.

Selected Bibliography

Including Exhibitions, Awards, and Lectures

ROBERTA BURNETT

HELEN CORDERO

Selected Publications

Babcock, Barbara A. "Clay Changes: Helen Cordero and the Pueblo Storyteller." *American Indian Art* 8:2 (1983): 30–39.
_____. *The Pueblo Storyteller.* Tucson: University of Arizona Press, 1986, 21–27.
Monthan, Guy, and Doris Monthan. "Helen Cordero." *American Indian Art* 2:4 (1977): 72-76.
_____. *Art and Indian Individualists.* Flagstaff, Ariz.: Northland Press, 1975, 16-25.
Toulouse, Betty. *Pueblo Pottery of the New Mexico Indians.* Santa Fe: Museum of New Mexico Press, 1977, 76–77.

Exhibitions

1981. Heard Museum Guild's Native American Arts Show, The Heard Museum, Phoenix, Arizona.
1981. "American Indian Art in the 1980s." The Native American Center for the Living Arts, Niagara Falls, New York.

TONY DA

Selected Publications

Cortright, Barbara. "The Beauty Collectors." *Arizona Highways* 50:5 (May 1974): 11 and unnumbered page. Photo of the artist.
Dillingham, Rick. "Martinez." In *Seven Families in Pueblo Pottery.* Albuquerque: University of New Mexico Press, 1974, 106-7.
Jacka, Jerry, and Spencer Gill. *Pottery Treasures.* Portland: Graphic Art Center Publishing Co., 1976, 39.
Lyon, Dennis. "The Polychrome Plates of Maria and Popovi." *American Indian Art* 1:2 (February 1976), 76–79.
Monthan, Guy, and Doris Monthan. *Art and Indian Individualists.* Flagstaff, Ariz.: Northland Press, 1975, 136–45.
Peterson, Susan. *Maria Martinez: Five Generations of Potters.* Washington, D.C.: Smithsonian Institution Press, 1978. For The Renwick Gallery exhibit.
Toulouse, Betty. *Pueblo Pottery of the New Mexico Indians.* Santa Fe: Museum of New Mexico Press, 1977, 76.
Wilson, Maggie. "The Beauty Makers." *Arizona Highways* 50:5 (May 1974) 37–41.

Exhibition

1978. Renwick Gallery, National Collection of Fine Arts, Washington, D.C.

JODY FOLWELL

Selected Publications

Cortright, Barbara. "Jody Folwell, Potter." *Artspace,* Summer, 1982, 33–35.
"Folwell/Cutler Works Featured." *Phoenix Gazette,* February 24, 1982.
Jacka, Jerry, and Lois Jacka. *Beyond Tradition: Contemporary Indian Art and Its Evolution.* Flagstaff, Ariz.: Northland Publishing Co., 1988, 163.
_____. "The New Individualists." *Arizona Highways,* May 1986, 8–9. Color photo and commentary.
Journal of the West, cover, April 1982.
Lichtenstein, Grace. "The Evolution of a Craft Tradition." *Ms. Magazine.* April 1983, 58–60, 92. Photos.
MacDonald, Bruce. "Traditional Pottery Finds Interpreter." *The Scottsdale Progress,* February 26, 1982.
Magill, Douglas C. "Gallery to Feature Four Pueblo Potters." *New York Times,* April 12, 1984.
McCoy, Ron. "Expressionist Pottery from Native America." *Southwest Profile,* November-January 1991–1992, 26–29. Color photos.
_____. "Literary Pottery." *Southwest Profile,* January 1987, 14–17. Color photos.
National Geographic Magazine, November 1982, 605. Photo.

Perlman, Barbara. "Courage: Her Greatest Asset." *Arizona Arts and Lifestyle,* Summer 1980, 20–21.
"Potters Give New Shape to an Old Art Form." *Mesa* (Arizona) *Tribune,* March 4, 1982.
Trimble, Stephen. "Talking with Clay." *New Mexico Magazine,* August 1986, 42. Photo.
Tucker, Sara. "Generations: Listening to the Earth, A Family Tradition." *Santa Fe Reporter,* "Voices," Summer 1989, 7, 9.
"Women Contain Their Art in Unusual Pots." *The Phoenix Gazette,* 1982.

Lecture

1990. "Historic and Modern Pueblo Ceramics: Tradition and Change." Recursos de Santa Fe, Santa Fe, New Mexico.

Broadcast Television

PBS-TV, "Jody Folwell." *American Indian Artists II* (a nationally distributed series on artists of significant stature). To be aired.

Exhibition

1981. "American Indian Art in the 1980s," The Native American Center for the Living Arts, Niagara Falls, New York.

JOSEPH LONEWOLF

Selected Publications

De Lauer, Marjel. "American Indian Artists: Joseph Lonewolf, Grace Medicine Flower." *Arizona Highways* 52 (August 1976), 42.

De Wald, Louise. "One Family of Potters." *New Mexico Magazine* 56:4 (April 1978): 30–33.

Dillingham, Rick. "Tafoya." In *Seven Families in Pueblo Pottery.* Albuquerque: University of New Mexico Press, 1974, 50, 78.

Dutton, Ann. "Blending Environment with Heredity." *Southwest Art,* March 1977, 50.

Jacka, Jerry. *Arizona Highways,* May 1986, 6. Photo, sgraffito pottery plate.

Manley, Ray. "Joseph Lonewolf." *Arizona Highways* 50 (May 1974): 36.

Wilson, Maggie. "The Beauty Makers." *Arizona Highways* 50:5 (May 1974): 36–41.

Young, Jon Nathan. *The Pottery Jewels of Joseph Lonewolf.* Scottsdale, Ariz.: Dandick Press, 1975.

Exhibition

1981. "American Indian Art in the 1980s." The Native American Center for the Living Arts, Niagara Falls, New York.

MARIA AND JULIAN MARTINEZ; POPOVI DA

Selected Publications

Dillingham, Rick. "Martinez." In *Seven Families in Pueblo Pottery.* Albuquerque: University of New Mexico Press, 1974, 106–7.

Fine, Roberta Ross. "The Legacy of Maria Martinez." *Santa Fean Magazine* 8:9 (October 1980): 30–34.

Hodge, Zahrah Preble. "Marie Martinez: Indian Master Potter." *Southern Workman* 62:5 (1933): 213–15.

Manley, Ray. "Maria of San Ildefonso." *Arizona Highways* 50 (May 1974): 4.

"Maria." *Exploration 1979.* Santa Fe: School of American Research, 1979, 20-21.

Marriott, Alice. *Maria: The Potter of San Ildefonso.* Norman: University of Oklahoma Press, 1948.

"Martinez, Maria Antonita," *Who's Who of American Women,* 8th ed. St. Louis: Von Hoffman Press, 1974-1975, 613.

McGreevy, Susan B. *Maria: The Legend, the Legacy.* Santa Fe: Sunstone Press, 1982.

Monthan, Guy, and Doris Monthan. *Art and Indian Individualists.* Flagstaff, Ariz.: Northland Press, 1975.

Nelson, Mary Carrol. *Maria Martinez.* Minneapolis: Dillon Press, 1972.

Peterson, Susan. *The Living Tradition of Maria Martinez.* Tokyo and New York: Kodansha, 1977.

_____. *Maria Martinez: Five Generations of Potters.* Washington, D.C.: Smithsonian Institution Press, 1978. For the Renwick Gallery exhibit.

Toulouse, Betty. "Maria: The Right Woman at the Right Time." *El Palacio* 86:4 (Winter 1980–1981), 3–7.

Spivey, Richard L. *Maria.* Flagstaff, Ariz.: Northland Press, 1979.

Exhibitions, Awards, and Honors

1904. "Louisiana Purchase Exhibition," St. Louis World's Fair. Pottery demonstration.

1914. Panama-California Exposition, San Diego World's Fair, group exhibit of San Ildefonso potters. Demonstration.

1934. Chicago World's Fair "Century of Progress," special exhibitors. "Special Recognition Award," Ford Exhibition; Bronze medal for "Indian Achievement," Indian Fire Council.

1939. San Francisco World's Fair, Golden Gate International Exhibition. Demonstration.

1953. Bronze Medal, to Maria, "Greatest Contribution of the Arts," University of Colorado at Boulder.

1954. "The Craftsmanship Medal," American Institute of Architects' 86th Annual Convention, Boston, Massachusetts.

1959. "Jane Adams Award for Distinguished Service," Rockford College, Santa Fe, New Mexico.

1967. "Three Generations Show," United States Department of Interior, Washington, D.C. Maria, Popovi Da, and Tony Da. Preview exhibit, Institute of American Indian Arts, Santa Fe, New Mexico.

1968. "Presidential Citation," American Ceramic Society, Pasadena, California.

1969. "Symbol of Man Award," Minnesota Museum of Art, St. Paul, Minnesota.

1971. Honorary Doctorate of Fine Arts, New Mexico State University, Las Cruces, New Mexico.

1974. "Catlin Peace Pipe Award," American Indian Lore Association.

1974. First Annual "Governor's Award," New Mexico Arts Commission.

1976. "Honorary Member of the Council," Title conferred by National Council on Education for the Ceramic Arts.

1977. Honorary Doctorate, Columbia College, Chicago, Illinois.

1977. "Presbyterian Hospital Foundation Award for Excellence."

1978. Renwick Gallery, National Collection of Fine Arts, Washington, D.C.

GRACE MEDICINE FLOWER

Selected Publications

Dedera, Don. *Artistry in Clay.* Flagstaff, Ariz.: Northland Publishing, 1985.

De Lauer, Marjel. "American Indian Artists: Joseph Lonewolf, Grace Medicine Flower." *Arizona Highways* 52 (August 1976): 42. Photos, 21–22, back cover.

Dillingham, Rick. "Tafoya," *Seven Families in Pueblo Pottery.* Albuquerque: University of New Mexico Press, 1974, 50, 74–75.

Jacka, Jerry, and Lois Jacka. *Beyond Tradition: Contemporary American Indian Art and Its Evolution.* Flagstaff, Ariz.: Northland Publishing, 1988, 160.

Klimiades, Mario. *This Song Remembers: Self-Portraits of North Americans in the Arts."* Boston: Houghton Mifflin, 1980, 109–15.

Manley, Ray. *Southwestern Indian Arts and Crafts.* Tucson, Ariz.: Ray Manley Photography, 1975.

McCoy, Ronald. "Homage to the Clay Lady." *Southwest Profile,* March 1990, 21-23.

Monthan, Guy, and Doris Monthan. *Art and Indian Individualists.* Flagstaff, Ariz.: Northland Press, 1975, 136–45.

The Pottery Jewels of Joseph Lonewolf. Scottsdale, Ariz.: Dandick Publishers, 1975.

Trimble, Stephen. *Talking with the Clay: The Art of Pueblo Pottery.* Santa Fe, New Mexico: School of American Research Press, 1987.

Broadcast Television

USA Today, segment on the family's work, 1988.

Cactus Pryor Show, Austin, Texas, 1978.

PBS-TV, *American Indian Artists,* documentary series, produced at KAET-TV, Tempe, Ariz., 1976.

Exhibitions and Honors

1974. Guest of Mrs. Richard Nixon, The White House, Washington, D.C.

1979. "One Space, Three Visions," Albuquerque Museum.

1981. "American Indian Art in the 1980s, The Native American Center for the Living Arts, Niagara Falls, New York.

1984. Jacqueline Kennedy Onassis visited with Grace Medicine Flower in her home at the Santa Clara pueblo, March.

NAMPEYO

Selected Publications

Dillingham, Rick. "Nampeyo." *Seven Families in Pueblo Pottery.* Albuquerque: University of New Mexico Press, 1974, 17–20.

Frisbie, Theodore R. "The Influence of J. Walter Fewkes on Nampeyo: Fact or Fancy?" In Albert H. Schroeder, ed., *The Changing Ways of Southwestern Indians: A Historic Perspective*. Glorieta, N.M.: Rio Grande Press, 1973, 231–43.

Jacka, Jerry, and Lois Jacka. *Beyond Tradition: Contemporary Indian Art and Its Evolution*. Flagstaff: Northland Press, 1988, 57.

McCoy, Ron. "Pueblo Potters of Genius: Nampeyo and the Team of Maria and Julian Martinez." *Antiques and Fine Art*, 100–107.

"Nampeyo," *Arizona Highways* 50:5 (May 1974): 16.

"Nampeyo Coiling a Pot," *Arizona Highways*. January 1975, 14. Photo.

DEXTRA QUOTSKUYVA NAMPEYO

Selected Publications

Dillingham, Rick. "Nampeyo." *Seven Families in Pueblo Pottery*. Albuquerque: University of New Mexico Press, 1974, 36–38.

Jacka, Jerry, and Lois Jacka. *Beyond Tradition: Contemporary Indian Art and Its Evolution*. Flagstaff, Ariz.: Northland Press, 1988, 57.

"Nampeyo." *Arizona Highways* 50:5 (May 1974): 16.

DORA TSE PÉ PEÑA

Selected Publications

Clark, William. "Masters of the Art: Dora Tse Pé Peña, Potter." *Indian Market Magazine* (Southwest Association on Indian Affairs), 26–27. Color photo.

_____. "San Ildefonso Potter Creates Art from Earth." *Albuquerque Journal*, August 23, 1987, G1, G6.

Dillingham, Rick. "The Gonzalez Family." In *Seven Families in Pueblo Pottery*. Albuquerque: University of New Mexico Press, 1974, 80, 83, 84. Photo of the artist.

McCoy, Ron. "Expanding the Mainstream." *Southwest Profile*, August 1988, 27–30.

"San Ildefonso Potters Find Peace." *Albuquerque Journal*, August 15, 1989, 7.

Trimble, Stephen. *Talking with the Clay*. Santa Fe, N.M.: School of American Research Press, 1987.

Permanent Collections

The White House Art Collection, Washington, D.C.
The Museum of Man, San Diego, California.

Lecture

1990. "Historic and Modern Pueblo Ceramics: Tradition and Change," Recursos de Santa Fe, Santa Fe, New Mexico.

ALFRED H. QÖYAWAYMA

Selected Publications

Baca, Elmo, and Suzanne Deats. *Santa Fe Design*. New York: Crown Publishing, 1990, three color photos and story, 186.

Berger, Bruce. "Modern Pots, Ancient Ways." *Americana Magazine*, March/April 1984, 52–55. Color photos.

Bishop, Ronald, Veletta Canouts, Suzanne de Atley, Victor Masayesva, and Alfred Qöyawayma. "An American Indian Outreach Program [at Hopi]," 1989 Western Museums Conference, Phoenix, Arizona, October 26, 1989.

Bishop, Ronald, Veletta Canouts, Suzanne de Atley, Alfred Qöyawayma, and C. W. Aikins. "The Formation of Ceramic Analytical Groups: Hopi Pottery Production and Exchange, A.D. 1300–1600." *Journal of Field Archaeology* 15 (1988): 317–37.

Brown, Carol Osman. "The Magic of Santa Fe Indian Market." *Native Peoples*, Spring 1991, 9–16.

Cortright, Barbara. "Recipient of Tradition." *Southwest Profile*, August 1985, 21–24. A critical essay with color and black and white photos.

Dittert, Alfred, and Fred Plog. *Generations in Clay—Pueblo Pottery of the American Southwest*. Flagstaff, Ariz.: Northland Press, 1980.

Gianelli, Frank. "Minorities Issue: Tops in Four Fields." *Graduating Engineer*, October 1984, 23–27. Color photos, 24, 25, 26.

_____. "Tops in Four Fields." *Winds of Change*, February 1986, 4–6. Color photos.

Jacka, Jerry, and Lois Jacka. *Beyond Tradition: Contemporary American Indian Art and Its Evolution*. Flagstaff, Ariz.: Northland Publishing Col, 1988, 50, 90, and back cover.

_____. "The New Individualists." *Arizona Highways*, May 1986. Color photos, inside front cover and 7.

Qöyawayma, Al. "Between Two Worlds." *Santa Fe*, Going Places with the Arts," Summer 1991, 8–13. Color photo.

_____. "Diversity at Work." *IEEE Spectrum*, June 1992, 28–29. Photo and article. An international publication of the Institute of Electronic and Electrical Engineers.

_____. *Qöyawayma, the Potter*. Santa Fe, N.M.: Santa Fe East, 1984, 31 pp. Sepia photos.

And other publications such as

Arizona Highways, The Hopi Tricentennial issue, September 1980, color photo.
National Geographic, November 1982, color photo and brief note.
Santa Fean, August 1983.
Southwest Profile, August 1983.

Videos and Broadcast Television

1980. *Generations in Clay—Pueblo Pottery of the American Southwest*, voice-over by Al Qöyawayma.

1983. ABC News, interview at Santa Fe Indian Market, aired on two prime time segments.

1985. Interview, Charles Loloma and Al Qöyawayma, Public Broadcasting, Santa Fe, New Mexico, 30 minutes.

1988. "Taking Tradition to Tomorrow," segment, in *American Indian Science and Engineering*, 30-minute video on the lives of Native Americans in science, education, and the arts.

1988. Victor Masayesva, director and producer: Hopi film on ancient Hopi ceramics project, Smithsonian Institute, Washington, D.C.

1989. Jacka, Jerry, and Lois Jacka, "*Beyond Tradition*," four segments. Video won two Rocky Mountain Emmy Awards.

1989. "Qöyawayma," *Arizona Art Forms*, 4-minute feature, PBS TV, played throughout Arizona over 20 times, still aired in 1992.

1990. "I Have a Dream," Asahi TV, Japan, 2 1/2 minute feature, played to 10 million viewers in July 1990.

1991. Contract for Video Consulting: Media Resource Associates; future video segment on *Indian America*, PBS TV, Washington, D.C.

1991. "Pueblo Potters Visit with the Maori People," half-hour documentary, New Zealand National Television Network.

1992. "Vision Session," half-hour documentary, Institute of American Indian Art (IAIA), July, 1992.

Lectures/Cultural Exchange

1977. University of Texas.
1979. White House, Docents.
1981. Phoenix Art Museum, Phoenix, Arizona.
1982. ACA Gallery, New York.
1983. Mauna Lani Bay Hotel, Hawaii.
1985. Arizona State University, Tempe, Arizona.
1985. Taylor Museum, Colorado Springs, Colorado, "Al Qoyawayma Retrospective."
1987. Scottsdale Historic Society, Scottsdale, Arizona.
1988. Museum of Northern Arizona, Flagstaff, Arizona.
1987. University of Colorado.

1991. Maori and south Pacific Arts Commission/TeWaka Toi, Fulbright Fellowship, TePokepoke Ukua Program, cultural exchange (one month), Waipoua, New Zealand, May 1991. Worked with Maori to re-establish an ancient pottery tradition.

1991. Heard Museum, Phoenix, Arizona, "Between Two Worlds: Native American Professionals Today."

RUSSELL SANCHEZ

Publications and Exhibitions

McCoy, Ron. "Expanding the Mainstream," *Southwest Profile*, August 1988, 27–30.

1980. Swaia, "Indian Market."

1981. Heard Museum Guild Show, Heard Museum, Phoenix, Arizona.

RICHARD ZANE SMITH

Selected Publications

Burnett, Roberta. "Richard Zane Smith." *Ceramics Monthly* 40 (September 1992): 58-61.

Southwest Art Magazine, April 1991, 26. Column includes notes and a photo.

Jacka, Jerry, and Lois Jacka. *Beyond Tradition: Contemporary American Indian Art and Its Evolution.* Flagstaff, Ariz.: Northland Publishing Co., 1988, 99 and 194.

_____. "The New Individualists." *Arizona Highways*, May 1986, 30 and 46.

Manhart, Thomas, and Marcia Manhart, eds. *The Eloquent Object.* Tulsa: The Philbrook Museum of Art, 1987, 35, 64. Color photos.

McCoy, Ron. "Corrugated Ware." *Southwest Profile*, August 1986, 48–51. Color photos.

_____. "The Cutting Edge." *Southwest Profile*, August 1987, 14–17. Color photo.

_____. "Southwestern Pottery: New Forms, Old Legends." *Craft International*, July–September 1987, 20–21.

Lectures and Demonstrations

1990. "Historic and Modern Pueblo Ceramics: Tradition and Change," The Wheelwright Museum of the American Indian, sponsored by Recursos de Santa Fe, New Mexico.

1991. National Council on Education for the Ceramic Arts, demonstration, *Arizona State University*, Tempe, Arizona.

MARGARET TAFOYA

Selected Publications

Blair, Mary Ellen, and Laurence Blair. *Margaret Tafoya: A Tewa Potter's Heritage and Legacy.* West Chester, Pa: Schiffer Publishing, Ltd., 1986.

Barnes, Scott. "Margaret Tafoya, Potter." *Santa Fean* 13:7 (August 1984): 39-41.

Dillingham, Rick. "Tafoya." In *Seven Families in Pueblo Pottery.* Albuquerque: University of New Mexico Press, 1974, 52-53.

Dillingham, Rick, Richard W. Lang, and Rain Parrish. *The Red and the Black.* Santa Fe, N.M.: The Wheelwright Museum, 1983, 14 pp.

Hunt, Marhorie, Boris Weintraub, and David Alan Harvey. "Masters of Traditional Arts," *National Geographic* 179 (January 1991): 74.

McGill, Douglas C. "Gallery to Feature Four Pueblo Potters." *New York Times*, April 12, 1984.

National Heritage Fellowship Award Program, National Endowment for the Arts, 1984. Photo of the artist, who was present to receive the award. Information program notes.

Perlman, Barbara. "Doing It Right! The Tafoya-Youngblood Family." *Arizona Arts and Lifestyle*, Winter 1981. Photos by Jerry Jacka.

Summar, Polly. "A Margaret Tafoya Retrospective." *New Mexico Magazine*, June 1983, 21.

"The Tafoya Family of Potters," 10-minute documentary videotape, produced by Denver Museum of Natural History in conjunction with retrospective exhibit, 1983.

Selected Exhibits and Awards

1981. "American Indian Art in 1980s," The Native American Center for the Living Arts, Niagara Falls, New York.

1983. "The Red and The Black: Santa Clara Pottery by Margaret Tafoya," The Museum of the American Indian, Santa Fe, New Mexico. A retrospective exhibition.

1983. "Margaret Tafoya: A Potter's Heritage and Her Legacy," a retrospective exhibit, with Nathan and Nancy Youngblood, Denver Museum of Natural History, Colorado.

1984. "Margaret Tafoya," Gallery 10, Scottsdale, Arizona, solo exhibition.

1984. Recipient, National Heritage Fellowship, National Endowment for the Arts, Washington, D.C.

SARAFINA GUTIERREZ TAFOYA

Selected Publications

Dillingham, Rick. "Tafoya," In *Seven Families in Pueblo Pottery.* Albuquerque: University of New Mexico Press, 1974, 49–50.

Toulouse, Betty. *Pueblo Pottery of the New Mexico Indians.* Santa Fe: Museum of New Mexico Press, 1977, 76.

DOROTHY TORIVIO

Selected Publications

Nancy C. Benson, "Pottery of the Pueblos." *Vista U.S.A.*, Winter 1986–1987, 40. Photos by Jerry Jacka.

Ceramics Monthly, "News & Retrospect," April 1987, 77–79.

Ceramics Monthly, " News & Retrospect," October 1985, 81.

"Dorothy Torivio—Complex Designs Result in Unique Pottery." *Art Talk*, March 1985, 13. Photos.

Jacka, Jerry, and Lois Jacka. *Beyond Tradition: Contemporary American Indian Art and Its Evolution.* Flagstaff, Ariz.: Northland Publishing Co., 1988, 55, 125.

_____. "The New Individualists." *Arizona Highways*, May 1986, 12–13.

McCoy, Ron. "Op Art Pottery." *Southwest Profile*, January–February, 1986, 40–43. Photos.

NANCY YOUNGBLOOD

Selected Publications

Berger, Bruce. "Pottery from the Pueblo: The Work of Nancy Youngblood Cutler." *Americana Magazine*, November–December 1985, 48–51. Color photos.

Craft Range. March–April 1983. Photo.

"Folwell Cutler Works Featured." *The Phoenix* (Arizona) *Gazette*, February 24, 1984.

Hart, William. "Buying Frenzy: Indian Works Sell Like Mad at Art Festival." *The Arizona Republic*, August 18, 1987, C5-C6. Photos.

Jacka, Jerry, and Lois Jacka. *Beyond Tradition: Contemporary American Indian Art and Its Evolution.* Flagstaff, Ariz.: Northland Publishing Co., 1988, 51.

_____. "The New Individualists." *Arizona Highways*, May 1986, 32. Color photo.

Luptak, Gene. "Self-Expression: Potter's Work Melds Tribal Tradition, Personal Identity." *The Arizona Republic*, March 27, 1987. Photos.

McCoy, Ron. "Jewel-Like Pottery." *Southwest Profile*, March–April 1987, 14–17.

_____. "The Show of Shows." *Southwest Profile*, August 1989, 27–30.

McGill, Douglas C. "Gallery to Feature Four Pueblo Potters." *New York Times*, April 12, 1984.

Mesa (Arizona) *Tribune*. "Potters Give New Shape to an Old Art Form," March 4, 1982.

New Mexico Craft Magazine. Cover article on Youngblood family of potters, 4:1 (n.d.), n.p.

Perlman, Barbara. "Doing It Right! The Tafoya-Youngblood Family." *Arizona Arts and Lifestyle*, Winter 1981. Photos.

Pine, Lynn. "Women Contain Their Art in Unusual Pots." *The Phoenix* (Arizona) *Gazette*, 1982

Silver, John. "The Santa Clara Legacy," *The Gilcrease Magazine of American History and Art*, October 1984, 1-7. Back cover, photos.

SWAIA Update. 1989 Indian Market 8:1 (October 1989): 3. Black and white photo, "Best of Show."

Video

1983. "The Tafoya Family of Potters." Documentary videotape, produced by Denver Museum of Natural History, 10 minutes, in conjunction with retrospective exhibit.

NATHAN YOUNGBLOOD

Selected Publications

Berger, Bruce. "Nathan Youngblood." *Ceramics Monthly*, November 1990, 52-57. Photos. Also appears in Berger's *The Telling Distance: Conversations with the American Southwest* (Seattle: Breitenbush Books), 1990. This book won the Western States' Arts Foundation Non-Fiction Award for 1990.

Craft Range. March–April, 1983. Photo, 1/4 page.

Ellis, Nancy. "The Clay Mother's Gift." *Southwest Profile*, May-June 1986, 12–15. Photos.

Good Morning, America, ABC TV, August, 1978.

McCoy, Ron. "Letting the Clay Take Over." *Southwest Profile*, August 1990, 30–36. Color photos.

McGill, Douglas C. "Gallery to Feature four Pueblo Potters." *New York Times*, April 12, 1984.

New Mexico Craft Magazine. Cover article on Youngblood family of potters 4:1 (n.d.), n.p.

Nichols, Carol. "Market in Santa Fe." *Fort Worth Star-Telegram*, September 1, 1983.

Perlman, Barbara. "Doing It Right! The Tafoya-Youngblood Family." *Arizona Arts and Lifestyle*, Winter 1981. Black and white photos by Jerry Jacka.

Silver, John. "The Santa Clara Legacy." *The Gilcrease Magazine of American History and Art*, October 1984, 1-7. Back cover and photo.

Vander Plas, Jaap., "Nathan Youngblood: But Most of All I Like My Grandmother." *Artlines*, August, 1985, 11. The major photo of pottery in this article is incorrectly attributed to Nathan Youngblood.

Video

"The Tafoya Family of Potters." 10-minute documentary videotape, produced by Denver Museum of Natural History in conjunction with retrospective exhibit, 2983.

Lectures

1981. De Colores, cultural program of the Southwest. Demonstration and interview.

1983. "Margaret Tafoya: A Potter's Heritage and Her Legacy." Denver Museum of Natural History, Denver, Colorado.

1984. "The Santa Clara Legacy," Gilcrease Museum, Tulsa, Oklahoma. Demonstrations by Nathan Youngblood.

1988. Cowboy Hall of Fame, Oklahoma City, Oklahoma.

1990. "Santa Clara Pueblo Ceramics: Tradition and Change." The Wheelwright Museum of the American Indian, sponsored by Recursos de Santa Fe, New Mexico.

1990. "Santa Clara Pottery." School of American Research, Santa Fe, New Mexico

Colorado State University, Ft. Collins, Colorado. Three-day lecture demonstration, including exhibition of traditional firing techniques.

Highlands University, Las Vegas, New Mexico. Lecture and exhibition.

Indian Arts and Crafts Association, annual meeting, Kansas City, Missouri Lecture-demonstration.

Hockaday Prep School and St. Mark's Prep School, Dallas, Texas Lecture-demonstration.

Trinity Valley, private school, Ft. Worth, Texas. lecture for gifted ceramics students.